Gerry O'Gorman

About the Author

JOHN O'DONOHUE was awarded a Ph.D. in philosophical theology from the University of Tubingen in 1990. He is the author of several works, including a book on the philosophy of Hegel, *Person als Vermittlung*; two collections of poetry, *Echoes of Memory* and *Conamara Blues*; and two international bestsellers, *Anam Cara* and *Eternal Echoes*. He lectures and holds workshops in Europe and America, and is researching a book on the philosophical mysticism of Meister Eckhart. He lives in Ireland.

BEAUTY

THE INVISIBLE EMBRACE

JOHN O'DONOHUE

Perennial

An Imprint of HarperCollins*Publishers*

An extension of this copyright page appears on page 261.

Published in Great Britain in 2003 under the title *Divine Beauty* by Bantam Press, a division of Transworld Publishers.

A hardcover edition of this book was published in 2004 by HarperCollins Publishers.

HarperCollins books may be purchased for educational, business, or sales promotional use. For information please write: Special Markets Department, HarperCollins Publishers Inc., 10 East 53rd Street, New York, NY 10022.

FIRST PERENNIAL EDITION PUBLISHED 2005.

The Library of Congress Cataloging-in-Publication Data is available upon request.

ISBN 0-06-095726-3 (pbk.)

08 09 ❖/RRD 10 9 8

This book is for
Ellen Wingard
Whose lovely heart and aesthetic sensibility
Is ever attuned to the Call of Beauty

and

Loretta Harrington-Roome
Whose gentle soul and mystical imagination
Always illuminates our Kinship with the Invisible

May Beauty bless their every breath and footstep.

CONTENTS

Certainly many instances of earthly beauty – a song, the twilit sea, the tone of the lyre, the voice of a boy, a verse, a statue, a column, a garden, a single flower – all possess the divine faculty of making man hearken unto the innermost and outermost boundaries of his existence, and therefore it is not to be wondered at that the lofty art of Orpheus was esteemed to have the power of diverting the streams from their beds and changing their courses, or luring the wild beasts of the forest with tender dominance, of arresting the cattle a-browse upon the meadows and moving them to listen, caught in the dream and enchanted, the dream-wish of all art: the world compelled to listen, ready to receive the song and its salvation.

HERMANN BROCH, *The Death of Virgil*

and in thy voice I catch
The language of my former heart . . .

WILLIAM WORDSWORTH, 'Tintern Abbey'

INTRODUCTION

It visits with inconstant glance
Each human heart and countenance;
Like hues and harmonies of evening, –
Like clouds in starlight widely spread, –
Like memory of music fled, –
Like aught that for its grace may be
Dear, and yet dearer for its mystery.

Spirit of Beauty, that dost consecrate
With thine own hues all thou dost shine upon
Of human thought or form, – where art thou gone?

PERCY BYSSHE SHELLEY, 'Hymn to Intellectual Beauty'

THE CRY OF OUR TIMES: TO AWAKEN BEAUTY

WE LIVE BETWEEN THE ACT OF AWAKENING AND THE ACT OF surrender. Each morning we awaken to the light and the

invitation to a new day in the world of time; each night we surrender to the dark to be taken to play in the world of dreams where time is no more. At birth we were awakened and emerged to become visible in the world. At death we will surrender again to the dark to become invisible. Awakening and surrender: they frame each day and each life; between them the journey where anything can happen, the beauty and the frailty. When the Celtic Imagination searched for the structures of shelter and meaning, it raised its eyes to the mountains and the heavens and put its trust in the faithful patterns of the sun, stars, moon and seasons. Long before them the Greeks too had raised the eye beyond the horizon and recognized the heavenly patterns of the cosmos. There they glimpsed a vision of order which was to become the heart of their understanding of beauty. All the frailty and uncertainty was seen to be ultimately sheltered by the eternal beauty which presides over all the journeys between awakening and surrender, the visible and the invisible, the light and the darkness.

The human soul is hungry for beauty; we seek it everywhere – in landscape, music, art, clothes, furniture, gardening, companionship, love, religion and in ourselves. No-one would desire not to be beautiful. When we experience the Beautiful, there is a sense of homecoming. Some of our most wonderful memories are of beautiful places where we felt immediately at home. We feel most alive in the presence of the Beautiful for it meets the needs of our soul. For a while the strains of struggle and endurance are relieved and our frailty is illuminated by a different light in which we come to glimpse behind the shudder of appearances the sure form of things. In the experience of beauty we awaken and surrender in the same act. Beauty brings a sense of completion and sureness. Without any of the usual calculation, we can slip into the Beautiful with the same ease as we slip into the seamless embrace of water; something ancient within us already trusts that this embrace will hold us.

These times are riven with anxiety and uncertainty, given the current global crisis. In the hearts of people some natural ease has

been broken. It is astounding how this has reached deep into the heart. Our trust in the future has lost its innocence. We know now that anything can happen, from one minute to the next. The traditional structures of shelter are shaking, their foundations revealed to be no longer stone but sand. We are suddenly thrown back on ourselves. Politics, religion and economics and the institutions of family and community, all have become abruptly unsure. At first, it sounds completely naïve to suggest that now might be the time to invoke and awaken beauty. Yet this is exactly the claim that this book explores. Why? Because there is nowhere else to turn and we are desperate; furthermore, it is because we have so disastrously neglected the Beautiful that we now find ourselves in such terrible crisis.

THE GLOBAL CRISIS AND THE VIOLATION OF BEAUTY

Let the beauty we love be what we do.
There are hundreds of ways to kneel and kiss the ground.

RUMI

IN A SENSE, ALL THE CONTEMPORARY CRISES CAN BE REDUCED TO a crisis about the nature of beauty. This perspective offers us new possibilities. In parched terrains new wells are to be discovered. When we address difficulty in terms of the call to beauty, new invitations come alive. Perhaps, for the first time, we gain a clear view of how much ugliness we endure and allow. The media generate relentless images of mediocrity and ugliness in talk-shows, tapestries of smothered language and frenetic gratification. The media are becoming the global mirror and these shows tend to enshrine the ugly as the normal standard. Beauty is mostly forgotten and made to seem naïve and romantic. The blindness of

property development creates rooms, buildings and suburbs which lack grace and mystery. Socially, this influences the atmosphere in the workplace, the schoolroom, the boardroom and the community. It also results in such degradation of the environment that we are turning more and more of our beautiful earth into a wasteland. Much of the stress and emptiness that haunts us can be traced back to our lack of attention to beauty. Internally, the mind becomes coarse and dull if it remains unvisited by images and thoughts which hold the radiance of beauty.

Hans Urs von Balthasar writes: 'Beauty is the disinterested one, without which the ancient world refused to understand itself, a word which both imperceptibly and yet unmistakably has bid farewell to our new world, a world of interests, leaving it to its own avarice and sadness. No longer loved or fostered by religion, beauty is lifted from its face as a mask, and its absence exposes features on that face which threaten to become incomprehensible to man ... Our situation today shows that beauty demands for itself at least as much courage as do truth and goodness, and she will not allow herself to be separated and banned from her two sisters without taking them along with herself in an act of mysterious vengeance.'

Coarseness is always the same relentless chafing; it makes every texture it touches raw and rough. There is an unseemly coarseness to our times which robs the grace from our textures of language, feeling and presence. Such coarseness falsifies and anaesthetizes our desire. This is particularly evident in the spread of greed, which to paraphrase Shakespeare 'makes hungry where most she satisfies'. Greed is unable to envisage any form of relationship other than absorption or possession. However, when we awaken to beauty, we keep desire alive in its freshness, passion and creativity. Beauty is not a deadener but a quickener!

Sadly, whether from resentment, fear or blindness, beauty is often refused, repudiated or cut down to the size of our timid perceptions. The tragedy is that what we refuse to attend to cannot

reach us. In turning away from beauty, we turn away from all that is wholesome and true, and deliver ourselves into an exile where the vulgar and artificial dull and deaden the human spirit. In their vicinity we are unable to feel or think with any refinement. They cannot truly engage us because of their emptiness; they pound our minds and feelings because they lack the coherence to embrace the inner form of the soul. They are not a presence but an absence that evicts.

It has become the habit of our times to mistake glamour for beauty. This concern is expressed trenchantly by Robert C. Morgan: 'Beauty is not glamour. Most of what the media ... the fashion world ... Hollywood ... the art world has to offer is glamour. Glamour, like the art world itself, is a highly fickle and commercially driven enterprise that contributes to ... the "humdrum". It appears and disappears ... No one ever catches up to glamour.' This is reminiscent of what Denis Donoghue once wrote about some lines of poetry that were the work of Fancy, not Imagination: 'the first effect of the lines is the only effect they will ever have, no amount of pondering will make them glow'. Glamour too has but a single flicker. In contrast, the Beautiful offers us an invitation to order, coherence and unity. When these needs are met, the soul feels at home in the world.

IF BEAUTY WERE INVITED

OUR TIMES ARE DRIVEN BY THE INESTIMABLE ENERGIES OF THE mechanical mind; its achievements derive from its singular focus, linear direction and force. When it dominates, the habit of gentleness dies out. We become blind: nature is rifled, politics eschews vision and becomes the obsessive servant of economics, and religion opts for the mathematics of system and forgets its mystical flame. Instead of true leadership which would be the servant of vision and

imagination, we have systems of puppetry which are carefully constructed and manipulated from elsewhere. We never know who we are dealing with; hidden agendas operate to deepen our insecurity and persuade us to be hopeless. Our present dilemma is telescoped in this wonderful phrase from Irish writer and visionary politician Michael D. Higgins: 'This *acceptance of inevitability* in our lives is consistent of course with the suggestion that there is but one vision of the economy, an end of history, the death of ethics, and an appropriate individualism that eschews solidarity and any transcendent public values.'

Yet constant struggle leaves us tired and empty. Our struggle for reform needs to be tempered and balanced with a capacity for celebration. When we lose sight of beauty our struggle becomes tired and functional. When we expect and engage the Beautiful, a new fluency is set free within us and between us. The heart becomes rekindled and our lives brighten with unexpected courage. It is courage that restores hope to the heart. In our day to day lives, we often show courage without realizing it. However, it is only when we are afraid that courage becomes a question. Courage is amazing because it can tap in to the heart of fear, taking that frightened energy and turning it towards initiative, creativity, action and hope. When courage comes alive, imprisoning walls become frontiers of new possibility, difficulty becomes invitation and the heart comes into a new rhythm of trust and sureness. There are secret sources of courage inside every human heart; yet courage needs to be awakened in us. The encounter with the Beautiful can bring such awakening. Courage is a spark that can become the flame of hope, lighting new and exciting pathways in what seemed to be dead, dark landscapes.

Let Beauty Surprise You

> The arts, whose task once was considered to be that of
> manifesting the beautiful, will discuss the idea only to dismiss
> it, regarding beauty only as the pretty, the simple, the pleasing,
> the mindless and the easy. Because beauty is conceived so
> naively, it appears as merely naive, and can be tolerated only if
> complicated by discord, shock, violence, and harsh terrestrial
> realities. I therefore feel justified in speaking of the
> repression of beauty.
>
> James Hillman

WHEN WE AWAKEN TO THE CALL OF BEAUTY, WE BECOME AWARE
of new ways of being in the world. We were created to be creators.
At its deepest heart, creativity is meant to serve and evoke beauty.
When this desire and capacity come alive, new wells spring up in
parched ground; difficulty becomes invitation and rather than
striving against the grain of our nature, we fall into rhythm with its
deepest urgency and passion. The time is now ripe for beauty to
surprise and liberate us. Beauty is a free spirit and will not be
trapped within the grid of intentionality. In the light of beauty, the
strategies of the ego melt like a web against a candle. As Frederick
Turner puts it, 'Beauty . . . is the highest integrative level of under-
standing and the most comprehensive capacity for effective action.
It enables us to go with, rather than against, the deepest tendency
or theme of the universe.'

The wonder of the Beautiful is its ability to surprise us. With
swift, sheer grace, it is like a divine breath that blows the heart
open. Immune to our strategies, it can take us when we least expect
it. Because our present habit of mind is governed by the calculus of
consumerism and busyness, we are less and less frequently available
to the exuberance of beauty. Indeed, we have brought calculation to
such a level that it now seems unsophisticated to admit surprise!
One of the great modern philosophers of Beauty, Immanuel Kant,

spoke of the joy we take in the Beautiful as a 'disinterested delight'. The animation of the Beautiful is so immediate and fulfilling that we simply enjoy it for itself; it never occurs to us to ask what purpose it serves. Our joy in the Beautiful is as native to us as our breath, a lyrical act where we surrender but to awaken.

Though we have become more helpless and hopeless, we have grown keenly aware of the urgency and necessity for real and positive change. We grow increasingly deaf to the worn platitudes of staid authority. Their forced, didactic tones no longer reach our need. Now we want the experience itself, not the analysis or the membership card to some new syndrome. Notions of self-improvement have become banal and wearisome. The zealots of analysis have become blind. In contrast, beauty offers us refreshment, elevation and remembrance of our true origin and real destination. In this sense, the Beautiful is the true priestess of individuation, inviting us to engage the infinite design that shapes our days and dreams. She does not force on us any manufactured coherence towards which we must falsely strain; this is the diametrical opposite of all forms of fundamentalism. She invites us to surrender so that we can participate in the forming of a new and vital coherence that is native to our desire. In such unsheltered and uncertain times we yearn for this order and coherence, which brings the emerging forms of our own growth into rhythm with the concealed order of creation. Hans-Georg Gadamer catches this need beautifully when he says 'the experience of the beautiful . . . is the invocation of a potentially whole and holy order of things, wherever it may be'. Indeed, it is part of the disturbance of the Beautiful that her graceful force dissolves the old cages that confine us as prisoners in the unlived life. Beauty is not just a call to growth, it is a transforming presence wherein we unfold towards growth almost before we realize it. Our deepest self-knowledge unfolds as we are embraced by Beauty.

'THE INVOCATION OF A WHOLE AND HOLY ORDER OF THINGS'

THIS BOOK PRESUMES THE EXISTENCE AND AUTONOMY OF THE Beautiful as a threshold which holds the real and the ideal in connection and conversation with each other. It does not set out to ground this philosophically; that would be the task of a purely philosophical work. Rather it is intended as a series of encounters with various forms of the Beautiful. The majesty of beauty is its gracious wholesomeness. The Beautiful unifies feeling, thought and dream. The form of this book endeavours to mirror this at-one-ment. This acquaintance coaxes the soul to the land of wonder where the journey becomes a bright path between source and horizon, awakening and surrender. Perhaps, through awakening our hearts to beauty, we can all come to know more intimately what John Keats meant when he wrote: 'I feel more and more every day, as my imagination strengthens, that I do not live in this world alone but in a thousand worlds' (Letter, 18 Oct. 1818).

Kathleen Raine says: 'Strangest of all is the ease with which the vision is lost, consciousness contracts, we forget over and over again, until recollection is stirred by some icon of that beauty. Then we remember and wonder why we ever forgot.' Beauty is an end-less and elusive theme. What beauty is can never be finally said. This exploration is limited and tentative, yet the hope is that this series of little icons of the Beautiful may compose their own mosaic to become a book that you might dream into . . .

SWANLIGHT
I.M. TONY O'MALLEY

If it could say itself January
Might brighten its syllables on the frost
Of these first New Year days whose cold is blue.

Meanwhile in this corner of its silence
A weak winter sun lowers down behind
The moor that rises away from the lake.

Beyond reach of light, the shadowed water
Succumbs to this darkening of spirit
That would deny the bog today's twilight.

All of a sudden something else breaks through
To appear at the far end of the lake
In two diagrams of white, uneven light.

I have never seen white so absolute
And alone, glistening in awkward form
Dreaming across the water a bright path.

As it stirs and changes I see what it is:
Two swans have found the mirror in the lake
Where a V of horizon lets light through

To make them light-source and light-shape in one.
Now they swim and fade through windows of reed
And disrobe the lake of apparition.

I look and look into their vanishing
See nothing. Departing that perfect ground
I knew I had been hungry for blessing.

1

THE CALL OF BEAUTY

Thy light alone –
Gives grace and truth to life's unquiet dream.

PERCY BYSSHE SHELLEY, 'Hymn to Intellectual Beauty'

EVERY LIFE IS BRAIDED WITH LUMINOUS MOMENTS.

I was with a friend out on Loch Corrib, the largest lake in the West
of Ireland. It was a beautiful summer's day. Time had come to rest
in the silence and stillness that presided there. The lake slept with-
out a ripple. A grey-blue haze enfolded everything. There was no
division any more between earth and sky. Reaching far into
the distance, everything was suffused in a majestic blue light. The
mountains of Conamara seemed like pile upon pile of delicate blue;
you felt you could almost reach out your hand and pull them
towards you. No object protruded anywhere. Trees, stones, fields
and islands had forgotten themselves in the daze of blue. Then,
suddenly, a harsh flutter as near us the lake surface split and a huge

cormorant flew from inside the water and struck up into the air. Its ragged black wings and large awkward shape were like an eruption from the underworld. Against the finely woven blue everywhere its strange form fluttered and gleamed in absolute black. She had the place to herself. She was the one clear object to be seen. And as if to conceal the source as she soared, she left her shadow thistling the lake surface. This was an event of pure disclosure: a sudden epiphany from between the worlds. The strange beauty of the cormorant was a counterpoint to the dream-like delicacy of the lake and the landscape. Sometimes beauty is that unpredictable; a threshold we had never noticed opens, mystery comes alive around us and we realize how the earth is full of concealed beauty. St Augustine expressed this memorably: 'I asked the earth, I asked the sea and the deeps, among the living animals, the things that creep. I asked the winds that blow, I asked the heavens, the sun, the moon, the stars, and to all things that stand at the doors of my flesh . . . My question was the gaze I turned to them. Their answer was their beauty.'

BEAUTY IS QUIETLY WOVEN THROUGH OUR DAYS

WHEN WE HEAR THE WORD 'BEAUTY', WE INEVITABLY THINK THAT beauty belongs in a special elite realm where only the extraordinary dwells. Yet without realizing it, each day each one of us is visited by beauty. When you actually listen to people, it is surprising how often beauty is mentioned. A world without beauty would be unbearable. Indeed the subtle touches of beauty are what enable most people to survive. Yet beauty is so quietly woven through our ordinary days that we hardly notice it. Everywhere there is tender-ness, care and kindness, there is beauty. Despite our natural difficulties with our parents, each of us has in our memory

moments of deep love we shared with them. Perhaps it was a moment in which you became aware of some infinite tenderness in the way your mother gazed upon you, and you knew that her heart would always carry you as tenderly as it carried herself. Or it might have been a phrase of affection that has continued to sound around your life like a bright circle of blessing.

In Greek the word for 'the beautiful' is *to kalon*. It is related to the word *kalein* which includes the notion of 'call'. When we experience beauty, we feel called. The Beautiful stirs passion and urgency in us and calls us forth from aloneness into the warmth and wonder of an eternal embrace. It unites us again with the neglected and forgotten grandeur of life. The call of beauty is not a cold call into the dark or the unknown; in some instinctive way we know that beauty is no stranger. We respond with joy to the call of beauty because in an instant it can awaken under the layers of the heart a forgotten brightness. Plato said: 'Beauty was ours in all its brightness ... Whole were we who celebrated that festival' (*Phaedrus*).

Beauty does not linger, it only visits. Yet beauty's visitation affects us and invites us into its rhythm, it calls us to feel, think and act beautifully in the world: to create and live a life that awakens the Beautiful. A life without delight is only half a life. Lest this be construed as a plea for decadence or a self-indulgence that is blind to the horrors of the world, we should remember that beauty does not restrict its visitations only to those whom fortune or circumstances favour. Indeed, it is often the whispers and glimpses of beauty which enable people to endure on desperate frontiers. Even, and perhaps especially, in the bleakest times, we can still discover and awaken beauty; these are precisely the times when we need it most. Nowhere else can we find the joy that beauty brings. Joy is not simply the fruit of circumstance; we can choose to be joyous independent of what is happening around us. The joyful heart sees and reads the world with a sense of freedom and graciousness. Despite all the difficult turns on the road, it never loses sight of the world as a gift. St Augustine said: 'The soul is

weighed in the balance by what delights her. Delight or enjoyment sets the soul in her ordered place. Where the delight is, there is the treasure.' Perhaps this is why there is such delight in beauty. In the midst of fragmentation and distress beauty draws the soul into an experience where an elegant order prevails. This brings a lovely tranquillity and satisfies the desire of the soul. When the Beautiful continues on its way, the soul has been strengthened by a delight that will further assist her in transfiguring struggle.

THE FIRST FACE: INTIMATIONS OF BEAUTY

A blind man recognizes a beloved face by barely touching it
with seeing fingers, and tears of joy, the true joy of recognition,
will fall from his eyes after a long separation.

OSIP MANDELSTAM, 'The Word and Culture'

EVEN AMIDST CHAOS AND DISORDER, SOMETHING IN THE HUMAN mind continues still to seek beauty. From our very first moments in the world we seem to be on a quest for beauty. The first thing the new infant sees is the human face. That sighting affects us deeply; for instinctively we seek shelter, confirmation and belonging in the face of the mother. We cannot remember that time; but most of us spent endless hours of our early time simply gazing up into the face of the mother. No other subsequent image in the world will ever rival the significance of the face. The lives of those we know, need and love all dwell behind faces. We are inevitably drawn to the beauty of the face for it is there that we had our first inkling of beauty. In its form, presence and balance of left and right, the face offers the first intimation of the symmetry and order that lies at the heart of beauty. Without that hidden order and rhythm of pattern, there could be no beauty. Nature is full of hidden geometry and harmony, as is the human mind; and the creations of the mind that

awaken or recreate this sense of pattern and order tend to awaken or unveil beauty. Symmetry satisfies us and coheres with our need for meaning and shelter in the world. Indeed, the notion of symmetry is central to the beauty of mathematics and science. It seems that physicists in choosing between different theories often feel that the more symmetrical one, generally, is the more beautiful and the truer.

Science tells us that the more symmetrical a face is, the more beautiful it is. Though order is necessary for beauty, the interesting thing is that a face that is not overburdened by structural perfection can still be very beautiful. More often than not it is the inner beauty of heart and mind that illuminates the face. A smile can completely transform a face. Ultimately, it is the soul that makes the face beautiful. Each face is its own landscape and is quietly vibrant with the invisible textures of memory, story, dream, need, want and gift that make up the beauty of the individual life. This is also the grace that love brings into one's life. As the soul can render the face luminous so too can love turn up the hidden light within a person's life. Love changes the way we see ourselves and others. We feel beautiful when we are loved, and to evoke an awareness of beauty in another is to give them a precious gift they will never lose. When we say from our heart to someone: 'You are beautiful', it is more than a statement or platitude, it is a recognition and invocation of the dignity, grandeur and grace of their spirit. There is something in the nature of beauty that goes beyond personality, good looks, image and fashion. When we affirm another's beauty, we affirm something that cannot be owned or drawn into the grid of small-mindedness or emotional need. There is profound nobility in beauty that can elevate a life, bring it into harmony with the artistry of its eternal source and destination. Perhaps Beauty does not linger because she wishes to whet our appetite and refine our longing so that we enter more fully into the limitless harvest of our inner inheritance.

The Jewel within the Fleeting Moment

BEYOND THE VEILS OF LANGUAGE AND THE NOISE OF ACTIVITY, the most profound events of our lives take place in those fleeting moments where something else shines through, something that can never be fixed in language, something given as quietly as the gift of your next breath. Days and nights unfold in the confidence and continuity of sequence. Most days take no notice of us; but then every so often there is a moment when time seems to crystallize. A voice changes tone and a deeper music becomes audible. A gaze holds and a hidden presence is glimpsed.

One year in university at the end of the semester I returned home for the summer holidays. When I walked into the kitchen my father looked up at me and I saw something in his gaze that I had never seen before. Some finality had entered his looking. Whether it was out in the mountains or among the fields around the house, his eyes had glimpsed a door opening towards him. His countenance had become more luminous and his natural gentleness was being claimed by a new silence. As we held each other for a moment in that gaze I knew death had picked his name out. Days later illness arrived and in three weeks the door of death had closed behind him. The gaze had revealed everything; time had stood still. The image of that gaze has always remained with me for it was a moment of the deepest and most tender knowing, a moment radiant with the strange beauty of sadness.

'In Difficult Times to Keep Something Beautiful in Your Heart'

THERE ARE TIMES WHEN LIFE SEEMS LITTLE MORE THAN A MATTER of struggle and endurance, when difficulty and disappointment form a crust around the heart. Because it can be deeply hurt, the

heart hardens. There are corners in every heart which are utterly devoid of illusion, places where we know and remember the nature of devastation. Yet though the music of the heart may grow faint, there is in each of us an unprotected place that beauty can always reach out and touch. It was Blaise Pascal who said: In difficult times you should always carry something beautiful in your mind.

Rilke said that during such times we should endeavour to stay close to one simple thing in nature. When the mind is festering with trouble or the heart torn, we can find healing among the silence of mountains or fields, or listen to the simple, steadying rhythm of waves. The slowness and the stillness gradually take us over. Our breathing deepens and our hearts calm and our hungers relent. When serenity is restored, new perspectives open to us and difficulty can begin to seem like an invitation to new growth. This is also the experience of prayer. The tired machinations of the ego are abandoned. It no longer needs to push or prove itself in the combat of competition. Beneath the frenetic streams of thought, the quieter, elemental nature of the self takes over and calms our presence. Rather than taking us out of ourselves, nature coaxes us deeper inwards, teaches us to rest in the serenity of our elemental nature. When we go out among nature, clay is returning to clay. We are returning to participate in the stillness of the earth which first dreamed us. This stillness is rich and fecund. One might think that an invitation to enter into the stillness of nature is merely naïve romanticism that likes to indulge itself and escape from the cut and thrust of life into some narcissistic cocoon. This invitation to friendship with nature does of course entail a willingness to be alone out there. Yet this aloneness is anything but lonely. Solitude gradually clarifies the heart until a true tranquillity is reached. The irony is that at the heart of that aloneness you feel intimately connected with the world. Indeed, the beauty of nature is often the wisest balm for it gently relieves and releases the caged mind. Calmness flows in to wash away anxiety and worry. The thirteenth-century mystic Meister Eckhart always encouraged such calmness:

Gelassenheit. Over against the world with all its turbulence, distraction and worry, one should cultivate a style of mind that can reach through to an inner stillness and calm. The world cannot ruffle the dignity of a soul that dwells in its own tranquillity. Gradually, this serenity will begin to pervade our seeing and change the way we look at things.

To Beautify the Gaze

THE HUMAN GAZE IS NOT THE CLOSED, FIXED VIEW OF A CAMERA but is creative and constructive. Both the gaze that sees and the object that is seen construct themselves simultaneously in the one act of vision. So much depends then on how we see things. More often than not the style of gaze determines what we see. There are many things near us that we never notice simply because of the way we see. The way we look at things has a huge influence on what becomes visible for us. If a house has been closed up for a long time, a film of dust settles on the windows. Decayed residue gradually manages to seal out the light. When we go into such a place, we smell the dankness of sour and fetid air. The same thing can happen in the rooms of the mind. If one has become stuck in a certain narrow or predictable way of seeing, the outside light cannot bring colour into one's life. Eventually the windows of the mind become blinded by an imperceptible film of dead thought and old feeling so that the air within becomes stale, life lessens and the outside world loses its invitation and challenge. When no fresh light can come into the mind, the colour and beauty fade from life. There is an uncanny symmetry between the inner and the outer world. Each person is the sole inhabitant of their own inner world; no-one else can get in there to configure how things are seen. Each of us is responsible for *how* we see, and how we see determines *what* we see. Seeing is not merely a physical act: the heart of vision is

shaped by the state of soul. When the soul is alive to beauty, we begin to see life in a fresh and vital way. The old habits of seeing are broken. The coating of dead dust falls from the windows. Freed from their dead forms the elements of one's life reveal new urgency and possibility.

We have often heard that beauty is in the eye of the beholder. This is usually taken to mean that the sense of beauty is utterly subjective; there is no accounting for taste because each person's taste is different. The statement has another, more subtle meaning: if our style of looking becomes beautiful, then beauty will become visible and shine forth for us. We will be surprised to discover beauty in unexpected places where the ungraceful eye would never linger. The graced eye can glimpse beauty anywhere, for beauty does not reserve itself for special elite moments or instances; it does not wait for perfection but is present already secretly in everything. When we beautify our gaze, the grace of hidden beauty becomes our joy and our sanctuary.

'BEAUTY, EVER ANCIENT, EVER NEW'

Beauty was a reversion to the pre-divine lingering in man as a memory of something that existed before his presence . . .
prior to the Gods.
HERMANN BROCH

ST AUGUSTINE TESTIFIES TO THE PERMANENCE AND ETERNITY OF beauty when he writes: 'Too late came I to love thee! Beauty, ever ancient, ever new, too late came I to love thee!' Yet beauty is never stale; it is never the same. Beauty is always new in every different presence and it quickens distinctively each time. When we gaze at the faces we love, we often notice how the days and years continue to enrich these faces with ever new textures of presence. The

experience of beauty always resembles a beginning. A clearance opens in the heart for something new. Perhaps this is why it always seems to embrace us completely and satisfies something profound in us. Beauty touches and renews our hope when it takes us out of the grid of ordinary time and brings us to another place, a place where history ceases and the weight of memory relents, a place ever ancient and ever new. For a while our hearts become young again, inspired with new vision and possibility. Meister Eckhart says: 'Time makes us old. Eternity keeps us young.'

It is quite fascinating how beauty touches the mind. No-one is immune to beauty. Regardless of background, burdens or limitations, when we find ourselves in a place of great beauty, clarity, recognition and excitement awaken in us. It is never a neutral experience. Despite all our disaffection with what can sometimes seem a harsh and cynical world, there is an eternal beckoning at the heart of beauty that touches what is still innocent in us. This sense of beauty was classically expressed early in the Western mystical tradition by Pseudo-Dionysius in his book *The Divine Names*. This work was to exercise a profound and continuous influence on all subsequent philosophical mysticism. He writes poetically of the flowing light of beauty and how it fills and brightens every form:

> That, beautiful beyond being, is said to be Beauty – for
> It gives beauty from itself in a manner appropriate to each,
> It causes the consonance and splendour of all,
> It flashes forth upon all, after the manner of light, the
> Beauty producing gifts of its flowing ray,
> It calls to itself,
> When it is called beauty.

To behold beauty dignifies your life; it heals you and calls you out beyond the smallness of your own self-limitation to experience new horizons. To experience beauty is to have your life enlarged.

Like the Moon on Breaking Tide: The Glimpse of Beauty

There is nothing as beautiful as the sadness of one
who is blind in Granada.

SPANISH PROVERB

TRUE BEAUTY IS NUMINOUS. WHEN A PERSON HAS BEAUTY, HER presence is full of radiance. In German, they say such a person has a 'grosse Ausstrahlung', literally, ' a flowing forth of radiance'. The individual is no longer confined within the frame of her own identity. There is a light in beauty which no frontier can limit or contain; it has a distinctive dignity. Like consciousness, beauty shines with a light from beyond itself. In medieval thought, Albert Magnus spoke of beauty as the brilliance of an object's form shining forth in its sensible presence.

Beauty is not to be captured or controlled for there is something intrinsically elusive in its nature. More like a visitation than a solid fact, beauty invests the aura of a person or infuses a landscape with an unexpected intimacy that satisfies our longing. True beauty cannot be invented or manufactured. We 'cannot bear very much reality'. Neither, it seems, can we bear very much beauty. The glimpse, the touch of beauty is enough to quicken our hearts with the longing for the divine. Beauty never finally satisfies though she intensifies our longing and refines it. Were the human person simply soul, beauty would be an absolute embrace. We are, however, threshold creatures of deep ambivalence and when beauty touches the matrix of human selfhood, it can only be just that: a touch.

'When Night Holds Sway and the Forest Is Free of Strangers' – Beauty Comes

BEAUTY ENJOYS A PROFOUND AND ANCIENT AUTONOMY. TRUE beauty is from elsewhere, a pure gift. It cannot be programmed nor its arrival foreseen. It never falls simply into the old patterns of what is already there nor is it frivolous or burdened with leaden solemnity. Frequently, beauty is playful like dancing sunlight, it cannot be predicted, and in the most unlikely scene or situation can suddenly emerge. This spontaneity and playfulness often subverts our self-importance and throws our plans and intentions into disarray. Without intending it, we find ourselves coming alive with a sense of celebration and delight. The pedestrian sequence of a working day breaks, a new door opens and the heart recognizes the silent majesty of the ordinary. The things we never notice, like health, friends and love, emerge from their subdued presence and stand out in their true radiance as gifts we could never have earned or achieved.

Beauty cannot be forced. It alone decides when it will come and sometimes it is the last thing we expect and the very last thing to arrive. Creative artists know this well. Great skill and inspiration set the context or scene where beauty might emerge. But it is not the mind of the artist alone that can determine whether beauty will arrive or not. There is a wonderful passage in Rilke's essay on Rodin where he discusses this mysterious dimension of beauty. Rodin's art 'was not based upon any great idea, but upon the conscientious realisation of something small, upon something capable of achievement, upon a matter of technique. There was no arrogance in him, he devoted himself to this insignificant and difficult aspect of beauty which he could survey, command and judge. The other, the greater beauty must come when all was ready for it as animals come to drink when night holds sway and the forest is free of strangers.' This can also be true in the soul. When we devote some calm time to the heart and come off the treadmill of stress and

distraction, we can enter into the beauty within. Each of us can pre-
pare for that inner arrival: where 'night holds sway' and the inner
forest becomes 'free of strangers'.

In the cut and thrust of life experience, beauty frequently
emerges when either great love or great sacrifice elevates an
experience above its daily confine to another level of presence and
possibility. Beauty is not quotidian, it is a rare delight. The Irish
seanfhocal (proverb) says: *An rud is annamh is iontach*, i.e. that which
is wonderful is seldom.

Though beauty is autonomous, there seem to be occasions when
human presence can become congruent with her will. In creative
work no amount of force or mechanical management can
guarantee beauty. Suddenly, without expecting it, beauty is there.
Yet ultimately beauty is a profound illumination of presence, a
stirring of the invisible in visible form and in order to receive this,
we need to cultivate a new style of approaching the world.

Towards a Reverence of Approach

... seeing that as I went, I left my beatitude behind me.

Dante, *La Vita Nuova*

WHEN BEAUTY TOUCHES OUR LIVES, THE MOMENT BECOMES
luminous. These grace-moments are gifts that surprise us. When
we look beyond the moment to our life journey, perhaps we can
choose a new rhythm of journeying which would be more
conscious of beauty and more open to inviting her to disclose her-
self to us in all the situations we travel through.

Yet what you encounter, recognize or discover depends to a large
degree on the quality of your approach. Many of the ancient
cultures practised careful rituals of approach. An encounter of
depth and spirit was preceded by careful preparation and often

involved a carefully phased journey of approach. Attention, respect and worthiness belonged to the event of nearing and disclosure. In China they tell the story of subjects from Mongolia who travelled vast distances to see the emperor. In Beijing, they had to practise for months the decorum appropriate to that moment of encounter. When the emperor finally passed, they could not even look up. The whole journey was rewarded with a mere glimpse of the emperor's feet. In the New Testament, a woman who had bled for years healed instantly when she touched the hem of Jesus's garment.

Our culture has little respect for privacy; we no longer recognize the sacred zone around each person. We feel we have a right to blunder unannounced into any area we wish. Because we have lost reverence of approach, we should not be too surprised at the lack of quality and beauty in our experience. At the heart of things is a secret law of balance and when our approach is respectful, sensitive and worthy, gifts of healing, challenge and creativity open to us. A gracious approach is the key that unlocks the treasure of encounter. The way we are present to each other is frequently superficial. We become more interested in 'connection' rather than communion. In many areas of our lives the rich potential of friendship and love remains out of our reach because we push towards 'connection'. When we deaden our own depths, we cannot strike a resonance in those we meet or in the work we do. A reverence of approach awakens depth and enables us to be truly present where we are. When we approach with reverence great things decide to approach us. Our real life comes to the surface and its light awakens the concealed beauty in things. When we walk on the earth with reverence, beauty will decide to trust us. The rushed heart and the arrogant mind lack the gentleness and patience to enter that embrace. Beauty is mysterious, a slow presence who waits for the ready, expectant heart. When the heart becomes attuned to her restrained glimmerings, it learns to recognize her intimations more frequently in places it would never have lingered before.

The Eternal Places That Grace the Journey

OFTEN WE APPROACH THINGS WITH GREED AND URGENCY. WE do not like to wait. As we wait at the vertical altar to go on-line, we become frustrated by the extra few seconds the machine needs to find its mind. Computer makers are constantly at work to cut the transition time; the flick from world to cyber-world must become seamless. We live under the imperative of the stand-alone digital instant; and it is uncanny how neatly that instant has become the measure not alone of time but also of space. Classically, the understanding of life, the unfolding of identity and creativity, the notion of growth and discovery were articulated through the metaphor of the journey. Virgil's *Aeneid* is the journey from fallen Troy to the glory of the new city of Rome. Homer's *Odyssey* is a great mystical journey home. Dante's *Divine Comedy* is an epic journey through hell and purgatory until the arrival in Paradise. Each human life is the journey from childhood to a realized adult life. Each day is a journey out of darkness into light. Each friendship and love is the intimate journey where the soul is born and grows. The journey is the drama of the heart's voyage into the tide of possibilities which open before it. Indeed, a book is a path of words which takes the heart in new directions.

In the Celtic tradition, warriors and monks undertook incredible journeys of imagination and spirit. The journey to the eternal, invisible world was called the *imram*. In Irish lyric poetry of the eighth century there is the story of the *Immram Curaig Máile Dúin*, The Voyage of Mael Duin's Currach. Mael Duin and his companions made a voyage and visited many wondrous islands. One day they came upon an island surrounded by a fence of brass. All around the fence was a beautiful pool, elevated high above the waves. Before the pool was a bridge. Mael Duin's warriors attempted time and again to climb up onto the island but kept slipping off the bridge of glass and plunging back down into the ocean. Then:

Towards them came a gentle white-throated woman
Whose nature was free from folly and whose deed
Was fair; she was clad in radiant raiment of
Swanlike brightness.

Her fair cloak, which was shining and beautiful, was
Surrounded by a hem of red gold. About her feet were
Silver sandals on which to rest.

Upon her bosom she wore a white brooch of
Wondrous silver, inlaid with woven gold of loveliest
Workmanship.

On her head fair yellow hair gleamed like gold; graceful
Were her steps and regal her fine stately movements.

Like a holy sanctuary in the lower portion of the huge
Bridge was a wave-bright well protected by the lovely
Bulk of a lid.

She poured lovely liquor but offered them none. She chanted wondrous music which lulled them to sleep. This lasted three days and then she led them to a feast in a banquet hall high above the ocean. While they were feasting she chanted 'marvellous names'. She knew and called out the name of each young man. But then she was asked to satisfy the lust of Mael Duin. She upbraided the warriors for being undignified and false. Then she mysteriously enjoined them: 'Ask the secret of the island, that I may be able to relate it to you.' When morning had come, they awoke in their boat and the beautiful island had vanished, no-one knew where.

In its encounter with us beauty invites our dignity and graciousness. Often it beckons us from afar but holds us off until our hearts become more refined and receptive; then beauty draws us into her mysterious invisible embrace. However, when the coarse thought

or grasping smallness protrudes, we can find ourselves forsaken, dropped down into the severance of our familiar, blind hungering.

WHEN THE SENSE OF DESTINATION BECOMES GRACIOUS, THE JOURNEY CAN BECOME AN ADVENTURE OF BEAUTY

How one walks through the world, the endless small adjustments of balance, is affected by the shifting weights of beautiful things.

ELAINE SCARRY

TRADITIONALLY, A JOURNEY WAS A RHYTHM OF THREE FORCES: time, self and space. Now the digital virus has truncated time and space. Marooned on each instant, we have forfeited the practice of patience, the attention to emergence and delight in the Eros of discovery. The self has become anxious for what the next instant might bring. This greed for destination obliterates the journey. The digital desire for the single instant schools the mind in false priority. Each instant proclaims its own authority and the present image demands the complete attention of the eye. There is no sense of natural sequence where an image is allowed to emerge from its background and context when the time is right, the eye is worthy and the heart is appropriate. The mechanics of electronic imaging reverses the incarnation of real encounter. But a great journey needs plenty of time. It should not be rushed; if it is, your life becomes a kind of abstract package tour devoid of beauty and meaning. There is such a constant whirr of movement that you never know where you are. You have no time to give yourself to the present experience. When you accumulate experiences at such a tempo, everything becomes thin. Consequently, you become ever more absent from your life and this fosters emptiness that haunts the heart.

When you regain a sense of your life as a journey of discovery, you return to rhythm with yourself. When you take the time to travel with reverence, a richer life unfolds before you. Moments of beauty begin to braid your days. When your mind becomes more acquainted with reverence, the light, grace and elegance of beauty find you more frequently. When the destination becomes gracious, the journey becomes an adventure of beauty. The wonder of the journey as a voyage of reverence and discovery finds lyrical expression in C.P. Cavafy's poem 'Ithaca'. He imagines the reader setting out on this journey to Ithaca, a journey rich with promise for senses and soul, rich with glad and difficult learning. The poem concludes with a wonderful evocation of the destination as midwife to the soul:

> Ithaca gave you the beautiful journey.
> Without her you would not have set out.
> She has nothing more to give you.
>
> And if you find her poor, Ithaca has not fooled you.
> Having become so wise, with so much experience,
> You will have understood, by then, what these Ithacas mean.

The poem advises great patience and never to hurry. Take your time and be everywhere you are.

NOSTALGIA FOR THE ETERNAL

AT ITS HEART, THE JOURNEY OF EACH LIFE IS A PILGRIMAGE through unforeseen sacred places that enlarge and enrich the soul. On the way time often unveils its eternal interior. In the third century Plotinus wrote his *Enneads*. The *Enneads* is a wonderful cathedral of thought, a Chartres of late antiquity. The thinking of

Plotinus is luminous with passion and nostalgia for the eternal:

> This is the spirit that Beauty must ever induce, wonderment and a
> delicious trouble, longing and love and a trembling that is all
> delight. For the unseen all this may be felt as for the seen; and this
> is the Soul's feel for it, every Soul in some degree, but those the more
> deeply that are the more truly apt to this higher love – just as all take
> delight in the beauty of the body but all are not stung as sharply, and
> those only that feel the keener wound are known as Lovers. These
> Lovers, then, lovers of the beauty outside of sense, must be made to
> declare themselves.

This is a magnificent evocation of what beauty is and does. Beauty
induces atmosphere and spirit: wonder, delicious turbulence, love,
longing and a trembling delight. Plotinus suggests that beauty
embraces both visible and invisible worlds. We encounter and
engage this beauty through the 'feel' of the soul. He defines lovers
as those who feel this deeper wound of invisible beauty; he also
suggests that these are secret, unknown lovers. The true sense of
beauty belongs to the inner mystery of identity. Love of the
beautiful is a secret and sacred passion.

Plotinus was keenly aware of the beauties of the natural world.
However, these beauties had their source in the eternal world from
which they were fugitives: they are 'the beauties of the realm of
sense, images and shadow pictures, Fugitives that have entered into
Matter – To adore, and to ravish where they are seen . . .' The
world is a mixed, in-between place peopled by images and
shadow-pictures. Eternal beauty cannot glow here in its full force
or purity; nevertheless it is present as a fugitive and awakens our
adoration when it is glimpsed.

The world of the senses is intensified with beauty that is meant
to recall us to the higher and eternal forms of beauty. The physical
thing in itself is not independently beautiful. Its beauty is made to
shine through the elegance of its form: 'In visible things . . . the

beautiful thing is essentially symmetrical, patterned. Symmetry itself owes its beauty to a remoter principle.' The force of invisible beauty infuses the visible object. This is the reason for ugliness: 'An ugly thing is something that has not been mastered by pattern.'

For Plotinus beauty is never merely external. Beauty is ultimately an elegant, inner luminosity; it is bestowed by the soul: 'For the soul . . . makes beautiful to the fullness of their capacity all things whatsoever that it grasps and moulds.' Beauty is not simply surface appearance intended to indulge us or bestow temporary pleasure. Following Plato, Plotinus advocates the cultivation of a sense of beauty; this is a work of the soul, it is the cultivation of virtue and the clarification of the heart. The life-journey can be a journey of ascent to beauty. The longing at the heart of attraction is for union with the Beautiful. Not everything in us is beautiful. We need to undertake the meticulous work of clearance and clarification in order that our inner beauty may shine. The radiance of the Good makes beauty real:

> But how are you to see into a virtuous Soul and know its loveliness? Withdraw into yourself and look. And if you do not find yourself beautiful yet, act as does the creator of a statue that is to be made beautiful: he cuts away here, he smooths there, he makes this line lighter, this other purer, until a lovely face has grown upon his work. So do you also: cut away all that is excessive, straighten all that is crooked, bring light to all that is overcast, labour to make all one glow of beauty and never cease chiselling your statue . . .

REVERENCE: A PATHWAY TO BEAUTY

IN ORDER TO BECOME ATTENTIVE TO BEAUTY, WE NEED TO rediscover the art of reverence. Our world seems to have lost all sense of reverence. We seldom even use the word any more. The notion of reverence is full of riches that we now need desperately. Put simply, it is appropriate that a human being should dwell on this earth with reverence. As children we became aware of the word 'reverence' as used to describe the way a person is present in prayer or liturgy. When a priest celebrated the mass with a sense of reverence, you sensed the depth of his presence to the mystery. Though the church was full of people, he was absorbed in something that could not be seen. Ultimately, reverence is respect before mystery. But it is more than an attitude of mind; reverence is also physical – a dignified attention of body showing that sacred is already here. Reverence is not to be reduced to a social posture. Reverence bestows dignity and it is only in the light of dignity that the beauty and mystery of a person will become visible. Reverence is not the stiff pious posture which remains frozen and lacks humour and play. To live with a sense of reverence is not to become a prisoner of a dull piety. Playfulness, humour and even a sense of the anarchic are companions of reverence because they insist on the proper proportion of the human presence in the light of the eternal. Reverence is also the companion of humility. When human hubris intrudes on or manipulates the sacred, the consequence is inevitably humiliation. In contrast, a sense of reverence includes the recognition that one is always in the presence of the sacred. To live with reverence is to live without judgement, prejudice and the saturation of consumerism. The consumerist heart becomes empty and lonesome because it has squandered reverence. As parent, child, lover, prayer or artist – a sense of reverence opens pathways of beauty to surprise us. The earth is full of thresholds where beauty awaits the wonder of our gaze.

2

WHERE DOES BEAUTY DWELL?

THE AFFECTION OF THE EARTH FOR US

Listen. Put on morning.
Waken into falling light.

W.S. GRAHAM, 'Listen. Put on Morning'

THE BEAUTY OF THE EARTH IS THE FIRST BEAUTY. MILLIONS OF years before us the earth lived in wild elegance. Landscape is the first-born of creation. Sculpted with huge patience over millennia, landscape has enormous diversity of shape, presence and memory. There is poignancy in beholding the beauty of landscape: often it feels as though it has been waiting for centuries for the recognition and witness of the human eye. In the ninth Duino Elegy, Rilke says:

> Perhaps we are *here* in order to say: house,
> bridge, fountain, gate, pitcher, fruit-tree, window ...
> To say them *more* intensely than the Things themselves
> Ever dreamed of existing.

How can we ever know the difference we make to the soul of the earth? Where the infinite stillness of the earth meets the passion of the human eye, invisible depths strain towards the mirror of the name. In the word, the earth breaks silence. It has waited a long time for the word. Concealed beneath familiarity and silence, the earth holds back and it never occurs to us to wonder how the earth sees us. Is it not possible that a place could have huge affection for those who dwell there? Perhaps your place loves having you there. It misses you when you are away and in its secret way rejoices when you return. Could it be possible that a landscape might have a deep friendship with you? That it could sense your presence and feel the care you extend towards it? Perhaps your favourite place feels proud of you. We tend to think of death as a return to clay, a victory for nature. But maybe it is the converse: that when you die, your native place will fill with sorrow. It will miss your voice, your breath and the bright waves of your thought, how you walked through the light and brought news of other places. When the funeral cortège passes the home of the departed person, is it the home that is getting one last chance to say farewell to its beloved resident or is it the deceased getting one last look at the home? Or is it both? Perhaps each day our lives undertake unknown tasks on behalf of the silent mind and vast soul of nature. During its millions of years of presence perhaps it was also waiting for us, for our eyes and our words. Each of us is a secret *envoi* of the earth.

We were once enwombed in the earth and the silence of the body remembers that dark, inner longing. Fashioned from clay, we carry the memory of the earth. Ancient, forgotten things stir within our hearts, memories from the time before the mind was born. Within us are depths that keep watch. These are depths that no words can trawl or light unriddle. Our neon times have neglected and evaded the depth-kingdoms of interiority in favour of the ghost realms of cyberspace. Our world becomes reduced to intense but transient foreground. We have unlearned the patience and attention of lingering at the thresholds where the unknown awaits us. We have

become haunted pilgrims addicted to distraction and driven by the speed and colour of images.

In Wild Places Light Illuminates Beauty

> Today images abound everywhere . . . Appearances registered,
> and transmitted with lightning speed . . . used to be called
> *physical* appearances because they belonged to solid bodies.
> Now appearances are volatile.
>
> John Berger

I LOVE THE IMAGINATION OF LIGHT: HOW GRADUALLY LIGHT WILL build a mood for the eye to discover something new in a familiar mountain. This glimpse serves to deepen the presence of the mountain and remind the eye that surface can be subtle and surprising. Gathered high in silence and stillness, the mountain is loaded with memory that no mind or word can reach. Light never shows the same mountain twice. Only the blindness of habit convinces us that we continue to live in the same place, that we see the same landscape. In truth, no place ever remains the same because light has no mind for repetition; it adores difference. Through its illuminations, it strives to suggest the silent depths that hide in the dark.

Light is always more fragile at a threshold. An island is an edged place, a tense threshold between ocean and sky, between land and light. The West of Ireland enjoys magnificent light. The collusion of cloud, rain, light and landscape is always surprising. Within the space of one morning, a whole sequence of different landscapes can appear outside the window. Now and again, the place becomes dense with darkening, then a cloud might open and a single ray of light will drench a gathering of stones to turn them into oracular presence. Or light might tease the serious face of a mountain with

a crazy geometry of shadow. Some mornings it seems the dawn cannot wait to break for the light to come out and play with the stillness of this landscape. Such light offers a continual feast for the eyes. Artists have always been drawn here in search of its secrets. The landscape curves and undulates. Each place is literally distinctive, etched against light and sea with vigorous and enduring individuality. Even the most untouched, raw places hold presence. No human has ever lingered here long enough to claim or domesticate them. They rest in the sureness of their own elemental narrative. Such places are wild sanctuaries because they dwell completely within themselves and can quietly draw us into their knowing and stillness. Almost without sensing it, the mind is gradually relieved of its inner pressing. The senses become soothed and the clay part of the heart is stirred by ancient beauty.

Perhaps because they are so much themselves, wild landscapes remind us of the unsearched territories of the mind. The light over a landscape is never a simple brightness; it is mixed and muted. Clouds love to play with light. A cloud can suddenly introduce shadow and reduce a glistening field to an eerie grey space. Or alternatively, a cloud-shadow can modulate the depth of colour a hillside receives. This alternating choreography can turn hillsides purple, green or even cream, depending on how the angle of light and the cloud's shadow conspire with each other. The visual effect is often breathtaking. Light is the great priestess of landscape. Deftly it searches out unnoticed places, corners of fields, the shadow-veils of certain bushes, the angled certainty of stones; it can slink low behind a stone wall turning the spaces between the stones into windows of gold. On a winter's evening it can set a black tree into poignant relief. Unable to penetrate the earth, light knows how to tease suggestions of depth from surface. Where radiance falls, depths gather to the surface as to a window. The persuasions of light bring us frequent mirrors that afford us a glimpse into the mystery that dwells in us. Sometimes in the radiance, forgotten treasure glimmers through 'earthen vessels'.

The earth is our origin and destination. The ancient rhythms of the earth have insinuated themselves into the rhythms of the human heart. The earth is not outside us; it is within: the clay from where the tree of the body grows. When we emerge from our offices, rooms and houses, we enter our natural element. We are children of the earth: people to whom the outdoors is home. Nothing can separate us from the vigour and vibrancy of this inheritance. In contrast to our frenetic, saturated lives, the earth offers a calming stillness. Movement and growth in nature takes its time. The patience of nature enjoys the ease of trust and hope. There is something in our clay nature that needs to continually experience this ancient, outer ease of the world. It helps us remember who we are and why we are here.

The beauty of the imagination is that it can discover such magnificent vastness inside a tiny space. Our culture is dominated by quantity. Even those who have plenty hunger for more and more. Everywhere around us, the reign of quantity extends and multiplies. Sadly the voyage of greed has all the urgency but no sense of destination. Desire becomes inflated and loses all sense of vision and proportion. When beauty becomes an acquisition it brings no delight. When time seemed longer and slower, the eye of the beholder had more space and distance to glimpse the beautiful. There was respect for the worlds that could be suggested by a glimpse. A striking illustration of this can be seen in the traditional cottages in the West of Ireland. These cottages were often built in the most beautiful landscapes. Yet the windows were always small. There was certainly a practical rationale behind this. There was no central heating then and there was a lot of rain and cold. Yet a small window exercised a discipline of proportion in relation to the external beauty. It never offered you the whole landscape: instead, from every angle you looked, it chose from the landscape a unique icon for your eyes. The grace of limit suggested more than your eyes could visually grasp. But times have changed. People who now build here insist on huge windows that flood the house from every

side with landscape. If one inquires about the particular rhythm of the place or the patterns of light the owners often seem baffled. The total view detracts from the eye's refinement.

The Beauty of Opposites in the Liturgy of Twilight

IN THE WEST OF IRELAND THE LAND IS GENERALLY POOR. FARMING and survival have always been difficult and people have had to work hard for a living. In winter the weather shows little mercy. The endless rain tends to darken the spirit. Yet mysteriously there is an ancient conversation between the ocean and the stone on this coastline which is mirrored in the complexity of twilight. There is great beauty in how the light takes its leave of the day. From the first blush of dawn, the day is carried everywhere by the light. Time unfolds in light. In the morning, light clears all the outside darkness and the shape of each thing emerges in the brightened emptiness. Light identifies itself completely with the voyage of a day; its transparency puts the day out in the open. There is nowhere for a day to hide; it is exposed every minute to the revelations of light. Perhaps this is why twilight appears gracious; when light abandons the day, it does not believe that it will ever return and consequently permits itself an extravagant valediction in a huge ritual of colour. The silence of twilight is striking because the flourish of the colouring has the grandeur of music.

As absolute servant, light conceals itself inside its own transparency. Yet confronted at evening by the finality of darkness, it turns on every last lamp of colour. It proclaims the eternity of each tree, stone, wave and countenance which it had accompanied during the day. At twilight the light succumbs to wonder and reveals the inner colour with which daylight had vested each object. Before the day is lost, twilight applies this huge poultice to draw out

all the passion of colour. Then, all the colours finally gather into a red host which the incoming darkness receives. The heart of darkness can be neither cold nor blind, infused as it is with such lived radiance. Indeed, this is also the rhythm of that threshold at the heart of human interiority. The light of our thought is always excavating our rich inheritance of darkness. The cradle of origin whose mysteries arise with the dawn, darkness is also the secret homeland where the slow harvestings of twilight return to become woven into the subtle eternity of memory:

> The messenger comes from that distant place
> Beside us where we cannot remember
> How unlikely it is that we are here
> Keepers of interiors not our own
> Strangers in whom dawn and twilight are one.

Twilight is a fascinating threshold for it is then that light finally falls away and the dark closes its grip on the world. This is a frontier of tension; it is at once beginning and end, origin and completion. Here is where two opposing forces reach towards each other to create a vital frontier filled with danger and possibility.

THE SOUL AS TWILIGHT THRESHOLD

*The beautiful can exist at the edge precisely
because it has nothing to lose and everything to give away.*
FREDERICK TURNER

OUR TIME IS HUNGRY IN SPIRIT. IN SOME UNNOTICED WAY WE HAVE managed to inflict severe surgery on ourselves. We have separated soul from experience, become utterly taken up with the outside world and allowed the interior life to shrink. Like a stream that

disappears underground, there remains on the surface only the slightest trickle. When we devote no time to the inner life, we lose the habit of soul. We become accustomed to keeping things at surface level. The deeper questions about who we are and what we are here for visit us less and less. If we allow time for soul, we will come to sense its dark and luminous depth. If we fail to acquaint ourselves with soul, we will remain strangers in our own lives.

When we begin to awaken to the light of soul, life takes on a new depth. The losses we have suffered, the delight and peace we have experienced, the beauty we have known, all belong together in a profound way. One of the greatest treasures in the world is a contented heart. When we befriend the twilight side of the heart, we discover a surer tranquillity where the darkness and the brightness of our lives dwell together. We gain the courage to search out where the real thresholds in life are, the vital frontiers, the parts of our life that we have not yet experienced. Beyond work, survival, relationships, even family, we become aware of our profound duty to our own life. Like the farmer in spring, we turn over a new furrow in the unlived field. We awaken our passion to live and are no longer afraid of the unknown, for even the darkest night has a core of twilight. We recover within us some of the native integrity that wild places enjoy outside. We learn to befriend our complexity and see the dance of opposition within us not as a negative or destructive thing but as an invitation to a creative adventure. The true beauty of a person glimmers like a slow twilight where the full force of each colour comes alive and yet blends with the others to create a new light. A person's beauty is sophisticated and sacred and is far beyond image, appearance or personality.

Beauty is substance and is never present merely as a naïve apparition in the vicinity of things. She is not a ghost who dwells in the preserve of daydream to lull us away for a while from the harshness of life. Beauty is not the mistress of nostalgia or avoidance; she is not flimsy. The greatest minds of antiquity, the medieval world and of modernity were not simply indulging

themselves in their portraiture of beauty. They sensed that beauty was the soul of the real. Beauty is the grandeur and elegance of experience that has come alive to its eternal depth and destiny. True beauty can emerge at the most vigorous threshold where the oppositions in life confront and engage each other. The philosopher Schopenhauer said: 'Opposites throw light upon each other.' Beauty does not belong exclusively to the regions of light and loveliness, cut off from the conflict and conversation of oppositions. The vigour and vitality of beauty derives precisely from the heart of difference. No life is one-sided; the life of each of us is animated by the inner conversation of forces which counter and complement each other. Beauty inhabits the cutting edge of creativity – mediating between the known and the unknown, light and darkness, masculine and feminine, visible and invisible, chaos and meaning, sound and silence, self and others.

BEAUTY AND THE CELTIC IMAGINATION: THE BALANCE OF THE MIND AND THE SENSES

THE BEAUTY OF THE EARTH IS A CONSTANT PLAY OF LIGHT AND dark, visible and invisible. We perceive and participate in that beauty through the interplay of senses and spirit. Our senses are lanterns that illuminate the world. Beauty is never simply in the mind alone. Beauty awakens for us through what we hear, touch, taste, scent and see. The great traditions have always recognized that beauty is a mysterious presence. Beauty envelops the heart and mind. In beauty's presence there is no longer any separation between thought and senses, between heart and soul. Indeed, the experience of beauty confirms the intricate harmony and creative tension of senses and thought. Without the senses, we could never know beauty. Without thought, beauty would seem transient and illusory.

Yet beauty is always more than the senses can perceive. While it
attracts and gladdens the senses, it also raises and refines what we
touch, taste, scent, hear and see. Beauty awakens the soul, yet it is
never simply ethereal. Beauty offers a profound psychological and
indeed mystical invitation. The dream of beauty is the self drawn
forth to its furthest awakening, where the senses and the soul are
utterly alive and yet in a harmony, brimming with presence. Unity
such as this seldom occurs. In some instinctively creative way, Celtic
thought and imagination recognized the lyrical unity that beauty
effects and requires, and managed to link huge differences together
within a unifying embrace. It avoided the dualism that separates
soul and senses. This false division blinds us to the presence of
beauty.

The Celtic Imagination often expressed spiritual insight in poetic
form, as in 'The Deer's Cry' from *The Confession of St Patrick*:

> I arise today
> through strength in the sky:
> light of sun
> moon's reflection
> dazzle of fire
> speed of lightning
> wild wind
> deep sea
> firm earth
> hard rock.
>
> I arise today
> With God's strength to pilot me:
> God's might to uphold me
> God's wisdom to guide me
> God's eye to look ahead for me
> God's ear to hear me
> God's word to speak for me

> God's hand to defend me
> God's way to lie before me
> God's shield to protect me
> God's host to safeguard me.
>
> (translated by John Skinner)

For the Celtic Imagination all of these images held a numinous and sacred resonance. This poem evokes the beauty of creation and the beauty of God as a single helix of presence. At its deepest level, beauty holds everything together as one pervasive presence. Nature and self have beauty because they participate in and express the presence of the one who is beautiful to know, the one whose fiery passion creates, sustains and welcomes everything. The incantatory 'I arise' brings out the mystery of awakening. The self does not awaken to find itself trapped in an isolated subjectivity, rather it awakens to ultimate participation; it is a living threshold between nature and divinity, a presence that is wild, free, diverse and indivisible.

There is a wonderful passage in St Bernard of Clairvaux in which interior beauty illuminates the sensuousness of human presence:

> when the brightness of beauty has replenished to overflowing the recesses of the heart, it is necessary that it should emerge into the open, just like the light hidden under a bushel: a light shining in the dark is not trying to conceal itself. The body is an image of the mind, which, like an effulgent light scattering forth its rays, is diffused through its limbs and senses, shining through in action, discourse, appearance, movement – even in laughter, if it is completely sincere and tinged with gravity.

This is a touching and passionate image of beauty filling up the heart and then overflowing to render body, language, gesture and laughter radiant. The mind and the senses unite in the experience of beauty.

THE THOUGHT OF BEAUTY AND THE
BEAUTY OF THOUGHT

WHILE THE BEAUTY OF NATURE AWAKENS AND FILLS OUR SENSES, the Eros of the human mind always desires to make a deeper voyage and explore the forms in which beauty dwells among us. It is one of the lovely ironies that our thinking about beauty has also revealed much about the beauty of thought itself. Thought is an amazing thing: it can be a mirror, a lens, a bridge, a wall, a window, a ladder or a house. There is nothing in the world that has the cutting edge of a new thought. It is fascinating to watch the clearance it can make and the new life it can bring. Often, without knowing it, we are waiting for a new idea to come and cut us free from our entanglement. When the idea is true and the space is ready for it, the idea overtakes everything. With grace-like swiftness, it descends and claims recognition; it cannot be returned or reversed. It becomes more forceful than any single action could be. Indeed, it becomes the mother of a whole sequence of new feeling, thinking and action. Though we live mostly in the visible world and our personalities, roles and work distinguish and identify us externally, we dwell more forcefully elsewhere. A person can dwell inside a thought. Sometimes a thought is the most intimate and sacred temple, a place where the silence of the earth is wed to the fire of heaven.

Many of the most intimate presences in our lives dwell within us in the form of thoughts. Though you might live with the one you love, he remains only physically adjacent to you; however, the thought of him can enter into the centre of you and become as intimate to you as yourself. In one of his poems, Rumi explores the approach and encounter of two lovers but then concludes: 'We were inside each other all along.' The suggestion is that 'being inside each other' is what brought them together outwardly in the first place. The converse is also true: when a relationship between two people dies, they stop being inside each other though they may

still live side by side. The same is true of family, friends and God: all enter us and remain with us through thought. Thought is more penetrating than light, it can travel further inwards to create an intimate world within the mind. This is at once the terror and the beauty of thought. Indeed, beauty itself can enter us as thought. In his poem 'The Arrow', Yeats says:

> I thought of your beauty, and this arrow
> Made out of a wild thought, is in my marrow.

A prophetic thought claims its own future; it awakens, disturbs and brings transformation. Such a thought is a gift of the imagination. It is not an abstract ghostly cipher. In such a thought, spirit and sensuousness cross at the frontier of their richest tension and exposure. A great thought is a sense–spirit object. It takes on a life of its own. We are familiar in our history with certain frontiers where such thoughts awakened. At a personal level, each of us is aware of certain threshold times in the lives of our hearts when such thoughts arrived and changed everything.

BEAUTY AS THE PERFECTION OF THINGS: THE MEDIEVAL VISION

BEAUTY EMERGED EARLY IN HUMAN REFLECTION AND HAS BEEN the inspiration and passion at the heart of human creativity ever since. Some of the most profound reflection on beauty was developed during medieval times. The secret dream of thought is to enfold everything within the contour of the idea. This is the Eros of thought: to desire everything. It wants to leave nothing out. Thought is curious and is driven by the desire to know. It wants to draw aside the veils of illusion and see what reality conceals. Words, images and ideas are its instruments of illumination.

Yet each individual who thinks is limited and confined within his own mind. The poignancy of thought is that it can never bridge the distance between the self and the world. The medieval mind filled in that interim distance with the interesting presence of the five Transcendentals: Being, the One, the Good, the True and the Beautiful. Being is the deepest reality, the substance of our world and all the things in it; the opposite would be Nothingness, the things that are not. The One claims that all things are somehow bound together in an all-embracing unity: despite all the differences in us, around us and between us, everything ultimately holds together as one; chaos does not have the final word. The True claims that reality is true and our experience is real and our actions endeavour to come into alignment with the truth. The Good suggests that in practising goodness we participate in the soul of the world. The fifth is the Beautiful.

Every act of thinking, mostly without our realizing it, is secretly grounded in these presences. If the One, the True, Being, the Good and the Beautiful were to vanish, the thought in the mind would have no pathway out to the world. Put simply, these presences guarantee our sense of meaning and sustain the sense of order, truth, presence, goodness and beauty in our world. For the medieval mind beauty was a central presence at the heart of the real. Without beauty the search for truth, the desire for goodness and the love of order and unity would be sterile exploits. Beauty brings warmth, elegance and grandeur. Something in our souls longs deeply for that graciousness and delight. When we advert to the presence of beauty, the direction, rhythm and energy of our lives become different.

The medieval mind did not believe that beauty was either the result of a mental attitude that longed to see beauty or a surface presence in Nature or a product of the artistic mind. They did not believe that a human person could simply create beauty. In the medieval view reality was a series of symmetrical levels issuing from God and culminating in God's perfection. All beauty derived

ultimately from the beauty of God. Thomas Aquinas was the towering figure in the thought world of the Middle Ages. His system of thought is a magnificent architecture. In saying that beauty was a transcendental, Aquinas was claiming that beauty dwells in the depth of things. The same notion is also put memorably by Yeats in his poem 'The Rose upon the Rood of Time':

> Come near, that no more blinded by man's fate,
> I find under the boughs of love and hate,
> In all poor foolish things that live a day,
> Eternal beauty wandering on her way.
>
> Come near, come near, come near – Ah, leave me still
> A little space for the rose-breath to fill!

CLARITAS: WHEN THE FORM OF BEAUTY SHINES

> Each object is in reality a small virtual volcano.
> HÉLÈNE CIXOUS

THE MEDIEVAL WORLD LOVED SYMBOLS. IT OFTEN PROBED THINGS so deeply to discover their supernatural reality that it ended up losing sight of the sensuous presence of the thing itself. But the thought of Aquinas is remarkable in its continuous insistence on the real, sensible presence of things. Each stone, tree, place and person was in its depths the expression of a divine idea. Consequently, each thing had a unique form. No thing is accidentally here. Nature is not dispersed chaos but a series of individual forms. The form is at once the structural principle of a thing and its essence and vital source. Aquinas had an understanding of nature and experience as dynamic, as constantly unfolding.

His philosophy is a hugely intricate poetics of growth and becoming. Beauty was to be understood as the perfection of a thing. Perfection is not static or dead, it is the fullness of life which a thing possesses: this is what constitutes the adventure of knowing in the system of Aquinas. To know a thing is to awaken to its depth, complexity and presence. According to him, each thing secretly and profoundly desires to be known. Consequently, his notion of beauty is grounded in that deep knowing. This is how the beauty of a thing shines out in *claritas* of form. Beauty is magnetic because it calls forth a thing's presence.

INTEGRITAS: THE DESTINATION OF GROWTH

Part of what it means to be, is to be beautiful. Beauty is not superadded to things: it is one of the springs of their reality. It is not that which effects a luscious response in perceivers; it is the interior geometry of things, making them perceptible as forms.
FRANCESCA ARAN MURPHY

For Aquinas beauty also included the notion of integrity, *integritas*. He understands that each thing is alive and on a journey to become fully itself. Integrity is achieved when there is a complete realization of whatever a thing is supposed to be. Integrity is the adequacy of a thing to itself. There is here a sense of achieved proportion between a thing and what it is called to be. Creation is always in the heave of growth and becoming and when a thing journeys towards its own perfection or fullness of life, it is also secretly journeying towards the divine likeness. The integrity of beauty is that inner straining towards goodness and completion. There is a wonderful urgency within things to realize the dream of their individual fulfilment; nothing is neutral, everything is on its way.

The light of a great thought is eternal. Hundreds, sometimes thousands of years after it dawned, it can still illuminate our world. Aquinas insisted that goodness, truth and integrity belonged essentially to beauty. In light of this, we can see that much of the current cultural breakdown can be understood as failure of vision with regard to beauty. Imagine: if the mind of the politician and developer could awaken to the ancient integrity of landscape, it would become more and more difficult to damage the beauty of nature. If architects and planners could recognize how ugly surroundings damage and diminish the mind, then building might recover a sense of beauty. If religion could put the beauty of God at its heart what refreshment and encouragement it would give and what creativity it would awaken. If the beauty of kindness were to become attractive, it would gradually create an atmosphere of compassion which would help the weak and wounded to trans-figure their lives. Plato expressed this pithily: 'The power of the good has taken refuge in the nature of the Beautiful' (*Philebus*, 65A). Aquinas's notion of beauty as the integrity and completion of a thing offers us both a wonderful lantern and a generous mirror to glimpse how we might bring the great ideas alive through our love of beauty.

Aquinas is careful not to overlook the sensuous element in the beauty of things. He says: 'Pulchra sunt quae visa placent', i.e. those things are beautiful which please when they are seen. He speaks of *delectatio*, the surge of delight and joy we feel when we experience beauty. We are taken beyond the dullness of habit and daily familiarity. Something breaks through the shell to release excite-ment in us. When we see beauty in sensible things, we are grasping their secret, living form. While the experience of beauty has a wonderful immediacy, it is not something that simply happens. Because the medieval mind had such a refined sense of how deeply complex even the simplest act of knowing is, experience was never understood as a sequence of non-stop epiphanies. The task of true knowing is slow and difficult; yet when pursued, it often opens us

to the delight of being surprised and overtaken by beauty. This is where Aquinas speaks of the peace that beauty brings. Peace is the tranquillity that comes when order is realized. Struggle and desire are deftly subsumed in the experience of harmony.

BEAUTY EVOKES ELEGANCE AND DIGNITY

Radiance belongs to being considered precisely as beautiful; it is, in being, that which catches the eye, or the ear, or the mind, and makes us want to perceive it again.

ETIENNE GILSON

THE MEDIEVAL MIND RECOGNIZED THAT WHILE WE CAN participate in beauty, we can never possess it. If we attempt to own beauty, we corrupt it. When soiled or damaged, beauty can turn negative and destructive. It is ultimately a sacred manifestation and should not be trespassed on by our lower hungers. In the presence of beauty, we are called to be gracious and worthy.

Beauty makes presence shine. It brings out elegance and dignity and has a confidence, an effortlessness that is not laboured or forced. This fluency and ease of presence is ultimately rooted below the surface in surer depths. In a sense, the question of beauty is about a way of looking at things. It is everywhere, and everything has beauty; it is merely a matter of discovering it. The most profound statement that can be made about something is the statement that 'it is'. Beauty *is*. The word *is* is the most magical word. It is a short, inconsequential little word and does not even sound special. Yet the word *is* is the greatest hymn to the 'thereness' of things. We are so thoroughly entangled in the web of the world that we are blind to the unfolding world being there before us. Our sleep of unknowing is often disturbed by suffering. Abruptly we awaken to the devastating realization that the givenness of things is utterly

tenuous. Even mountains hang on strings. The 'isness' of things is miraculous: that there is something rather than nothing.

'BEING HERE IS SO MUCH'

THE HUMAN MIND IS IN ITSELF A WORLD WITH HUGE MOUNTAINS, deep valleys and forests of the unknown. Given the private depths, deep strangeness and wonders of our interior life, it is amazing that we can reach out towards the world and to each other with such intimacy and understanding. More amazing still is our ability to make everything so familiar and normal that we actually succeed in forgetting how strange and wondrous it is to be here. Rilke said: 'Being here is so much.' We turn the mystery and strangeness of this world into our private territory. We make a home out of the world. Life becomes predictable and we function automatically within our frames: route to work, colleagues, friends, patterns of thinking and feeling, the faces of the family, etc. Without sensing it, we become lost inside the automatic traffic of functioning. It is only when something goes wrong that we are hauled back to the edge. Quite abruptly the familiar map has melted and territories that were sure ground an hour ago don't exist any more. Heidegger said that it is only when a hammer does not work that you suddenly realize that it is a hammer.

It is tragic that something has to go wrong before we can realize the gift of the world and our lives, gifts we could never have dreamed or earned. When something goes deeply wrong, the realization it forces is inevitably learned at the grave of loss. If we were able to live in a deeper state of awareness and wisdom, our days on earth would find a new frequency: spaces would open naturally for beauty to touch us and we need beauty as deeply as we need love. Beauty is not an extra luxury, an accidental experience that we happen to have if we are lucky. Beauty dwells at the heart

of life. If we can free ourselves from our robot-like habits of predictability, repetition and function, we begin to walk differently on the earth. We come to dwell more in the truth of beauty. Ontologically, beauty is the secret sound of the deepest thereness of things. To recognize and celebrate beauty is to recognize the ultimate sacredness of experience, to glimpse the subtle embrace of belonging where we are wed to the divine, the beauty of every moment, of every thing.

Beauty loves freedom; then it is no surprise that we engage beauty through the imagination. The imagination always goes beyond the frames and cages of the expected and predictable. The imagination loves possibility and freedom is the ether where possibility lives. Uncharted territories are always beckoning. Beauty is at home in this realm of the invisible, the unexpected and the unknown. It emerges from its own depths, sure in poise and generous in possibility. Yet there is a certain disturbance in the call of beauty, a displacement. As T.S. Eliot says in 'Journey of the Magi': we can no longer be at ease in the old dispensation. We are forced to recognize something new, something that shows up the limitations we have accepted and our subtle but deadening compromises. Beauty calls us beyond ourselves and it encourages us to engage the dream that dwells in the soul.

One time in Atlanta, Georgia, I noticed the constant presence of a certain weed by the roadside. I asked what its name was. I was told that it was the 'kudzu' weed which could grow a foot long in a day. When I returned home and reflected on my trip, the kudzu struck me as a precise metaphor for consumerism. Most of us move now in such a thicket of excess that we can no longer make out the real contours of things. Where there is entanglement, there is no perspective or clarity to make out the true identity of anything. We need to make a clearance in order to begin to see where we are and who we are; then we can discover true proportion. And without a sense of proportion, we cannot recognize beauty.

THE LEGEND OF THE *GLAS GABHNA*

IT IS INCREDIBLE HOW BLINDNESS AND HABIT HAVE DULLED OUR minds. We live in the midst of abundance and feel like paupers. Our lonely emptiness seems to be the result of our desire to turn everything into product. Only if it becomes a product does a thing become real. Like the surrealistic sculptures of Jean Tinguely, we reduce beauty to contorted shapes that bring us neither shelter nor invitation.

Yet the world we have inherited is teeming with possibilities. If we could but see it, each moment offers us a richness which invites our care and graciousness. There is an old story from County Clare about the *Glas Gabhna*. In the mountains near Carron, there lived a smith who had a magical cow. When she was milked, she could fill any vessel. The smith knew how valuable she was. He had seven sons and one of them always 'stood to her', or in other words watched over her. Over a long period of time, she gave an endless supply of milk. Even today one can see in that landscape certain bare patches where nothing grows. These were the places the cow was said to have lain down. Her fame and magic spread everywhere. One day, while on his watch, one of the sons fatally fell asleep. An old woman came by and saw the magical cow unguarded. She had a sieve with her and she began to milk the cow into the sieve. She milked and milked. The milk flowed endlessly onto the earth until the cow fell down. When the son awoke, he saw the ground white with milk beneath the fallen cow. He went to call help. When the father and sons returned, the cow had gone away. She was never heard of again. Then some time after she had departed, seven streams broke forth from the spot where she had been milked. These are to be seen there today, the Seven Streams of Taosca.

This legend perfectly highlights what can happen when we abuse the sacrament of abundance, we drive away graciousness. The generosity of the cow was unfailing, she would fill any vessel.

In terms of abundance, we could read the vessel as the form which receives the gift. Once the form becomes false and manipulative, the gift is destroyed. It would be lovely were we more awake to our gifts: we could engage them with a form proportionate to their generosity. Sadly, much of our inner riches are wasted and lost; perhaps we remain scattered and empty because we tend to use the 'sieve' rather than the 'vessel'. Greed damages what it desires and the gift of abundance always tests us. It invites us to a sense of proportion in how we see, feel and act. Without proportion, there is no balance, and the force of imbalance ultimately brings destruction. Since classical times, it has always been recognized that beauty demands proportion and balance. When they are neglected, beauty and graciousness recede and the flow of gifts dries up. When we dwell in graciousness, we are never without the gifts we need; there is plenitude and abundance. Graciousness dignifies human presence and when it is present, it brings out the best in people. It opens a perspective which enables us to *see* the gifts that we have. It creates an atmosphere which awakens nobility of mind and heart. A gracious mind has compassion and sensitive understanding. It is without greed; rather than concentrating on what is absent or missing, it is able to celebrate and give thanks for what is present.

TO WALK GRACIOUSLY THROUGH LIFE

To think that we have at our disposal the biggest thing in the universe, and that it is language. What one can do with language is . . . infinite.
HÉLÈNE CIXOUS

GRACIOUSNESS IS A QUALITY OF MIND THAT DOES NOT SEPARATE truth and beauty. Talk of truth always makes it sound as if truth were the cardinal virtue. Yet without beauty, truth becomes blind

and can be turned into a blunt and heartless imperative. When we hold beauty and truth together, truth will always have a sense of compassion and gentleness. Sometimes the so-called 'facts of a situation' actually tell us little or nothing about the heart of an experience. Only in the light of beauty can we come to see what is really present. This is true also of the way in which we view our own life. If we were to describe our life strictly in terms of its factual truth, most of its interesting, complex and surprising dimensions would remain unmentioned. The gracious eye can find the corners where growth and healing are at work even when we feel weak and limited. It is no wonder that Jesus said: the gentle shall inherit the earth. When we succeed in being gracious and gentle with ourselves and others, we begin to truly inherit the inner kingdom.

In his book *Crossing Unmarked Snow*, William Stafford has the following inspiring sentences, according to which one could live an honourable life:

> The things you do not have to say make you rich.
> Saying things you do not have to say weakens your talk.
> Hearing things you do not need to hear dulls your hearing.
> And things you know before you hear them – those are you,
> Those are why you are in the world.

We are not as near each other as we would like to imagine. Words create the bridges between us. Without them we would be lost islands. Affection, recognition and understanding travel across these fragile bridges and enable us to discover each other and awaken friendship and intimacy. Words are never just words. The range and depth of a person's soul is inevitably revealed in the quality of the words she uses. When chosen with reverence and care, words not only describe what they say but also suggest what can never be said.

Bill Stafford suggests that these things which dwell out of reach,

beyond words, are the things that make the soul rich. The inexpressible depth in us is our true treasure. In our endless social chatter and psychological labelling, we frequently cheapen its beauty. We need to learn the art of inner reverence and never force the soul out into the false light of social gratification and expectation. To observe an appropriate silence regarding our interiority means our talk will never be weak. In a culture where there is a morass of second-hand chatter, we need to mind our hearing; otherwise it becomes dull and deaf to the voice of what is real and beautiful. To practise the discipline of reverence which Bill Stafford recommends means that we remain always secretly ready to receive the words that could illuminate our destiny.

BEAUTY AVOIDS THE SIREN CALL OF THE OBVIOUS

A beautiful thing, though simple in its immediate presence,
always gives us a sense of depth below depth, almost an
innocent wild vertigo as one falls through its levels.
FREDERICK TURNER

THE EXPERIENCE OF BEAUTY HAS FOR THE MOST PART A particular force. It envelops and overcomes us. Yet there are times when beauty reveals itself slowly. There are times when beauty is shy and hesitates until it can trust the worthiness of the beholder. Human culture seems to build its temples of meaning in the wrong places, in the garish marketplaces of transient fashion and public image. Beauty tends to avoid the siren call of the obvious. Away from the blatant centre, it prefers the neglected margin. Beyond the traffic of voyeuristic seeing, beauty waits until the patience and depth of a gaze are refined enough to engage and discover it. In this sense, beauty is not a quality externally present in something. It emerges at that threshold where reverence of mind engages the

subtle presence of the other person, place or object. The hidden heart of beauty offers itself only when it is approached in a rhythm worthy of its trust and showing.

Only if there is beauty in us can we recognize beauty elsewhere: beauty knows beauty. In this way, beauty can be a mirror that manifests our own beauty. This has little to do with narcissism or self-absorption. To achieve a glimpse of inner beauty strengthens our sense of dignity and grace. The glimpse ennobles us; it helps awaken and refine our reverence for the intimate eternal that dwells in us. Yet the recognition of another person's beauty can sometimes induce envy and a sense of inferiority. When we succumb to envy, we have become blind to ourselves. In the end, the truth is surprisingly ordinary – that there is beauty in every life regardless of how inauspicious, dull or hardened its surface might seem.

WHERE FEELING AND FORM FIND BALANCE

THERE IS A SUBLIME COHERENCE AT THE HEART OF BEAUTY, AN order which has a lyrical simplicity. Since beauty issues from depth, this order has emerged from intense engagement with chaos, confusion and contradiction. It is a beauty that the soul has won from the heart of darkness. Such beauty cannot simply be siphoned off from chaos. Neither can it be fabricated or slipped over chaos as a benign, concealing mask. Such beauty engages in the labour and grace of the imagination. Beauty is ultimately a gift.

Sometimes the perfection of beauty can seem aloof and cold. There is the clichéd image of the man or woman who is immensely good looking. Their attraction draws others towards them. But the magnetism turns hollow if their hearts are shown to be cold or empty. Sometimes a work of art has the same style of perfection – technically accomplished, formally adept yet disappointingly void

of presence. This is especially clear in a musical performance. Each note is hit immaculately, yet the fibre and tenor of the sequence remains strangely hollow. For true beauty is not merely a formal, technical order or quality in a thing. When passion of feeling and technical brilliance come together, the beauty can be devastating and transfiguring. Feeling in itself can tend towards sentimentality and often masquerade as concern when in truth it is concealed resentment or smothered anger. There is a profound balancing within beauty. Perhaps the magnetic tension of beauty issues precisely from the threshold where passionate extremes come into balance. Beauty invites refinement of feeling and thought. It calls us ever towards a greater fullness of presence.

ELEVATED BY THE GRANDEUR OF A GREATER HARMONY

KEATS SAID: 'BEAUTY IS TRUTH, TRUTH BEAUTY – THAT IS ALL YE know on earth, and all ye need to know.' Keats's famous lines concur with the medieval understanding of the Transcendentals. In both instances beauty and truth are internally linked. The search for truth is allied with the visitation of beauty. In contemporary thought, truth has become an arid and weary concept. From the practice of people's lives, one gains a similar impression. There is a relentless search for the factual and this quest often lacks warmth or reverence. At a certain stage in our life we may wake up to the urgency of life, how short it is. Then the quest for truth becomes the ultimate project. We can often forage for years in the empty fields of self-analysis and self-improvement and sacrifice much of our real substance for specks of cold, lonesome factual truth. The wisdom of the tradition reminds us that if we choose to journey on the path of truth, it then becomes a sacred duty to walk hand in hand with beauty.

The twelfth-century Persian mystic Ibn Arabi writes of such beauty in his classic about the spiritual journey, *Journey to the Lord of Power*: 'And if you do not stop . . . He reveals to you the world of formation and adornment and beauty, what is proper for the intellect to dwell upon from among the holy forms, vital breathings from beauty of form and harmony, and the overflow of languor and tenderness and mercy in all things characterized by them . . .'

There is a kindness in beauty which can inform and bless a lesser force adjacent to it. It has been shown, for instance, that when there are two harps tuned to the same frequency in a room, one a large harp and the other smaller, if a chord is struck in the bigger harp it fills and infuses the little harp with the grandeur and beauty of its resonance and brings it into tuneful harmony. Then, the little harp sounds out its own tune in its own voice. This is one of the unnoticed ways in which a child learns to become herself. Perhaps the most powerful way parents rear children is through the quality of their presence and the atmosphere that pertains in the in-between times of each day. Unconsciously, the child absorbs this and hopefully parents send out enough tuneful spirit for the child to come into harmony with her own voice. In its graciousness, beauty often touches our hearts with the grandeur and nobility of its larger resonance. In our daily lives such resonance usually eludes us. We can only awaken to it when beauty visits us. Like intimacy, beauty is reserved. It turns us towards that primal music from which all silence and language grow.

3

THE MUSIC OF BEAUTY

Because difference constitutes music . . .
Sound is . . . the rubbing of notes between two drops of water,
the breath between the note and the silence, the sound of thought.
. . . To write is to note down the music of the world.
HÉLÈNE CIXOUS

THE MUSIC OF THE EARTH

IN THE BEGINNING WAS THE SILENCE. BEFORE ANYTHING WAS, there was silence everywhere. As the universe was born the silence was broken in the fiery violence of becoming. As planets settled in the cold, endless night of the cosmos, silence was restored; and it was a deep and dark silence. We can imagine the cry of the first wind as it billowed against the strange curvature of new mountains and warmed over the restless, boiling oceans. In time, the earth settled and entered the adventure of its own journey. The

rippling of waters and the wail of the wind were the only sounds until the arrival of the animals. Gradually the earth developed its own music. Streams gave voice to the silence of valleys. Between the mountains and the ocean, rivers ferried the long songs of landscape. In fresh spring wells the dreaming of stone mountains sounded forth. And from infinite distance the moon choreographed each sequence of tides. As the memory of the earth deepened, the wind built into a *Caoineadh* – a huge keening. It was as if the music of the mourning wind voiced the distilled loneliness of the earth. Who knows what presences depended on the wind in order to come to voice or how long they have waited for voice. The wind is the spirit-sound of the ancient earth.

Over hundreds of millions of years, the earth deepened its elemental music. Each note arises out of the infinite silence of the earth and falls away again into the vast stillness. The elemental conversation of the silence and the music of nature gives the earth a spirit of intimacy. There is an interesting symmetry between the silence of the earth and the silence of the human body. Just as the music of the wind and water breaks the deep silence of the earth, so the sound of the word breaks the private silence of the body. This threshold between silence and word sets the imagination free to create beauty. A world without this threshold would be a world of nightmare. An earth where noise never stopped or where clear dead silence was endless could never be a home for the mind. It is somehow consoling that at a primal level the heart of silence ripples in music and word. In terms of our theme, it is as though the deepest dream of silence is the beauty of music and word.

Unlike all our ancestral creatures, we have transformed the earth. We have brought much destruction and done much damage, yet our music is among the most delightful sounds on earth. Faced with the strangeness and silence of the earth, one of the most beautiful human creations has been music. The creation of exquisite music is one of the glories of the human imagination. Indeed, if we had done little else, music would remain our

incredible gift to creation for there is no other sound on earth to compare with the beauty and depth of music. It has an eternal resonance. Yet of course that is as we hear it. Perhaps to animal hearing, there is nothing more beautiful than the sound of wind through a forest or the rhythmic salsa of Wild Ocean as it crashes against a cliff-face. To the human ear, however, music echoes the deepest grandeur and the most sublime intimacy of the soul.

MUSIC CREATES ITS OWN TIME

> Music survives, composing her own sphere,
> Angel of Tones, Medusa, Queen of the Air,
> And when we would accost her with real cries
> Silver on silver thrills itself to ice.
>
> GEOFFREY HILL, 'Tenebrae'

IN CONTRAST TO MOST OTHER FORMS OF ART, MUSIC ALTERS YOUR experience of time. To enter a piece of music, or to have the music enfold you, is to depart for a while from regulated time. Music creates a rhythm that beats out its own time-shape. Whilst theatre invites the suspension of disbelief as we enter and participate in the drama the characters create, in music there is a suspension of the world. We are deftly seduced into another place of pure feeling. No other art distils feeling the way music does; this is how it can utterly claim us. Despite the complexity of its content or structure, the tonality of music invades the heart. In music, the most intricate complexity can live in the most lyrical form. Music is depth in seamless form. It is no wonder then that all poetry strives towards the condition of music. As T.S. Eliot said: 'Poetry like music should communicate before it is understood.'

Feeling is where the heart lives. In claiming the heart so swiftly and totally, the beauty of music crosses all psychological and

cultural frontiers. There is a profound sense in which music opens a secret door in time and reaches in to the eternal. This is the authority and grace of music: it evokes or creates an atmosphere where presence awakens to its eternal depth. In our everyday experience the quality of presence is generally limited and broken. Much of the time we are distracted; we might manage to be externally present, but often our minds are secretly elsewhere. Music can transform this fragmentation, for when you enter into a piece of music your feeling deepens and your presence clarifies. It brings you back to the mystery of who you are and it surprises you by inadvertently resonating with depths inside your heart that you had forgotten or neglected. Music can also stir memories, good or bad, and transport you back in time.

Music embraces the whole person. It entrances the mind and the heart and its vibrations reach and touch the entire physical body. Yet there is something deeper still in the way that music pervades us. In contrast to every other art form, it finds us out in a more immediate and total way. The inrush of intimacy in music is irresistible. It takes you before you can halt it. It is as though music reaches that subtle threshold within us where the soul dovetails with the eternal. We always seem to forget that the soul has two faces. One face is turned towards our lives; it animates and illuminates every moment of our presence. The other face is always turned towards the divine presence. Here the soul receives the Divine Smile or the Kiss of God, as Meister Eckhart might express it. Perhaps this is where the mystical depth of music issues from: that threshold where the face of the soul becomes imbued with the strange tenderness of divine illumination.

THE SIMULTANEITY OF MUSIC

The essence of rhythm is the preparation of a new event by the
ending of a previous one . . . Everything that prepares a future
creates rhythm; everything that begets or intensifies
expectation . . .
SUSANNE K. LANGER

MUSIC ARISES FROM THE REALM OF SIMULTANEITY. IT TAKES US TO a level where time becomes a circle. Here one thing does not follow another in a regular line of sequence. Somehow at that depth, all times are present together: the joys and losses of your past, the wonder of the present and the unknown possibilities of the future; music plays out of this profound simultaneity. This is why often when one listens to Beethoven or Bach, one feels one is being cradled in a sublime Now; there is no 'before' or 'after', 'otherwise' or 'elsewhere'. Here memory and possibility come together in an invisible embrace. Music draws us into transfigured time through the sonority of distilled feeling. Music is the most immediate of presences; it infuses the whole self, and is at the same time utterly elusive. Yet it is impossible to be definite about music. It creates its own time and cannot be measured by seconds or minutes. It also creates a new space that cannot be measured by inches or metres. Music dwells in a world of its own.

I remember a night of music in Piazza San Marco in Venice. There was an international dance festival. It was the night of a full moon. Out on the ocean a storm was raging. The sea was rising fiercely and frighteningly in and around Venice. The orchestra on stage were playing Stravinsky to an accompanying ballet. Somewhere in that evening of music everything came together in a magnificently charged way: the ocean, the dance, the music, all of us caught in a dark, elemental surge. The music brought everything into one seamless circle of being. For a while we dwelt inside the music, were embraced and protected by it. For a while there was no 'outside'.

Music Is the Dream of Silence

And harmonies unheard in sound create the harmonies we hear
and wake the soul to the consciousness of beauty.

PLOTINUS

IT IS STRANGE THAT ALTHOUGH WE CANNOT SEE OR TOUCH MUSIC,
it evokes and creates such a clear and sure world. Especially at
orchestral concerts, I have often been struck by the question: where
does music actually dwell? I love the ritual and form of a concert:
how the conductor evokes a fluency and harmony from the
diversity that is an orchestra; how the soprano soars to meet the
music; how the audience and performers are affected and enfolded
in this invisible force. A deaf alien would be amazed at our
gathered attention and unity. Though we cannot see music with the
eye, many musicians speak of seeing music with their inner senses;
they see shapes of flow, shapes of structure. Some see music in their
dreams appearing as forms or patterns. A friend once had a dream
of seeing her Sufi teacher walking into heaven. She vanished
beyond visibility; when she returned later there were notes sticking
to her limbs like bars of light. For a while she had been walking in
that other land where the stuff of music grows naturally!

There is a sense in which music is a homecoming. As we slip
below the surface mind, below the flotsam of the surface world, we
travel to our true level, where the deep silence of identity, that
silence that holds the mind in poise, is reached and embraced by
music. Like the flow of some primal wave, music has the
confidence of an originary force. Once evoked, it knows where
the deepest source awaits. Ravel said: 'Music is dream crystallized
into sound.'

Music is the surest voice of silence. From the beginning silence
and sound have been sisters. Music invites silence to its furthest
inner depths and outer frontiers. The patience in which silence is
eternally refined could only voice itself in music. Music and silence

are like lovers who gaze at each other and long for each other. Schubert once said: all music begins and ends in silence. Indeed, the secret of Schubert is how he sculpts silence with sound. The dream of silence is music. Though the content may be full of sorrow or pathos, music seems to desire a certain lightness and playfulness; physically as sound it continues to move and flow. Perhaps listening to music renews the heart precisely for this reason: it plumbs the gravity of sorrow until it finds the point of submerged light and lightness. Listening to music stirs the heavy heart; it alters the gravity. Unconsciously it schools us in a different way to hold sorrow. When the music is dark it works through dissonance and harsh notes; like underpainting their beauty is slow to reveal itself but it does ultimately dawn. It frees a space to let in lightness. Unlike anything else in the world, music is neither image nor word and yet it can say and show more than a painting or poem.

WHEN THE LAND GETS INTO THE MUSIC

We have fallen into the place
where everything is music.
RUMI, 'Where Everything Is Music'

IRELAND HAS A GREAT STORE OF TRADITIONAL MUSIC AND THERE is a great diversity of style and nuance. Each region has a distinctive tradition. One can hear the contours of the landscape shape the tonality and spirit of the music. The memory of the people is echoed in the music. Traditional Irish music is joyous and lively. The reels, jigs, hornpipes, polkas and slides have tremendous energy and passion. In the 'slow airs' the wistfulness of loss and sorrow is piercing. When one considers the history of suffering which the Irish have endured through colonization, famine and emigration, it is fascinating that our music has such heart. Indeed

some of the greatest and most distinctive Irish music developed among Irish emigrants, especially in America, and must have been one of their few shelters in exile. Arriving in a strange land and having to work hard, far away from their family, friends and home landscapes, music must have opened secret doors in the memory and allowed the heart to come home again. When they felt lost and forsaken, they rejoiced in this universal language that crosses all frontiers and barriers. The music of a people offers a unique entry to their unconscious life. The tenor of what haunts and delights them becomes audible there. The cry of a people is in their music. The mystery of music is its uncanny ability to coax harmony out of contradiction and chaos. Often the beauty of great music is a beauty born from the rasp of chaos. The confidence of creativity knows that deep conflict often yields the most interesting harmony and order.

In the Irish tradition we have *sean-nós* singing. This is a style of unaccompanied singing in the Irish language which has a primal tonality and very beautiful rhythm. The resonance and style of *sean-nós* seems to mirror the landscape and sensibility of the people. There is a special repertoire of these songs and they are sung over and over. Each *sean-nós* singer has a unique but easily recognizable style. The song comes alive in a new way as it is etched in the singer's voice; the cut and style of the phrasing determines everything. The sounds of the Irish soul cannot be expressed in the same way in English.

BELONGING TO MUSIC

Music is a science of love relating to harmony and rhythm.
PLATO

MUSIC BRINGS GREAT BEAUTY INTO OUR LIVES. IN THE WAY THAT IT arrives, lingers and vanishes, it offers us a clue to the eternal nature

of beauty. Like music, beauty dwells in some invisible realm adjacent to us, yet it never becomes our possession. But when it emerges to visit us, it wafts us away to a realm where desolation and gravity no longer preside. Though we may indeed be wounded by beauty at times, like the darkness of music, it can be a sweet pain.

When you really listen to music, you become detached from the world; indeed you enter another world. Within the shelter of music, other things become possible for you, things that you could never feel or know in your day to day world. Sound can create a world as real as that of the clock, the field or the street. You breathe and dwell within that soundscape as though it were a world specially created to mirror and echo the deepest longings of your life. There is profound belonging in music which at certain times in your life can embrace and reach you more deeply than friend or lover. It is as though the music instinctively knows where you dwell and what you need.

Music does not touch merely the mind and the senses; it engages that ancient and primal presence we call soul. The soul is never fully at home in the social world that we inhabit. It is too large for our contained, managed lives. Indeed, it is surprising that the soul seems to accommodate us and permit us to continue within the fixed and linear identities we have built for ourselves. Perhaps in our times of confusion and forsakenness the soul is asserting itself, endeavouring to draw us aside in order to speak to our hearts. Upheavals in life are often times when the soul has become too smothered; it needs to push through the layers of surface under which it is buried. In essence, the soul is the force of remembrance within us. It reminds us that we are children of the eternal and that our time on earth is meant to be a pilgrimage of growth and creativity. This is what music does. It evokes a world where that ancient beauty can resonate within us again. The eternal echoing of music reclaims us for a while for our true longing.

THE DARK BEAUTY OF EROS IN
TRISTAN AND ISOLDE

THE MUSIC OF WAGNER HAS A MAGNIFICENT ARCHITECTURE OF longing. His opera *Tristan and Isolde* explores the voyage of love in terms of longing and the search for fulfilment and union. Tristan and Isolde are deeply in love but their love can never find consummation or completion. The music constantly holds out the promise of ecstasy but never allows it to be realized. This structure of longing and its suspension makes up the intense drama of the music. The opening chord, known as the 'Tristan chord', famously holds two dissonances together; and from that moment on the music creates a continuous sequence of discord. As each emerging discord is resolved, the resolution creates another, new and deeper discord. Throughout the opera there is a cumulative increase in tension and it is not until the final chord is heard that the discord is finally resolved. Wagner was powerfully influenced by the philosophy of Schopenhauer. The Argentinian writer Jorge Luis Borges says that he learned German for one reason: to read Schopenhauer in the original. Schopenhauer considered the world and its inhabitants embodiments of longing. The world and life in it is an expression of will. Wagner too saw music as the embodiment of this intense longing. For him, music was not simply another creative or aesthetic dimension of human experience and expression; it was the real expression of human nature. No other mode of expression corresponds as intimately and directly to who we are – to the longing that animates us and informs our presence in the world. The music of *Tristan and Isolde* articulates our huge craving for love. The real drama here is not the action or plot; they serve merely to render visible the depth, poignancy and craving of the invisible worlds of Tristan and Isolde. Wagner said of the opera: 'Here I sank myself with complete confidence into the depths of the soul's inner workings, and then built outwards from this, the world's most intimate and central point, towards external forms . . .

Here life and death and the very existence of the external world appear only as manifestation of the inner workings of the soul.'

Wagner's music is charged with an incredible force of Eros. It is not the surface Eros of transient lust but the deepest Eros where soul and senses are awakened within the strain of primal longing. *Tristan and Isolde* is patterned with imagery of day and night. Usually in the world of the imagination, day stands for brightness, colour and goodness whereas the night represents the unknown, darkness and often evil. Wagner reverses this: day brings sorrow and night brings joy and rapture. This opera is a magnificent voyage into the Eros at the heart of the world; it is the call to life and creation that quickens the soul and captures the heart. When we enter the opera, forgotten sanctuaries open in the heart and neglected voices become audible in us. The magnificence of this music of Eros consists above all in the fact that it is a profound engagement with the other side of Eros, namely death. The glory of Wagner is the transfiguration of death and Eros in music. Wagner's music has a profound, dark beauty that shores up against the great silence into which every life finally fades.

THE HAUNTING BEAUTY OF BEETHOVEN

GREAT MUSIC IS NOT A MATTER OF GREAT IDEAS OR INTRICATE melodies. It is not about difficult phrasing or complex harmonies. Truly great music brings to expression the states of the soul. This huge nobility enhances the heart and opens the imagination to the deeper mystery and riches of being here. The human soul is tested and exposed by suffering and there is an elegance in the way great music explores suffering. Beethoven created music out of his own suffering. It is one of the loneliest ironies in the Western tradition that this magnificent composer suffered illness precisely when he had reached the heart of his gift. For him, who had gleaned divine

music from the depths of silence, all fell silent. He became deaf. For someone like Beethoven, for whom life was music, it is unimaginable what pain this caused. He wrote about this torment in the famous 'Heiligenstadt Testament' which was only discovered after his death:

> I was compelled early to isolate myself, to live in loneliness, when I at times tried to forget all this, O how harshly was I repulsed by the doubly sad experience of my bad hearing ... Ah how could I possibly admit an infirmity in the one sense which should have been more perfect in me than in others, a sense which I once possessed in highest perfection, a perfection such as few surely in my profession enjoy or have ever enjoyed ... But what a humiliation when one stood beside me and heard a flute in the distance and *I heard nothing*, or someone heard *the shepherd singing* and again I heard nothing, such incidents brought me to the verge of despair, but little more and I would have put an end to my life ... only art it was that withheld me, ah it seemed impossible to leave the world until I had produced all that I felt called upon to produce ...

When the first signs of deafness began, Beethoven responded with defiance. In the scherzo in the Ninth Symphony there is a wonderful evocation of the force that triumphs over destiny, and his *Eroica* or Third Symphony charts the great transition where his soul moves towards acceptance of and integration with his awful destiny. From that isolation of deafness he creates music of an immensely profound, divine and complex beauty. This new growth of soul comes to magnificent flowering in the last string quartets. From despair and forsakenness, he creates sublime and unforgettable beauty. Sorrow is transformed by tranquillity.

The violinist Anne-Sophie Mutter, who loves Beethoven, echoes this when speaking of beauty: 'Beauty, for me, is felt to be beautiful only when it is contrasted with its opposite, when we can also see the abyss, the shadow.'

MUSIC AND HEALING:
'I CAN SEE DOWN ALONG THE MUSIC'

I HAVE A FRIEND WHO IS A MUSIC THERAPIST. I HAVE SEEN HER work with a man who had had a stroke; he could no longer speak. I saw her last session with him where she sang and played in an attentive and accompanying improvised style. Within the emerging rhythm as she accompanied, anticipated and challenged him, both of them remained within the flow of the melody. He began to hum the music with her and ended up actually speaking. It was such a touching experience to see this person unexpectedly freed.

Music is often the only language which can find those banished to the nameless interior of illness. It calls out to the buried knowing in them, its rhythmic, lyrical warmth eventually freeing their frozen rhythm. She says: 'I can see down along the music into a person – as though the music were a tunnel between them and me. Or to use another image: through the invisible hands of music I search for the person and the music can find them and bring them back. Only music can reach the trapped knowing within them.'

THE MUSIC OF THE VOICE

And you, who with your soft but searching voice
Drew me out of the sleep where I was lost,
Who held me near your heart that I might rest
Confiding in the darkness of your choice:
Possessed by you I chose to have no choice,
Fulfilled in you I sought no further quest.

GEOFFREY HILL, 'Tenebrae'

EVEN WITHIN THE HIGH REFINEMENT OF CLASSICAL MUSIC THE human voice still creates the most touching and tender music of all.

A beautiful voice raises our hearts and stirs something ancient in us, perhaps reminding us of our capacity for the eternal. Such a voice can claim you immediately even before you have time to think about it. I have often been at a music session where someone might be asked to sing and as soon as the beautiful voice rises up all noise and distraction cease and everyone becomes enraptured as the beauty of the voice brings out the music of the heart. When you hear a soprano like Joan Sutherland scale the highest mountains of Mozart, it takes your breath away, or Jessye Norman singing the *Four Last Songs* of Strauss. But why does exquisite song stir us deeply? Perhaps, more than any instrument, song can capture us because the human voice is our very own sound; the voice is the most intimate signature of human individuality and, of all the sounds in creation, comes from an utterly different place. Though there is earth in the voice, the voice is not of the earth. It is the voice of the in-between creature, the one in whom both earth and heaven become partially vocal. The voice is the sound of human consciousness being breathed out into the spaces. Unlike things of clay which contain themselves, the soul always strains beyond the body. A stone can dwell within itself for four hundred million years, take every sieve of wind and wash of rain, yet hold its Zen-like stillness. From the very moment of birth, consciousness is already leaking from our intense yet porous interiority. To be who we are, we need the consolation and companionship of the outside. Utter self-containment is either the gift of the mystic who has broken through to the divine within, or the burden of one who has become numbed and catatonic because the outside was too terrible. The human voice is a slender but vital bridge that takes us across the perilous distance to the others who are out there. The voice is always the outer sounding of the mind; it brings to expression the inner life that no-one else can lean over and look into.

Yet the voice is not merely an instrument, nor a vehicle for thought. The voice is almost a self; it is not simply or directly at the service of its owner; it has a life of its own. Its rhythm and tone are

not always under the control of the conscious, strategic self. Each person has more than one voice. There is no such thing as the single, simple self; a diversity of selves dwells in each of us. In a certain sense, all art endeavours to attain the grace and depth of human mystery. There is wonderful complexity in nature and indeed in the world of artificial objects; yet no complexity can rival the complexity of the human mind and heart. Nowhere else does complexity have such fluency and seamless swiftness. Whole diverse regions within the heart can quicken in one fleeting thought or gesture. A glimpse of an expression in someone's eyes can awaken a train of forgotten memories. The mystery of the voice lies in its timbre and rhythm. Often in the human voice things long lost in the valleys of the mind can unexpectedly surface. As the voice curves, rises and falls, it causes the listener to hearken to another presence that even the speaker might barely sense but cannot silence. Sometimes, without our knowing or wanting it, our lives speak out. In spite of ourselves, we end up saying things that the soul knows but the mind would prefer to leave unsaid.

To Decipher the Voices within the Voice

IT CAN BE QUITE SURPRISING TO DISCOVER THE 'OWNER' OF A VOICE to be someone totally different from what one expected from merely hearing their voice. People often have this experience with radio. For years they may have listened to their favourite radio presenter. The kingdom of that voice has conjured up a certain image of the person in their minds. When they meet the person in reality, the face does not fit the voice. It is as though our voices have a certain independence, a life of their own without us. Yet sometimes nothing represents us as accurately as our voices. When you know someone well, you can tell from the music of their voice what is happening in their heart. The lone voice always tells more than it intends.

The idea that words are a clear expression of the mind's content is an illusion. There is a range and depth to the voice that can neither be predicted nor controlled. To decipher the voices within the voice is an art in itself. Sometimes a voice can carry a world towards you. When you are far away from someone you love, think of the promise that voice can hold when you telephone each other. The physical sound of the voice in your ear is almost like the touch of the person's hand upon your shoulder. Over the distance the voice can ferry a world of presence. It is often a little startling after such a call to come off the phone and find the person is not there. The voice has evoked the intimacy and made the person present. Indeed, the telephone is frequently an instrument of revelation; it is one of the most natural extensions of human presence. Without leaving your living room your voice can be heard in an office thousands of miles away. And how funny it now seems to us that years ago, before every home had a phone, when an old person used a phone for the first time they instinctively shouted into it as if the extra volume was required for the voice to cover the distance.

The Discerning Voice

But on condition that we liberate ourselves from our own interior despots, we are the most poetic beings, the newest, the most virgin in the world.

HÉLÈNE CIXOUS

HUMAN IDENTITY IS COMPLEX. NOTHING IS EVER GIVEN SIMPLY OR immediately. Even the simplest act of perception has many layers. Often at night a dream can take up a gesture or glimpses barely registered during the day and create a whole drama. Time and memory often reveal things later that were staring us in the eye, but we never noticed then. The quest for the truth of things is never

ending. To be human is to be ambivalent. Every experience is open to countless readings and interpretations. We never see a thing completely. In sure anticipation, our eyes have always already altered what awaits our gaze. The search for truth is difficult and uncomfortable. Because the mystery is too much for us, we opt to settle for the surface of things. Comfort becomes more important than true presence. This is precisely why we need to hear the discerning voice.

Somewhere in every heart there is a discerning voice. This voice distrusts the status quo. It sounds out the falsity in things and encourages dissent from the images things tend to assume. It underlines the secret crevices where the surface has become strained. It advises distance and opens up a new perspective through which the concealed meaning of a situation might emerge. The inner voice makes any complicity uneasy. Its intention is to keep the heart clean and clear. This voice is an inner whisper not obvious or known to others outside. It receives little attention and is not usually highlighted among a person's qualities. Yet so much depends on that small voice. The truth of its whisper marks the line between honour and egoism, kindness and chaos. In extreme situations, which have been emptied of all shelter and tenderness, that small voice whispers from somewhere beyond and encourages the heart to hold out for dignity, respect, beauty and love. That whisper brings forgotten nobility into an arena where violence has traduced everything. This faithful voice can illuminate the dark lands of despair. It becomes both the sign and presence of a transcendence that no force or horror can extinguish. Each day in the world, in the prisons, hospitals and killing fields, against all the odds, this still, small voice continues to echo the beauty of the human being. In haunted places this voice carries the light of beauty like a magical lantern to transform desolation, to remind us that regardless of what may be wrenched from us, there is a dignity and hope that we do not have to lose. This voice brings us directly into contact with the inalienable presence of beauty in the soul.

The lone, discerning voice has an effect utterly disproportionate to its singularity. Tempered with the tungsten edge of truth, it can cut through the densest morass of falsity. Asked at the right time, a searching question can make a fortress collapse. Despite all the illusion, deception and cover-up, something at the heart of the world still wishes to remain faithful, and hidden deep in everything is a presence that cannot resist truth. As Plato, Plotinus and Aquinas insisted, the Good and the True are sisters of the Beautiful.

The discerning voice can also show a darker side and turn in on itself to become a voice of self-criticism and make your heart into a place of torment. Harsh and unrelenting, it finds fault with everything. Even when unexpected acknowledgement or recognition comes your way, this voice will claw at you and make you feel you are unworthy. Nothing can ever be good enough. In some people's lives this self-critical voice is highly developed and has managed to install itself permanently as the primary internal choreographer. This voice can assume complete control in determining how you see yourself and the world. It can make you blind to the beauty in you. Shakespeare captures this perfectly in Sonnet 1 (where 'self-substantial' means 'self-consuming'):

> But thou, contracted to thine own bright eyes,
> Feed'st thy light's flame with self-substantial fuel,
> Making a famine where abundance lies,
> Thyself thy foe, to thy sweet self too cruel.

THE HEALING VOICE

WHEN SUFFERING ARRIVES AT THE DOOR OF YOUR LIFE, YOU FEEL lost and isolated. Pain becomes more intimate than anything else. This is when the companionship and support of family and friends makes all the difference. Their presence beside you brings a grace

of courage and hope. It is a wonderful moment, then, when a voice of kindness and care reaches towards you. Suffering brings you to a land where no-one can find you. Yet when the human voice focuses in empathetic tenderness, it can find its way across any distance to the desolate heart of another's pain. The healing voice becomes the inner presence of the friend, watchful and kind at the source.

In the desolate and torn terrain of suffering, there is no beauty that reaches deeper than the beauty of the healing voice. In his classic reflection on *Being and Time*, Martin Heidegger discovered that at the heart of time dwelt 'care'. The ability to care is the hallmark of the human, the touchstone of morality and the ground of holiness. Without the warmth of care, the world becomes a graveyard. In the kindness of care, the divine comes alive in us.

THE INNER VOICE OF THE SOUL

We live in wordsheds.
NED CROSBY

THE VOICE OF COMPASSION IS NOT ABSORBED WITH ITSELF. IT IS not a voice intent on its own satisfaction or affirmation; rather it is a voice imbued with understanding, forgiveness and healing. This voice dwells somewhere in every human heart. Ultimately it is the voice of the soul. Part of the joy in developing a spiritual life is the discovery of this beautiful gift that you perhaps never even suspected you had. When you take the time to draw on your listening-imagination, you will begin to hear this gentle voice at the heart of your life. It is deeper and surer than all the other voices of disappointment, unease, self-criticism and bleakness. All holiness is about learning to hear the voice of your own soul. It is always there and the more deeply you learn to listen, the greater the surprises and discoveries that will unfold. To enter into the

gentleness of your own soul changes the tone and quality of your life. Your life is no longer consumed by hunger for the next event, experience or achievement. You learn to come down from the treadmill and walk on the earth. You gain a new respect for yourself and others and you learn to see how wonderfully precious this one life is. You begin to *see through* the enchanting veils of illusion that you had taken for reality. You no longer squander yourself on things and situations that deplete your essence. You know now that your true source is not outside you. Your soul is your true source and a new energy and passion awakens in you. The soul dwells where beauty lives. Hermann Broch says: 'For the soul stands forever at her source, stands true to the grandeur of her awakening, and to her the end itself possesses the dignity of the beginning; no song becomes lost that has ever plucked the strings of her lyre, and exposed in ever-renewed readiness, she preserves herself through every single tone in which she ever resounded.'

THE LOST VOICE

DANTE'S EPIC BEGINS FAMOUSLY WITH THE NARRATOR SAYING:

> In the middle of the journey of our life
> I came to myself within a dark wood
> Where the straight way was lost.
> Ah, how hard a thing it is to tell
> Of that wood, savage and harsh and dense,
> The thought of which renews my fear!
> So bitter is it that death is hardly more.

In a certain sense, the whole *Divine Comedy* is an exploration of the inner wilderness of the lost voice. This is, however, a voice that is magnificently lost. The rich kingdoms of medieval sensibility gather here

in all their fascination and terror. As in the unfurling of individual destiny, times of loss can bring discovery. This is recognized trenchantly in the mystical tradition. The Dark Night of the Soul is the night in which all images die and all belonging is severed; the abyss where Nothingness dwells. When the voice speaks from the realm of such relentless Un-doing, it is a voice in which wilderness has come alive.

This is a limbo of desolation and despair, reminiscent of Shakespeare's phrase: 'With what I most enjoy contented least.' Endurance is all; now there is nothing else. A time of bleakness can also be a time of pruning. Sometimes when our minds are dispersed and scattered, this pruning cuts away all the false branching where our passion and energy were leaking out. While it is painful to experience and endure this, a new focus and clarity emerge. The light that is hard won offers the greatest illumination. A gift wrestled from bleakness will often confer a sense of sureness and grounding of the self, a strengthening proportionate to the travail of its birth. The severity of Nothingness can lead to beauty. Where life had gone stale, transfiguration occurs. The ruthless winter clearance of spirit quietly leads to springtime of new possibility. Perhaps Nothingness is the secret source from which all beginning springs.

There are also times of malaise, when life moves into the stillness of quiet death. Though you function externally, something is silently dying inside you, something you can no longer save. You are not yet able to name what you are losing, but you sense that its departure cannot be halted. Those who know you well can hear behind your words the deadened voice, the monotone of unremedied sadness. Your lost voice cannot be quieted. It becomes audible despite your best efforts to mask it. Sometimes even from a stranger one overhears the pathos of the lost voice: it may speak with passion on a fascinating topic, yet its mournful music seeps out, suggesting the no man's land where the speaker is now marooned. Put flippantly, no-one ever really knows what they are saying. The adventure of voice into silence and silence into voice: this is the privilege and burden of the poet.

THE VOICE OF THE POET

Chiefly because our pauper-speech must find
Strange terms to fit the strangeness of the thing.

LUCRETIUS, *De rerum natura*

POETRY IS WHERE LANGUAGE ATTAINS ITS GREATEST PRECISION
and richest suggestion. The poem is a shape of words cut to evoke
a world the reader can complete. The poem is shaped to enter and
inhabit forgotten or not yet discovered alcoves in the reader's heart.
The vocational quest of the poet is the discovery of her own
voice. The poet never imitates or repeats poems already in the
archive of the tradition. The poet wants to drink from the well of
origin: to write the poem that has not yet been written. In order
to enter this level of originality, the poet must reach beyond the
chorus of chattering voices that people the surface of a culture.
Furthermore, the poet must reach deeper inward; go deeper than
the private hoard of voices down to the root-voice. It is here that
individuality has the taste of danger, vitality and vulnerability. Here
the creative is not forced or appropriated from elsewhere.
Here creativity has the necessity of inevitability; this is the thresh-
old where imagination engages raw, unformed experience. This is
the sense you have when you read a true poem. You know it could
not be other than it is. Its self and its form are one. There is nothing
predictable here. For the poet there is a sense of frightening
vulnerability, for anything can come, anything can happen. The
unknown outside and the unknown interior can conceive anything.
The poet becomes the passing womb for something that wants to be
born, wants to become visible and live independently in the world.
A true poem has a fully formed, autonomous individuality. Keats
says: 'Poetry should be great and unobtrusive, a thing which enters
into one's soul, and does not startle or amaze it with itself, but with
its subject' (Letter, 3 Feb. 1818).

It is interesting that true poetic beauty emerges when the poet is

absolutely faithful to the uniqueness of her own voice. Beauty holds faith with the deepest signature of individuality; it graces the passion of individuality when it risks itself beyond its own frontiers, out to where the depth of the abyss calls. The danger of that exposure seems to call beauty. Here the gaze of familiarity falls away and repetition arrests. Something original and new wants to come through. Beauty is individual and original, a presence from the source. She responds to the cry of the original voice. Keats also said: 'Poetry should surprise by a fine excess, and not by singularity ... if poetry comes not as naturally as leaves to a tree it had better not come at all' (Letter, 27 Feb. 1818).

Silence is not just the space or medium through which sound comes. Rather silence comes to voice in sound. The primeval beauty of silence becomes audible in the elemental music of the earth and in our music of instrument and voice. At the core of the world and at the core of the soul is silence that ripples with the music of beauty and the whisperings of the eternal.

While music and its voices sound out the depths of silence and delight our listening, colour calls forth the secrets of darkness and light to bring joy to the eye.

4

THE COLOUR OF BEAUTY

Most people don't look . . .
The gaze that pierces – few have it –
What does the gaze pierce?
The question mark.

HENRI CARTIER-BRESSON

COLOUR IS THE LANGUAGE OF LIGHT; IT ADORNS THE EARTH with beauty. Through colour light brings its passion, kindness and imagination to all things: pink to granite, green to leaves, blue to ocean, yellow to dawn. Light is not simply a functional brightness that clears space for visibility. Perhaps of all the elements, light has the most refined imagination; it is never merely a medium. Light is the greatest unnoticed force of transfiguration in the world: it literally alters everything it touches and through colour dresses nature to delight, befriend, inspire and shelter us. The miracle of colour is a testament to the diverse, precise and ever surprising beauty of the primal imagination. The intense passion of the first artist glows forth in the rich colours of creation. In this sense, colour

is the visual Eucharist of things. In a world without colour, it would be impossible to imagine beauty; for colour and beauty are sisters. As Goethe said: the eye needs colour as much as it needs light.

Spring Sacraments of Colour in the Burren

MY EARLIEST MEMORIES ARE OF THE LANDSCAPE OF THE BURREN IN the West of Ireland. The Burren is an ancient kingdom of limestone sculptures carved slowly by rain, wind and time. Limestone is a living stone. Everywhere light conspires to invest these stone shapes with nuance. When rain comes, the whole stonescape turns blue-black. Rain has artistic permission here that it could enjoy in no other landscape. Mostly invisible and quickly absorbed by the earth, rain achieves powerful visibility on the vast limestone pavements. Like an artist who has fallen into despair, it drenches the grey stone with gleaming black. Everywhere the stone drinks in blackness as though it secretly corresponded to its inner mind. Then the rain ceases and the sun returns; the light effects a complete transfiguration. Gradually the dark dries off and the stonescape literally resurrects, glistening with washed whiteness, a reminder that this stone world once lived on the ocean floor.

Winter always makes the Burren more severe. The ameliorating green of trees and grasses diminishes in cold paleness. As the grip of winter loosens, the landscape gradually returns from bleakness to the welcome of exotic spring flowers which have an unexpected home here. The Burren is famous for its rare alpine and arctic flora and gradually amidst the grey stonescape, these delicate flowers creep forth in subtle sacraments of colour. Profusions of gentian surface like blue stars, white and purple orchids rise to offer their quiet grandeur to view, mountain avens with their white and yellow countenances make the stone seem kind. In crowds the harebells test their deft blueness against the breeze. Rich orange,

yellow lichens come to cover the white limestone bearing beautiful names like Sea Ivory, Tar Lichen, Orange Sea Lichen and Common Orange Lichen. And perhaps most striking of all, the Bloody Cranesbill rises in its delicate crimson petals and white heart through the *scailps* (crevices) in the limestone.

As a child I often watched a local blacksmith at work. He would place the silver horseshoes into a black, coal-dust fire to redden them. Under the fierce breath of the bellows the mound of black dust was an instant furnace of redness. Perhaps, similarly the very breath of life breathes into things until their individual colours flame. Such is the generosity of air, self-effacing and unseen it asks nothing of the eye, yet it offers life to the invisible fields where light can unfold its scriptures of colour. We dwell between the air and the earth, guests of that middle kingdom where light and colour embrace.

THE APPARITION OF COLOUR

ONCE WHILE TRAVELLING IN CHINA I WAS ON MY WAY TO Shanghai Airport. It was a dull morning. The road, suburbs and landscape were grey and colourless. Even the track and trek of commuters seemed like some underworld parade. It began to rain in slanted layers. Then I noticed a cyclist coming towards me. Attached to the back of his bicycle was a large basket piled high with balls of wool in every colour you could imagine. This determined cyclist was like a traveller from another world who transfigured the whole grey suburban landscape with his gentle cargo of blues, yellows, greens, indigos, oranges, purples and ochres.

The presence and experience of colour is at the very heart of human life. In a sense, we are created for a life full of colour. It is no accident that we abandon the world when the colours vanish and the reign of darkness commences. Night is the land where all

the outer colours sleep. We awaken and return to the world when the colours return at dawn. There is a beautiful word in Irish for this: *luisne* – the first blush of light before dawn breaks. Gradually, the coloured horizon of dawn gives way to daylight.

THE RAINBOW AS PRISM

WE TAKE DAYLIGHT FOR GRANTED. YET DAYLIGHT IS NOT SIMPLY there; it is an event, a smooth all-pervasive happening. Daylight is created light, a light woven seamlessly from a whole series of colours. The unnoticed miracle of everyday light is exposed in the rainbow, an apparition that is both illusory and tenuous. Conamara is a landscape beloved of rainbows. Between the rich light and the frequent rains, rainbows love to appear here. Every rainbow is a revelation: the optic through water drops that separates seamless daylight to reveal and display the secret inlay of colours that dwell at the heart of ordinary light.

In a sense, one could speak of the secret life of colour. Despite its outward beckoning, like true beauty, colour is immensely hesitant in giving away its secrets. Painters learn to respect the hesitancy of colour and endeavour to refine their skill to become worthy of its revelations. A painter learns the language of colour slowly. As in learning any language, you struggle for a long time outside the language. There is a willed deliberateness to how you sequence the strange words to make a sentence. Then one day the language lets you in to where the words dance to your thoughts with ease and fluency. Perhaps for a painter, too, there is a day when colour lets him in, when his palette sings with synergy and delight. For the artist Paul Klee that day happened during a trip to Tunisia in 1914. He wrote: 'Colour possesses me. I don't have to pursue it. It will possess me always, I know it. That is the meaning of this happy hour. Colour and I are one. I am a painter.'

The attempt to understand and explain colour has always fascinated the human mind. In classical times Aristotle's theory held that colour belonged objectively to things. This understanding held sway until the seventeenth century. One day in his room, a young Isaac Newton was experimenting with light. He placed a prism against the light ray coming through his window and noticed how the prism split the white light into its constituent colours. The genius of his intuition inspired him to place a second prism upside down in the path of the diverse colours. In that moment the colours coalesced again into a seamless white light. Newton concluded that colour is generated by subjective perception and vision. For Aristotle, light awakened colour. For the medieval mind, light was the vehicle of colour. But for Newton light *is* colour.

The Rose Is Red Because It Rejects Red

COLOUR HAS ALWAYS INTRIGUED ME AND IN RESEARCHING THIS book I found great delight in learning about colour, what it actually is and how it comes about. We need to sketch in some simple physics in order to illuminate this. Colour is not a cloak worn by an object; each colour is generated and shows the vulnerability of an object: its Being-Seen-ness. One of the great illusions of human vision is that there is stillness, yet what seems still to our eyes is in fact never still. The whole physical world is in a state of permanent vibration and change. Each object is constantly astir. The physical world is an electromagnetic field. Each thing is deftly aflow in the play of energy, namely, electromagnetic waves. The waves flow in different frequencies. Our eyes only pick up a small section of this vibrating wave-world: this is what we call visible light. What we see, we see in light; yet what we see is always partial, a selection from the full spectrum of what is there but not visible to us. There is a real world of invisible light here around us but we cannot see it.

Though we feel at home and sure in the visible world, it is in truth a limited place. Visible light comprises only one-tenth of the whole light spectrum. When we see the whole flow of visible light together, it is white.

Different colours arise when certain wavelengths are filleted from the spectrum. Colour is always the result of a subtraction from whiteness and not the singular, lonely choice of outer garment by an object. Each object is already pulsing to a certain frequency and the hunger or generosity of this frequency determines how much colour an object absorbs. Each bird, stone, tree, wave and face is sistered to sunlight in an individual way. Each thing comes alive in the sun: how a stone vibrates to the sun is how it absorbs the light's energy at that frequency and the rhythm of the frequency is the key to its colour. This frequency fillets out a specific colour from the spectrum of light and this then becomes the colour of the object. For centuries a granite rock might lie in the corner of a field, perfectly still, dressed in sure colour – this is what the eye sees, yet what the eye cannot see are the secret vibrations and continuous inner change that underlie and indeed create this still, coloured image. Colour is never dead or neutral: it issues from individual, secret frequencies.

What is the spectrum of colour? It is the reservoir, the broad band of colour that is always present. But the human eye can never behold the whole visual/non-visual range of that spectrum. In this sense, each object is an abbreviation: its individual frequency absorbs one colour from the spectrum, while the other colours are still present but remain unseen. This is why there is transparency. When the rays of light do not correspond with the individual pulse of an object, the object reflects the light. But we never actually notice or see the light rays which pass through. It is the light rays which the object resists and will not let in that return and reach our eyes. The very thereness of a flower or a stone is an act of resistance to light, and colour is the fruit of this resistance. The colours we cannot see are the ones the object absorbs. The colour it rejects is,

ironically, the one in which we see it dressed. For instance, a rose absorbs yellow and blue, and it rejects red. So we see a rose as red. A daffodil absorbs blue and red, but rejects yellow and yet it is this yellow we see.

While the object resists the light, the object is also penetrated by the light. The activity that gives an object its colour has all the play and excitement of lovemaking. Yet much remains hidden in the solitude of the object where the unseen colours continue to dwell. If an object could get up and look at itself in a mirror, it would undoubtedly be surprised at its public countenance. In all probability this is not how it would see itself; the mirror would offer no glimpse of the inner colours which have no need of the outside eye: they continue to live concealed within the object.

THE EYE IS THE DESTINATION OF COLOUR

WHEN WE COME TO GLIMPSE HOW COLOUR ARISES, WE BEGIN TO understand what a rich symbolic world colour suggests. Colour is not simply a surface pigment or covering. The very heart of an object glows through its colour, and colour is always reaching towards us. Without our eyes there is no colour. All colour is colour reflected from an object towards us and the eye is the secret destination of colour. What happens between the granite stone and the sun is read by the brain and the eye as colour. We could say, then, that it belongs to the psychic grandeur of the human heart, that it is fashioned to behold the world in the vitality, warmth and wonder of colour. We are creatures fashioned to behold colour because the soul loves beauty. Plato stated this elegantly in the *Phaedrus*. He suggests that our present love of beauty is an awakened echo of our earlier life in the eternal world. There we knew beauty because we lived in her grace: 'But of beauty, I repeat again that we saw her there shining in company with the celestial

forms; and coming to earth we find her here too, shining in clear-ness through the clearest aperture of sense ... But this is the privilege of beauty, that being the loveliest she is also the most palpable to sight.'

The beauty of colour is an intricate play of presence and absence. As we have seen, a colour is never alone, for each reflected colour arises through the interplay of other hidden colours which we do not see. After the perished paleness of winter, the sight of a field of new spring grass is pleasing in its hope and urgency. Yet such a field of breathing greenness is the achievement of chlorophyll, which has breathed in the red and blue of the sunlight to reflect and release green. Colour is always a dance where the vital partners are in-visible. Indeed one could legitimately speak of the music of colour. A soprano can break a wine glass if her note happens to hit the natural vibrational note of the glass and, in a sense, this is the way that colour too is released. When a ray of light hits the natural vibrational note of an object, it alters the vibration; it becomes absorbed itself in this alteration and what is reflected outwards is the object's colour. The Impressionist movement, for instance, was totally immersed in the attempt to capture these vibrations of colour.

From another perspective, we could say that the colour we perceive is the remains of the other colours which have been absorbed. The colour that gleams towards us lives from its invisible ghosts, the colours buried deep in the seen object. When we behold the magnificent and vanishing raiment of autumn colour, we are seeing a double valediction, the inner leave-taking of the hidden companion colours without which the outer autumn colours could never have attained visibility. Language is weak in bringing the visual to expression. The French philosopher Derrida said that colour has not yet been named. All colour has its origin in the brightness of white.

WHITE: WOMB OF COLOUR

For Lima has taken the white veil . . . this whiteness keeps her
ruins for ever new.
HERMAN MELVILLE, *Moby Dick*

EACH COLOUR EVOKES ITS OWN WORLD OF FEELING AND
association. White is associated with purity and innocence. Snow
turns the earth white in a wondrous transformation. Snow does
what the night does: it absolves the world of colour. Whereas the
night gives black absolution, the snow gives white absolution.
The totality and certainty of white in a landscape under snow must
cause the night some unease!

Several years ago in Cape Town, a friend and I had the oppor-
tunity of visiting Robben Island, the prison where Nelson Mandela
and his friends were incarcerated for twenty-eight years. We also
visited the lime mines on the island where they slaved by day.
Imagine the searing exposure of their skin to the relentless bite of
the lime. When the fierce African sun turned the lime into blinding
whiteness, how their eyesight was tormented and seared. One ex-
prisoner, now a tour guide, told us that after the long working day
– the lime on their skin, the salt of their sweat and the salt of their
tears – they were often forced to have hot showers in salt water. It
must have seemed to them that not only their white oppressors but
the very whiteness of nature itself was rising up against their colour.

In the Native American tradition a whole new era of trans-
figuration is initiated by the birth of the sacred white buffalo calf.
Within the Christian tradition, the new time was to begin with the
lamb: 'And behold the lion shall lie down with the lamb . . . And
there shall be no more hurt or pain on all my holy mountain.' One
of the most exhilarating epiphanies in the New Testament is the
Transfiguration of Jesus on Mount Tabor. In this moment, the
poet-carpenter let 'his glory be seen'. This is an event of the most
radiant, blinding whiteness.

It is interesting that the Spirit of inspiration, renewal and trans-figuration, the Holy Spirit, is symbolized by a white dove. Peace and serenity too are symbolized by the dove. White is also the colour of surrender. Elementally, the poles where the earth ends are also white: the Arctic and the Antarctic. White is the colour of the ocean when she is restless or when she dances, her white foamy waves crashing to the shore.

The appearance and definition of white is made possible by the presence of darkness and perhaps the softest light that shines upon the earth is moonlight. The white light of the moon is infinitely gentle with the dark. It insists on no awakening or disturbance of colour except for the occasional illumination of a breaking wave. The moon guides the rhythm of the tides and the red rhythm of the blood. Held with such nobility in the dome of night, it offers an ever-ebbing journey of light. It wanes to a clean, vertical arch of light, almost a question mark high in the night. Then over the course of a month, its faith of light grows until it becomes a full circle of the most subtle illumination, at ease with the singularity of the dark but faithful to the courage of individual forms which it visits and holds in outline everywhere. The colour of moonlight against the black dome of night seems blue-white.

THE COLOUR WHITE AND THE BEAUTY OF THE UNFINISHED

WE INEVITABLY ASSOCIATE BEAUTY WITH PERFECTION. BUT THERE can also be great beauty in something that is imperfect and un-finished. One of the best examples of this is at the Metropolitan Museum in New York and is by the German painter Albrecht Dürer (1471–1528): a painting in oil on wood called *Salvator Mundi*. It is a powerful painting. When you enter the room, it immediately claims your eye. It depicts Christ, the 'Saviour of the World'. His

right hand is raised in blessing. The earth is represented by the globe he holds in his left hand. Christ is dressed in a beautiful rich blue alb, with a crimson cloak draped over his shoulders. His hair hangs down his shoulders in long, rich brown ringlets and his face is angled to the right. Dürer began this painting shortly before he departed for Italy in 1505 but he never finished it. Portions of the hands and the face of Christ are not painted. Dürer had however drawn in the features of the face and hands and these drawings are visible against the white panel. Against the deep, rich coloured background and drapery the unpainted face is a white illumination shining forth from the painting. We know that the uniqueness of Jesus is his essence: God in the form of a man. This unfinished painting achieves the happy accident of enabling the beauty and radiance of a divine face to shine from a human body.

BLACK: THE COLOUR OF THE DARK

The beauty of colour . . . derives from shape,
from the conquest of the darkness inherent in Matter,
by the pouring in of light, the unembodied . . .
PLOTINUS, *Enneads*

THROUGHOUT THE HISTORY OF COLOUR THERE HAS ALWAYS BEEN the suspicion that colours belonged only to the surface. Deep down everything was dark and black. Farm life seemed to confirm this. In spring the plough would turn a green field into a black one. Turned over, the green skin of grass revealed dark earth under-neath. Work on the bog brought further evidence of dark under-surfaces. Externally, the bog is the most sophisticated patch-work of subtle colours: saffron, purple, brown, white and green. Even in the midst of winter one can discover on the boggy black summit the most beautiful traces of burgundy. In springtime when

turf is cut the bog is laced with colours. The top scraw is cleaned off to isolate the layer of turf to be cut. The browner turf is on top. The deeper you cut, the darker the turf becomes until you finally reach the last layers of turf down on the stone. This turf comes out like large slabs of black butter. It is called *cloch mhoin*, literally, stone turf. When it dries, this is always the hardest turf. Cutting down is a journey into the black archive of the bog's memory. The blackest turf belongs to the oldest time; on a cold winter's night, by the open fire, the blackest turf burns longest and gives the brightest flame.

Our ancestors were persistent voyagers in the dark. Without the benefit of artificial light, their day was lived between dawn and dusk. Their homes were caves – the dark mouths that nature had cut into the sides of hills, cliffs or mountains. Even during daylight it remained dark in there. Now and again, they must have longed to bring in some of the outside colour to adorn their caves. Imagine a mother gathering a bunch of the most beautiful wild flowers in blues, purples, yellows and whites, and placing them on some altar within the cave's darkness. Imagine her seeing her dark home brightening with brief colour. Dwelling constantly in such a world of darkness, it is no wonder that sun and moon in their bright journeying would appear to be deities.

THE SHADOW BETWEEN THE LIGHT

BLACK IS PROBABLY THE MOST ANCIENT COLOUR, THE PRIMAL birth-source whence everything emerged. Darkness is the great canvas against which beauty becomes visible. Darkness withholds presence; it resists the beam of eye-light and deepens the mystery. The slightest flicker of bright wings can make the darkness of a night unforgettable. It is fascinating to consider that ancient kinship of light and dark, white and black. White light always shapes the darkest shadow. Indeed the shadow is the child of the

threshold where black and white converge. There could be no shadow without light. A shadow is a dark figure cast on some surface by a body which stands in the way of light and takes the form of the intruding body. It is the counterpart of that body in black form. The Swiss psychiatrist Carl Jung seizes upon this image for his theory of the shadow as the dark aspect of the self. The conscious self usually rejects the shadow and it is forced to dwell in the unconscious. The shadow originates in all the negative experiences a person has accumulated, and part of the task of becoming free is the retrieval of the banished shadow. There are many difficult riches trapped in the shadow side. Jung said the shadow held 90 per cent gold. To learn to recognize, accept and integrate the shadow is to transfigure much of the bruised areas of the heart which dwell in fear and unease and rob us of joy and creativity. For instance, an incredibly nice, smiling person who is doomed to please people often has a shadow side where anger and disdain are nested. Often the outside clown is internally sad and despairing. An abrasive, awkward presence can sometimes conceal the kindest heart. When we meet someone, we never know who we are actually meeting.

There are two words in Irish for shadow: *scáth* and *scáil*. *Scáth* includes the positive meaning of shelter. There is an old proverb: 'Is ar scáth a chéile a mhaireann na daoine', i.e., People live in one another's shadow. This proverb suggests the intimacy of Celtic folk culture as a cohesive web which protects individuality in its shelter. The phrase *gan scáth* was also used (literally, 'without shadow') and it signified one who is fearless. Interestingly, *scáil* also means spirit, which together with soul and body makes up the threefold division of the person. And there is a wonderful poetic phrase for a very thin person: *mar scáil i mbuidéal*, like a shadow in a bottle. There is a poetic import to the phrase 'without a shadow of a doubt': in all probability, there is no doubt without a shadow. Doubt is the shadow cast when something gets in the way of the light. Ironically, doubt itself often brings greater light because of the shadow it casts.

In Sonnet 27 Shakespeare has this lovely quatrain:

> Save that my soul's imaginary sight
> Presents thy shadow to my sightless view,
> Which like a jewel (hung in ghastly night),
> Makes black night beauteous, and her old face new.

THE SECRET LIFE OF BLACK

IN TERMS OF PHYSICS, BLACK OCCURS WHEN AN OBJECT IS absorbing all of the coloured wavelengths. This is why nothing is reflected back. Black represents pure hunger for colour; it exercises no generosity, the eye receives nothing. When it looks at black, it is looking at the grave of colour. It is not surprising that black has been the colour of grief and mourning. In Western tradition, the priest wears black vestments when celebrating the funeral liturgy. The mourners wore black. When the husband died, for a period the woman wore widow's weeds.

Goethe says that colours are the deeds and sufferings of light.

Yet it is not that black is without colour; it is rather that it is the absence, the outer surface, behind which colours secretly dwell. The heart of blackness is full of colour. The outer absence veils a rich interiority of presence. This casts an almost comic ambivalence on the wearing of black as a symbol of the ascetic.

Black is also the colour of ink. Books are printed in black ink. There is again some irony here: the most colourful worlds, characters and adventures live inside lines of black narrative. In contrast to prose, a poem leaves more room on the page for the white silence and space to intensify the black lines where the music is distilled. Indeed, in a world where colour is often garish, the

simple clarity of black and white maintains a lovely dignity. This is especially true of photography. Fergus Bourke's stunning black and white photographs of Conamara succeed in bringing out the unwatched stillness of this landscape. He looks carefully and waits for the days when Conamara unexpectedly reveals itself. He manages to delve deeper beneath the deft weave of colour until he can glimpse and catch in black and white the hidden liturgy of primal forms that shape this place. In film too, black and white can be hugely effective. Andrei Tarkovsky's early film *Andrei Rublev* is magnificently constructed in a black and white sequence which schools the eyes in shadow and light all the way through until they become drenched in the glory of its final epiphany. Black has also been a dominant colour in spirituality. As we saw earlier, the mystics speak of the Dark Night of the Soul. Meister Eckhart said: 'The Light that is God flows out and darkens every light.'

THE COLOUR OF THE DARK

IN THE LAST MONTHS OF HIS TURBULENT LIFE, CARAVAGGIO (1571–1610) completed his extraordinary dark painting, *The Denial of Peter*. It depicts Peter before a fireplace in the courtyard of the High Priest where one of the women is accusing Peter of being a follower of Christ. Two soldiers are also pointing their fingers at him and Peter is denying the three accusations. This canvas is so dark; it has none of the beauty or the softness that colour brings. It is a black painting of relentless and bleak psychological portraiture. The figures are shrouded in black and dark brown earth colours. The only light is meagre and illuminates the faces of the accusers and the startled, helpless eyes of the old, bald Peter, the betrayer. His finger points at himself. He knows what he is doing. His brow is furrowed and his eyes are wet with tears. His presence is not

fearful but limp with resignation and shame; this contrasts with the alertness and vigour of his accusers. The betrayal of a friend, of a loved one, is an undignified, demeaning thing. Caravaggio's powerful portraiture draws out the irreversible awfulness of the deed as the light of kindness and belonging fades in the encircling gloom. This is an incredible portrait of a moment when weakness killed beauty. This darkening gloom seems forever beyond the dream of dawn.

THE PASSION OF RED

THE NIGHT BREAKS WHEN THE RED FIRE OF DAWN IS KINDLED and the world glows again in the beauty of colour. Of all colours, red is perhaps the most passionate and intense. Red is never neutral. When red is present, something is happening: red is for danger. It is not a colour that dwells in some secure middle region where rest and stillness prevail. Red is a threshold colour; it tends to accompany and intensify beginnings and endings. Red is also the colour of birth and is probably the colour in which the universe was born. It is believed that the Big Bang was the primal red explosion out of which the cosmos emerged. Our earth was born in a red fire. Despite its solid outer surface, the heart of the earth is a wild fire-dance of red magma. When a volcano erupts we begin to understand that ground is only vaguely solid. The torrential red rivers that flow from a volcano reveal what a tenuous foundation ground is. Underneath the surface of the land and beneath the floor of the oceans, there is no solid stone-like foundation. The earth is grounded on a primordial red ocean. If it was red at the origin and is red at the root, it is somehow natural that the intense threshold experiences of life are often accompanied by the colour red.

Each colour has its own scale of brightness and red has many hues that range from dark crimson to faint orange. It has such force

and vibrancy because it is the colour of life. Blood is the fluent stream that keeps the body alive, forever flowing out from and flowing back into the red well of the heart. Blood is also our most ancient stream. The secrets of ancestry, the blueprints for future descendants, sleep within this flow. It is a surprising image: within the permanent darkness of your body a ceaseless red-bush streaming. Like a mild bellows in the dark, breath deepens the life of the red: black and red are the primary colours at the heart of identity.

In the outer world too, these colours were often wed to evoke or confirm primal kinship. One thinks of wars and killings. Every event happens in time, and time moves on. Time erases even the most vibrant events. But place is somehow different. An experience never simply happens *in* a place: regardless of how hidden or internal an experience between people might be, it does not remain sealed between them, it leaks out and happens *to* the place as well. Landscape absorbs experience. There has always been the recognition that the earth holds a particularly intense memory in those places where blood was spilt. It is interesting that the colour red as such is rarely present in the land, yet primitive peoples may have imagined that the very earth itself calls out for revenge against the evil ones who spilled human blood. There is a mythic sense here that the flow of human blood can render a place disturbed – not merely some human frontier but a natural boundary has been violated: earth and blood should not be mixed. Traces of human biography seep in to disturb the pre-conscious stillness of the earth. It seems that when spilt on earth human blood leaves an indelible stain. The red tears of human blood disturb the innocence of the earth; through the blood, thoughts seep inside the clay to perhaps infest its stillness with the virus of narrative.

The letting of blood is one of the oldest ritual expressions of entering into a new bond. Blood brothers do it – so do the Mafia. When two people have a child together, the child is of them: their own flesh and blood. In the new child, the two red streams of ancestry flow further and forth into each other.

Few colours are as freighted with symbolic significance as red. In a girl's life, the arrival of the red flow signifies the transition to womanhood. She becomes a daughter of the moon, kin to its rhythm of red tide. In the life of a revolutionary movement the ultimate sacrifice for the fatherland is often seen as the willingness to spill one's blood.

THE ULTIMATE GIFT IS RED

IN RELIGION RED IS A VITAL COLOUR. ONE OF THE CENTRAL ICONS of the Catholic Church is the Sacred Heart. This is a picture of Jesus with the red heart exposed and framed in thorns; it is portraiture of love as sacrifice. At the heart of Christianity the colour is red. The pinnacle of love is realized in the spilling of the blood of Jesus. In the Eucharist, bread and wine become the body and blood of Christ. The ultimate gift is a red gift. Kinship with Jesus is not achieved merely through sentiment, idea or faith but in the visceral act of eating his body and drinking his blood: filling oneself with the redness of Jesus. It is no wonder that red was the primary colour in medieval art and chemistry. After Pentecost Sunday the priest wears red vestments at mass. Here red symbolizes the flame of new courage and transfiguration which the Holy Spirit brings. One of the most beautiful religious uses of red is the red of the sanctuary lamp. It is lovely at night to enter a dark oratory and find that lamp aglow, a red womb-light that invites you to kneel in reverence before the Presence of Presences.

Before electricity came to rural areas, the candle and the oil lamp were the means of light. These lights left the room still pre-dominantly wrapped in shadow. Such shadow provided the ideal darkening to bring out the red mysteries of the open fire. The fire was wonderful to watch. People who lived on their own would say: the fire is company. The fire was a happening, a narrative that

began as a spark within a cold mound of darkness. Then it built and bloomed until each sod of dead turf became fluent and the whole fire was entwined in the dance. The sounds crackled and deepened and fell gradually into white, silent ashes.

PAINTING IT RED

MY FAVOURITE PAINTING IN RED IS *LA COIFFURE* BY EDGAR DEGAS at the National Gallery in London. It is a painting of an older woman combing a girl's hair. Her head extends over the back of the chair and the woman combs her red hair out into the same red background of the canvas. The older woman is wearing a white apron and a cerise blouse. The girl wears an orange-red dress and there is a white table angled at the front of the painting. Matisse owned and loved this painting. In some strange way you are made to feel as if the orange redness of the scene is being combed from the young woman, out through her hair. Her fiery red interiority is being combed out. And although a vibrant red/orange takes over almost the entire canvas, there remains a profound serenity at the heart of this painting.

THE DELIGHTS OF YELLOW

Imagine someone pointing to a place in the iris of a Rembrandt eye and saying: 'The walls in my room should be painted this colour'.
WITTGENSTEIN

A YELLOW FIRE BURNS ETERNALLY, AWAY OUT IN THE INFINITE distance of the cosmos. All colour, light and earthly life depend on

that yellow furnace. Without our knowing it, distance, as always, is one of our great protectors. Were we nearer to the yellow fire-source, it would scorch everything to cinders. Conversely, were this sun-fire to slip down into a crevice in the pattern that holds its face towards us, the earth would freeze over and all life would disappear. The colour yellow holds such warmth, brightness and attraction for us because it is the colour of the source that sustains us. A room that is yellow can throw a glad brightness back into the space it surrounds. Put some pinks, reds and burnt umber in there and it almost feels as though you are nestled within a honeycomb!

Goethe says: 'Yellow brings with her the nature of brightness and has a delightful, encouraging, exciting and soft quality.' We see this in spring with the daffodils. Wordsworth catches the surprise of their yellow apparition. But it is also a moment of beauty which remains ever present in his memory and makes solitude sweet:

> For oft, when on my couch I lie
> In vacant or in pensive mood
> They flash upon that inward eye
> Which is the bliss of solitude.

The Fields of Saffron

THE LIGHT IN CONAMARA IS ALWAYS COMPLEX. HOWEVER, LATE autumn, early winter brings a new colour surprise. From being pale and slightly forlorn, the bog grass begins to deepen into the richest saffron and is gilded with yellow and orange. Against the cold, black winter mountains these newly arrived fields stand out and when the rain ceases and sunlight returns, the saffron fields take flame. The landscapes illuminate as if lit from underneath and the mountains stand dark among fields of blazing saffron. It is as though the rain had cleansed and polished the grass in order for the

sun to effect absolute illumination. This miracle of illumination is recognized in the local phrase: *buíochas dhon Fhómhair* – Thanks to the autumn.

Years ago almost every family home in Ireland had its altar of holy pictures. In these pictures the heads of the saints were rimmed with yellow haloes. Because they were saints, the invisible world was already brightening towards visibility around them. The haloes were not attached to the heads; some secret firmness in the air seemed to keep them in place. In the Christian religious tradition, the glory of God has always been imagined in terms of light and this glory is the name of ultimate divine beauty. All light is then a manifestation of divine beauty.

As we have seen, in terms of its physics, yellow has absorbed red and green and then reflects yellow back. Red is the colour of life, blood and fire; and green is the colour of growth and of hope. Little wonder that yellow has such a life-giving brightness.

An Autumn Field of Corn

THOUGH FARM WORK IS HARD, THERE ARE CERTAIN TIMES IN EACH season when the work becomes beautiful and the farmer becomes an artist who transforms the landscape. In autumn the corn is ripe and there is a special threshold when the pale yellow turns golden. Farmers watch for this turning; for this is the time to cut the corn. Cutting corn with a scythe is hard, but also beautifully rhythmic work. When your eye develops, you know exactly the measure of corn to choose, then in one clear curved swing of the scythe, you have an exact sheaf. It is the one kind of farm work where there is such an intricate strange combination: surface gold where the ripe ears of corn become enriched with light, but beneath the ears the Kafkaesque grid of endless linearity and then at the end, the fallen field of gold with its new surface of sharp, cut-off stems. Late at

evening a field of stooks stands against the light and the golden stubble is apostrophized with the black crows and ravens who have watched and waited all day for the time of feasting to come.

The flame of a candle is a beautiful yellow. But it is a yellow that carries its own shadow and below both of them is the concealed red tip of the burning wick.

Lemons wear lovely yellow over their sour well of juice.

Children are fascinated by colour. A new gift with gorgeous colour can absolutely enthral a child's mind. They will want to show everyone the beauty of their new gift. Their innocent wonder is eager to share its delight and seek confirmation, especially from an adult. The loneliest representation of such a moment I have seen was in a photograph in an exhibition of photographs from a Jewish ghetto during the Holocaust. A young child, his face full of excitement, is pointing to his sweater to show his new yellow star to a Nazi soldier.

In 1215 Pope Innocent III had declared that male and female Jews should wear yellow badges.

WILD DELIGHT IN YELLOW

I went and sat in front of Turner for hours and I realized
something profound – that the vanishing point in the work
does not vanish so that you have the feeling that love, truth and
beauty go on forever.

CATHERINE CLANCY, sculptor and painter

ONE OF THE BRIGHTEST ROOMS IN ANY MUSEUM MUST SURELY BE the Clore Gallery at Tate Britain which houses the paintings of Turner. His paintings are veritable explosions of light. They are

canvases pulsing with energy made visible. Turner loved to paint the ocean and often bathed it in a beautiful urgency of sunlight. Turner's yellows are rich, luminous and passionate. With him you often feel as though colour is the mother of essence, the source out of which the object grows and emerges. *The Harbour of Brest* (1826–8) depicts the harbour suffused in light. Sometimes in a scene the objects and the material world become faint as light drenches everything. You feel many of his scenes are barely held to that moment. They are poised on a precarious threshold between emerging and receding light. Turner manages to turn the magnificent moment of radiance into a still, other moment where all could empty and vanish. He is the master of iridescence and evanescence; yet, ironically, the pigments in his paintings are incredibly delicate and beautiful. In Patrick Heron's phrase: 'Colour is shape and shape is colour. Form exists but colour is there first.' Turner's palette is often subdued too, as in *Waves breaking against the Wind*. This painting portrays an anonymous seascape, yet his genius renders the motion of the sea and the spray of the wind as an intimate event and place. The colours are toned to make sea and wind particular and personal. He uses greys, whites and ochre work against a faint yellow sky.

Once in Mexico I went out fishing before dawn with a local fisherman. When we were well out into the ocean the dawn came up with all the beauty of a Turner painting. The horizon became one huge refined yellow and orange apocalypse. It was like a divine salute to all the submerged dreaming of the ocean.

GREEN: THE COLOUR OF GROWTH

WHILE YELLOW REVEALS THE OUTER JOY AND KINDNESS OF LIGHT, the workings of light have entered more deeply into the colour green. Green is the colour of growth, the colour of hope. As winter

begins to relent, the first green buds appear. Against the bare barks of tree and bush they seem out of place, some kind of mistake. Yet these infant spots of green secretly hold all the fabulous dressage of the spring, summer and autumn colour yet to appear.

One of my favourite images from childhood is of summer meadows. After the hay was cut, the shorn white meadows would quickly recover and a few weeks later these meadows would be clumped with fresh, new after-grass. Often, then, the sheep would be let in to graze there. When you opened the gate, you could almost feel the meadow breathing. It was absolutely carpeted with grass. The colour of this grass was so rich as to seem blue-green. The sheep needed neither introduction nor persuasion; they simply gave in and became instant addicts!

Green is the colour of youthfulness; it is full of spring energy. It is the colour of the earth aflourish. Green is not static but full of the energy and direction of growth, urgent on its journey towards the light. Gravity cannot keep it down; the call of light is always stronger. Green is the colour of relentless desire. Even from under earth smothered over with concrete or tarmacadam, the green blade will rise. Nothing can keep grass down. Its desire endures, holding itself focused to enter the most minuscule crevice and begin its soft climb to the high light. You can find the green blade any-where – on top of ancient ruins way above the ground or growing in little indentations on top of massive rocks. It rests the eye, and still remains the colour of the day's desire. You will find little or no green in the sky! Only in writing this did I become aware that my eyes had always known this but my mind had not yet realized it.

Because we tend to place ourselves at the centre of the spaces we occupy, we inevitably view these spaces in terms of how they house us. We rarely consider them in relation to how they might feel as a shape of embrace or confinement. Imagine what a trauma it must be for a room when the colour of its paint is changed. Imagine how a room that has lived as soft yellow for years feels behind a new countenance of green!! Still more disturbing, consider how a colour

can become a distilled memory image. The Irish famine was one of the most brutal and dark times in our history. My father often spoke of hearing his grandfather coming in and telling of finding a man dead on our mountains and how his lips were green. The hunger had driven him to eat grass.

BLUE: THE COLOUR OF FARAWAY

What advantage would someone have over me who knew a
direct path from blue to yellow?

WITTGENSTEIN

DISTANCE AND LIGHT OFTEN CONSPIRE TO CREATE UNEXPECTED beauty. On certain summer days the dark mountains here in Conamara become suffused with delicate blue fog. In the distance the mountains lose their coarse eroded aspect and assume the dream of being shrouded in delicate muslin of blue. There is nothing else left but blue. Distance loves blue. More often than not distance will choose to express its faraway-ness in blue. Somehow it feels appropriate that distance and loss have the same colour and the colour of such sorrow is blue. This conviction is at the heart of the haunting music we call 'The Blues'. When someone says or sings 'I have the blues', the tonality enfolds us. There are certain valleys in the interior worlds that seem to be totally blue. The blue suggested by the blues has a dignity and completion to it. The blues may wail but ultimately they are not narcissistic or sycophantic. There is recognition of a higher order, that sooner or later destiny may play everyone a blue card. The phrase 'I have the blues' seems to cohere with the tonality of such destiny and experience. It is impossible to feel the same gravitas if another colour is used: I've got the whites or I've got the yellows does not evoke the elegant darkness that blue conveys.

Red was the dominant colour of ancient civilization until the high Middle Ages. During all this time there was practically no attention to blue. Yet in the late Middle Ages blue took the place of red as the West's favourite colour. Then for more than three centuries, from the fourteenth to the seventeenth century, blue became dominant. It was the colour reserved for Mary, Mother of God and for royalty. In the eighteenth century the use of indigo and the discovery of Prussian blue ended the reign of blue.

NIGHT AND DAY ARE INSIDE BLUE

YET BLUE IS A STRANGE COLOUR. IT HOLDS NIGHT AND DAY WITHIN it. Though the land is mostly without blue, this makes clearance to intensify the blue of sky and water. The earth could have no more perfect covering than the sky. Earth and sky complement and counterpoint each other so perfectly because each is invested with the predominantly absent colour of the other. The earth is green, the sky has no green. The sky is blue, the earth has no blue. The ocean is the great mirror of the sky. It holds its own reserve of transparent mystery under its blue surface. Goethe says that rather than coming at us or hemming us in, blue draws us after it into the distance. Blue seems to be the colour of the infinite – an endless expanse where darkness and brightness dwell in blue light.

OUT OF THE BLUE

BLUE OFTEN SEEMS TO STAND AT A MYSTERIOUS ANGLE TO HUMAN sensibility and intention. When something absolutely unexpected visits our lives, we say: it came out of the blue. Of the unexpected that in all probability will never occur, or at most happen rarely, we have the phrase: once in a blue moon. These unnoticed phrases in

our language confirm blue as the indecipherable source from where the unexpected sets out towards us. All the while we continue with our lives never suspecting that we have become its destination and target. Great rituals are meant to harness and bless the unexpected. Perhaps this is why blue appears as desirable for a bride. For her wedding, it is recommended that she have:

> Something old,
> Something new,
> Something borrowed,
> Something blue.

When we quarried limestone, it was surprising to find deep beneath the white-grey surface a richer colour. When we broke into the deeper layering and the caked stone fell out, we noticed that the interior of the limestone was a rich blue. This blue depth of limestone was often counterpointed by white knuckles of fossil nesting within it. The most beautiful blue stone of all is of course lapis lazuli.

The other blue of childhood was bluestone. In summer the green potato stalks were sprayed with bluestone to prevent blight. We had to fill a large barrel of water and then the powdered bluestone was suspended in the water in a canvas bag. For some days afterwards the potato stalks looked as if they had been caught out in a blue rain.

COLOUR THRESHOLDS

The line changes the colour of the colours on either side of it.
PATRICK HERON

A colour *shines* in its surroundings. (Just as eyes only smile in a face.)
WITTGENSTEIN

OUR EXPLORATION OF COLOUR HAS CONCENTRATED ON CERTAIN distinctive colours but every colour tends to change in the vicinity of other colours.

Colour is the clothing of beauty. No colour stands alone. Each single colour emerges in a dance where its other sustaining partners are invisible. Colour is always a togetherness that remains kinetic, a brightening or darkening. Yet each colour has its own individuality, personality and native mood. The divine artistry of nature is seen in how lyrically it combines and modulates its raiment of colours. Natural beauty is not accidental. There is a wondrous elegance and grace of imagination behind it. An artist who takes her easel outside to paint the most ordinary corner of a field learns quietly the intricacy, elegance and majesty of what is hidden in the ordinary. Colour has bequeathed her deepest secrets to nature.

Within even one, single colour there is a fluent geography of tone: at one end the colour belongs more to the darkness, at the other end more to the light. Each colour is its own spectrum. Within itself and together with other colours each colour remains fluent in that perennial yet elusive dance of hue.

Vasili Kandinsky, the Russian painter, often said that when he saw colour, he heard music: 'Colour is the keyboard, the eyes are the harmonies, the soul is the piano with many strings. The artist is the hand that plays, touching one key or another to cause vibrations in the soul.'

Paul Klee said: 'Colour links us with cosmic regions. In this it is similar to music. Colour can take on, in the same manner as musical tones, myriad possible shades from the first small steps to the rich flowering of the coloured chord.'

We will conclude our exploration with a pen sketch of a master colourist, Vermeer: his use of light and subtlety of tone evoke the inner nuance and sophistication of colour.

VERMEER:
DELICATE MYSTERIES IN EXQUISITE STILLNESS

THE FRICK MUSEUM IN NEW YORK IS ONE OF THE MOST BEAUTIFUL museums in the world. You can literally walk in, out of the noise and maze of Manhattan streets, to find yourself in another era, in a mansion with some of the world's most magnificent paintings. Among the Frick collection are several masterpieces by Vermeer.

Vermeer was a seventeenth-century Dutch painter from Delft. His subjects have little to do with heroic action or epic themes. Indeed, they have nothing to do with action at all. Yet this artist has created works of immense beauty, choosing incidental moments in the ordinary life of unknown people. His imagination and skill create scenes imbued with qualities evoking great drama that remain understated yet charged with subtle force. Vermeer's paintings are real presences. His most famous is probably *Girl with a Pearl Earring*. This has been called 'The Dutch Mona Lisa'. It is a painting of a young girl against a black background. She has just turned her head to look at us. Vermeer catches her in this pure moment of unguarded attention. She is wearing a blue turban. Her mouth is open and its corners seem moist. She seems utterly pure and fresh and she has a clear innocence. Yet her eyes are dark, uncertain and questioning. Though imprecise, the pearl earring glows against the dark. The darkness outlines her, as if for a moment it had just released her. But its shadows still claim her back, her neck and much of her face. The light blue of the turban is unexpected but perfect. It crowns her presence beautifully. This blue is more radiant still because part of it is caught in dark shadow. The arc of the turban that is illuminated seems almost like a halo, an arc of sky-blue over this young soul caught between darknesses. That stillness of blue seems to know more already than her life-voyage will ever discover. Vermeer achieves the portrait of innocence caught in a moment of questioning wonder, a bright moment hung perfectly from the dark.

Vermeer's paintings are visual poems. On a small canvas he can evoke the inner world latent in a suspended moment. He manages to slow time down until transparent stillness envelops the scene. In that stillness the multiple futures of the scene are caught in the glimmer of their as yet unchosen possibility. The colours are always subtle and the composition is simply exquisite. You forget that you are looking at a flat surface and that a painting is merely an illusion made with paint. Vermeer brings you right up close and allows you to peer into a scene that has the visual integrity of reality. The scene is utterly ordinary. And it is the delicate creation of this deceptive ordinariness that is one of his greatest achievements. It seems to be completely natural. The figures seem so securely there. It is as though we are permitted to lift a veil and glance in at lives that exist without us. Each scene is unforced. Vermeer invests them with a tranquillity which invites and confirms our instinctive trust. Someone once said that the introversion of Bach's music echoes the introversion of Vermeer's paintings and their ineffable visual music.

Vermeer is the master in evoking interior spaces. In *The Soldier with a Laughing Girl*, a soldier with his back to us is seated at a table with a girl who faces him and us. From an open window light comes in. Vermeer achieves great depth through the technique of single point perspective. He makes the Cavalier's figure larger so that the girl becomes more diminutive and thus seems further away from us. The officer has a long red coat which is radiant in the light. His huge hat with its shadow almost completely hides his face from us. The girl's face and upper body take the brunt of the light. Her mouth is open, her face is intent and interested, her head is covered with a white scarf. The light through the window is what confers reality on the scene. The exquisite modulation of the light evokes the mood and the depth of the skin tone. The transmutation of light is the key to Vermeer. The quality of the light is the signature of the drama. The slow, attentive light fills the space between the two figures and sustains their gazing, yet it leaves the

surround of their figures and the rest of the scene suffused with shadow. Light precedes object in Vermeer; it is as though it is the light itself that is imagining the scene within the painting. This patient light evokes the invisible interiors concealed in the minds and hearts of the Cavalier and the girl. It bestows a remarkable calm on what is most probably a seduction scene. There is dignity, longing and the sustained Eros of approach and approaching delight. Through the careful delicacy of composition and the immaculate restraint of mood, Vermeer is almost able to render the introverted world explicit. He holds the tension of that threshold between image and silence in perfect balance.

Vermeer's work attracts us because we feel drawn into the point of the intimacy where an event is secretly building towards its own definition or disclosure. His contemplative attention is able to imagine and compose a scene which becomes cumulatively deeper, the deeper you gaze into it. These are scenes of carefully selected and distilled presence. Vermeer is a master at suggesting the quiet depths that dwell behind appearance. He evokes them as they are about to stir towards the surface. The masterly stillness is achieved through his uncanny ability to render such depths of emotion with refined transparency. His simplicity is mystery rendered lyrical. In a loud and garish neon time, the quietude of his work draws our eyes into a subtle rhythm of gazing where we might come to glimpse the structures of quiet depths. His reticence is more vocal than any statement or description. Each scene is created with a grace of proportion and sureness of measure. We are shown just enough to imagine everything else. In Vermeer all the secrets are held inside the weight of stillness.

5

The Joy of Shapes That Dance

> Sound and gesture are contemporary, identical and
> indistinguishable ... Linked to its own past, the gesture fills up
> with music and becomes rounded, like the universe ... The
> beauty of gesture renders time visible.
>
> CATHERINE DAVID

STILLNESS IS THE CANVAS AGAINST WHICH MOVEMENT CAN
become beautiful. We can only appreciate movement against the
background of stillness. Were everything kinetic, we could not
know what movement is. As sound is sistered to silence, movement
is sistered to stillness.

BREAKING STILLNESS:
THE RIVER AS IDEAL SEQUENCE

IT IS LOVELY TO SIT ON THE RIM OF A RISING VALLEY AND WATCH
along its depth-line the grace of a river's journey. The long flow of

its water traverses each field at the same time but with an ever new continuity. The river unfolds equally all along the one line of its one journey. From source to sea it is one flow; nowhere does it pile up. Nowhere does the water break to leave an empty space. From source to sea, it is one unbroken song of flow – ever changing yet always one. The grace of a river is a reminder of how nature seeks elegance and achieves immense beauty of cohesion and balance. A river blends music of movement with an enduring and accompanying depth of stillness. Again its journey is always out of silence, and this silence dwells deep in the river too. If only our lives could achieve, or indeed allow, such grace and elegance. If we could but find a rhythm of being which could balance a contemplative grace, a poetry of motion and an accompanying stillness and silence, our pilgrimage through this world would flow in beauty through the most ragged and forsaken heartlands of confusion and dishevelment. It would continue to hold a clear flow-line between the memory and depth of the earth and the eternal fluency of the ocean and never lose the passion of flowing towards the ever new promise of the future.

A river somehow illuminates the beauty of time. In a river, past, present and future coalesce in the one passionate flowing. A river is continuous flow of future. Though it flows through landscape, it never divides space into 'sooner' or 'later', 'before' or 'after'. The river is a miracle of presence. Each place it flows through is the place it is. The river holds its elegance regardless of the places it flows through. Though a river maintains a line of direction, it somehow turns still, fixed space into the embrace of a flowing circle of presence. It gives itself to the urgency of becoming but never at the cost of disowning its origin. It engages the world while belonging always secretly within its memory and still strives forward into the endless flow of emerging possibility. In the sublime and unnoticed artfulness of its presence, the wisdom of a river has much to teach us.

THE RESTLESS BEAUTY OF THE OCEAN

*I was born by the sea ... my first idea of movement of the dance,
certainly came from the rhythm of the waves ...*
ISADORA DUNCAN

THE WORDS 'SEA' AND 'OCEAN' ARE TOO SMALL TO IMAGE SUCH wild divinity. The ocean is beyond language. The flow of the ocean presents a most beautiful dance. She is eternally restless and delights the eye most with the structured rhythm of waves. The seashore is a fascinating threshold. With sublime elegance, the ocean approaches and embraces the landscape and each wave has a unique grace and rhythm. The grandeur of ocean movement is consistently enthralling yet there is consolation and consistency in the faithfulness of the ocean. Water stirs something very deep and ancient in the human heart. It satisfies us in a more intimate way than the other elements. Our eyes and hearts follow its rhythm as if the flow of water were the mirror where time becomes obliquely visible. The image of water can hold such longing. The faraway force of the moon that draws the tides to dance is a vivid metaphor for the passionate kinship of the elements that stirs across infinite distance.

The ocean often puts on a display of beauty that is charged with danger. When the ocean becomes angry the fury of its charge against the cliffs makes powerful drama. It fills the heart with awe and makes us understand how the ancient Greeks could believe that the ocean was the God Poseidon. To watch the Atlantic pummel into the cliffs at Dun Aonghusa on the Aran Islands is incredibly exciting. Within a wave, tons of water blast into the cliff and rise into the sky in white fury as though some caged force has broken free in the depths and wants revenge on the silence and impassive stillness of the watching island. Yet, even in its wildest passion, the ocean still holds dignity; it builds in every form of wave. The ocean surface is incessantly restless with every

conceivable crest and blister of water. Yet the ocean maintains poise. However and wherever it throws itself, it never falls outside of itself. It can spread and scatter every which way, yet it is always held within the shelter of the one rhythm.

Unlike the land, which is fixed in one place, the sea manifests freedom: she is the primal dance, a dance that has always moved to its own music. The wild divinity of the ocean infuses the shore with ancient sound. Who can tell what secrets she searches from the shoreline? What news she whispers to the shore in the gossip of urgent wavelets? This is a primal conversation. The place where absolute change rushes against still permanence, where the urgency of Becoming confronts the stillness of Being, where restless desire meets the silence and serenity of stone. Beyond human seeing and knowing, the meeting of ocean and shoreline must be one of the places where the earth almost breaks through to word.

The ocean remains faithful to the land, it always returns. As Keats wrote: 'It keeps eternal Whisperings around/ Desolate shores . . .' When the tide goes out, the seashore is exposed, its eroded stone pockmarked and chewed by tide. Between tides this line of fragmented shore seems vulnerable as though exposed in an arrested posture from which it cannot stir. It is reminiscent of edge-lines in your life where fluency abandons you. In such times of emotional devastation, the woundedness and fragmentation stand out, naked and exposed. The natural ease of rhythm seizes up. Each gesture, thought and action has to be deliberately willed. Everything becomes extremely difficult. What you would have accomplished without the slightest thought now becomes an action that seems impossible. Yet hope whispers that the tide always returns. Transfiguration graces you gradually. You stood exposed and atrophied, unable to move in the grip of pain; even the ground was naked and broken beneath you. Now gradually fluency returns. You recover your spontaneity and new buoyancy raises you up and your heart is again relieved and glad as

when the ocean returns along the shoreline and everything becomes subsumed in the play and dance of young waves.

When I was studying in Germany, I missed the West of Ireland and especially the wild callings of the ocean. In Tübingen one felt in the centre of the European landmass. The ocean was so far away. Driving home after my first year, I was excited at the prospect of seeing the ocean again and when I finally reached Calais, there she was. Suddenly, tears overwhelmed me. I began to cry. I had absolutely no warning that this would happen but I began to realize how deeply I had missed the ocean. Without knowing it, my body had been lonely for the sound, the sight and the effervescence of the ocean. The Irish word for the ocean is feminine: *an Fharraige*. In the musical sequence of its syllables, you can almost hear the build-up of a wave, and then it disperses in the 'ge' like the fall-away of an outward breath.

THE WIND

MOVEMENT IS A SIGN OF LIFE. IT IS INTRIGUING THAT THE presence which has the most grace and swiftness cannot be seen, namely, the wind. In the Hebrew tradition the word for wind, *ruach,* was also the word used for 'God'. The wind has power and huge presence. It symbolizes pure freedom. In the New Testament in a conversation with Nicodemus, Jesus likens the way of the Holy Spirit to the rhythm and energy of the wind; it is presence as spontaneity:

> The wind blows wherever it pleases; you hear its sound, but you cannot tell where it comes from or where it is going. That is how it is with all who are born of the Spirit.
>
> JOHN 3: 8–9

To dwell in new spirit is to enter a complete spontaneity of direction; this is a voyage of trust imbued with passion – any destination is possible. In phrases like this we glimpse the wild heart of Jesus.

At times the wind has a haunting, poignant music. When it rises in the night and shores against the walls of the house, it sounds out a great loneliness. Perhaps the wind achieves poignancy because it has no name. It is nothing and from nowhere. Yet its cry is almost a voice and sounds as if the sorrow of stone and clay, of the dead or those seeking birth, has somehow become a force of emptiness. Their longing has transformed their nothingness into a cry. This atmosphere of wind has unreached realms of longing. It is a keening that no mind could ease. At other times the wind is utterly buoyant, rousing and refreshing. When you walk into that mood of wind, it cleanses your mind and invigorates your body. It feels as if the wind would love you to dance – let you surf its undulations and steal you away from the weight of your body, casting you hither and thither like the shimmer of dust. Such wind is wild with dream. One of the loveliest images of earthly movement is how a bird plays among the high geographies of wind-force, soaring, sliding and balancing on its invisible hills and waves. Before ever the human mind became fascinated with the rhythm, structure and meaning of movement, the birds knew how to enjoy and play within the temporary landscapes of the wind.

THE GRACE OF ANIMAL MOVEMENT

ANIMAL MOVEMENT CAN EXHIBIT WONDERFUL GRACE. ANIMALS have a native closeness to the earth and they move in the sure rhythm of this belonging. This shows the dignity of animals. They enjoy an inner composure and coherence. The serrated confusions of the human mind are not their burden. Animals have fluency of presence.

Cats are a joy to watch. They rarely walk without rhythm. They relate to space fluently and gracefully. A cat moves as if his body were not an object but an unfurling gesture. He inhabits a sureness that seems deft and weightless. And at times even the daintiest kitten can assume the regal aura of the tiger. The sense of movement is often more graceful and beautiful in the wild where animals have not been intruded upon, or forced into the brittle world of domestication.

WHEN WE FELL OUT OF ANIMAL PRESENCE WAS DANCE OUR FIRST LANGUAGE?

THE HUMAN ANIMAL MAKES THE MOST COMPLEX MOVEMENT. IN ITS every gesture the long, upright body of a person is weighted with consciousness. More often than not the inner gravity of thought is heavier than the gravity of the clay. Being invisible, thought does not take up space. Yet sometimes there is nothing as heavy as a thought. A deeply troubling and painful thought can load the body with the dead weight of a stone. The body is never merely an object among others. The indwelling of mind makes the body somehow luminous. The simplest body movement is always more than itself and it becomes the outer language of our hidden, inner world. It is quite astonishing how helplessly our bodies speak us out, how the language of the body bears the unique signature of our individual difference. Each of us moves so differently. We look differently and reach towards things distinctively.

I remember one evening outside a café in Paris on the corner of a busy street. Lines of people were walking by. There was a large crowd seated outside, people-watching. After a while a street artist began his act. He would go a little further up the street and walk behind somebody, perfectly imitating their physical gait and gesture as they walked past the crowd outside the café. It became a

wonderful street show. The victim never knew he was being imitated and when the crowd laughed, he would turn around to see what the cause was. His imitator was always quick enough to turn away. This only increased the drama. Usually the victim sensed it and found him out by the next movement. The comedy derived from the precision of the imitation. It was uncanny how quickly the street artist could decipher the distinguishing physical gait of the person he chose to follow and imitate it perfectly, inhabit it completely. This reminded me of the lovely phrase of welcome from the Aran Islands: 'Fáilte roimh thorann do chos, ní amháin thú fhéin': the sound of your footsteps is as welcome as yourself.

Because we carry the weight of the world in our hearts, we know how delightful it is to dance. In dance the human body reclaims childlikeness. When you can dance it is as though you do not have a care in the world. The body gives itself away playfully to the rhythm of the music; the burden of consciousness becomes suspended. For a while the innocence of the dance claims you completely as the mind relents and the body becomes its own celebration. Because the body dwells mainly in silence it loves to find expression in the language of dance. At the beginning, in that blurred time when we had fallen out of the seamlessness of animal presence, perhaps dance was our first language.

'How Can We Know the Dancer from the Dance?'

When you truly dance, you're finding what you never lost.
You can't just dance: the dance is given to you.
AFRICAN-AMERICAN DANCER

THOUGH ITS ORIGINS ARE COMPLEX AND SOMETIMES DARK, FOLK-dance is usually free and celebratory. It reflects the energy and

passion of a place and its people. In dance-theatre the choreography of figures can assume incredible shapes. It is a powerful form. One of the pioneers of contemporary dance is Pina Bausch. Her dances can turn movement into unforgettable narrative. She plays immaculately with space. In her dance, space emerges as a powerful presence, estranged, disturbing, welcoming, creative, shimmering with dream or engraved with memory. Her dance breaks the stillness as deftly as song breaks silence. Great dance is like fluent sculpture. The body arches itself around the emptiness to fashion a sequence of transient shapes that bring out the contemplative depth of sensuousness. Yeats offers a wonderful exploration of the dance–dancer unity at the end of his poem 'Among School Children':

> Labour is blossoming or dancing where
> The body is not bruised to pleasure soul,
> Nor beauty born out of its own despair,
> Nor blear-eyed wisdom out of midnight oil.
> O chestnut-tree, great-rooted blossomer,
> Are you the leaf, the blossom or the bole?
> O body swayed to music, O brightening glance,
> How can we know the dancer from the dance?

This final verse is a questioning vision which unifies the voices of despair and possibility, creativity and separation which inform the poem. Here at last is a vision of identity focused in the image of the chestnut tree anchored in the elemental clay yet swaying in the freed air. The 'brightening glance' can see that true creativity dwells in and emerges from that lyrical, elemental unity where deliberateness, force and separation are subsumed in the beauty of the dance. In the 'blossoming', dancer and dance are no longer separable. Memory and possibility dwell in the one fluency. Creativity is a dance where the flow of the eternal gleams through the brittleness of time and the distance of space.

In the West of Ireland one can still see *sean-nós* dancing. Though its form has its own rigour, this is wild, primal dancing; it is un-affected, without choreography or cosmetic. It is free dancing where the whole body moves to the desire of the music. The dancer dances as if he were obeying invisible figures. It is a dance un-predictable in its urgent vitality as though the music had slipped into the solar plexus of the dancer. The *sean-nós* dance is from within the music. The dancer allows the dance to take over his name and nature. He becomes the dance. It is actually a wonderful illustration of Yeats's line, for in this instance, it is impossible to tell the dancer from the dance.

'Our Steps . . . We Lose Them without a Thought'

Now I am going to reveal to you something which is very pure,
a totally white thought. It is always in my heart; it blooms at
each of my steps . . . The dance is love, it is only love, it alone,
and that is enough . . . I, then, it is amorously that I dance: to
poems, to music but now I would like to no longer dance to
anything but the rhythm of my soul.

Isadora Duncan

IN HIS DIALOGUE 'DANCE AND THE SOUL', THE FRENCH POET PAUL Valéry has written of the beauty of dance. He describes the thoughtlessness of our normal walking: 'Our steps are so easy and familiar to us that they never have the honour to be considered in themselves, and as strange acts . . . in the simplicity of our ignorance they lead as they know how; and according to the ground, the goal, the humour, the state of the man, or even the lighting of the way, they are what they are: we lose them without a thought.' He contrasts this with the way the dancer walks: 'A simple walk, the

simplest chain of steps! . . . It is as though she purchases space with equal and exquisite acts, and coined with her heel, as she walked, the ringing effigies of movement. She seems to reckon and count out in pieces of pure gold what we thoughtlessly spend in vulgar change of steps, when we walk to any end.' Later in the dialogue, he offers a eulogy to the dancer:

> who divides and gathers herself together again, who rises and falls, so promptly opening out and closing in, and who appears to belong to constellations other than ours – seems to live, completely at ease, in an element comparable to fire – in a most subtle essence of music and movement, wherein she breathes boundless energy, while she participates with all her being in the pure and immediate violence of extreme felicity – If we compare our grave and weighty condition with the state of that sparkling salamander, does it not seem to you that our ordinary acts . . . are like coarse materials, like an impure stuff of duration . . .

In dance the gravity of the body is released. A fluency and lightness invest each gesture and stir the whole body. Stillness breaks in waves of visible grace. Writing of the Countess Cathleen in Paradise, Yeats has these lines:

> Did the kiss of Mother Mary
> Put that music in her face?
> Yet she goes with footstep wary
> Full of earth's old timid grace.

One of the most intriguing forms of dance is when an object is cut against the stillness in such a way that it becomes filled with the suggestion of movement.

SCULPTURE: THE STILL DANCE

Abandoned stones which I become interested in invite me to
enter into their life's purpose. It is my task to define and make
visible the intent of their being.

ISAMU NOGUCHI, *The Isamu Noguchi Garden Museum*

SOMETIMES WE UNWITTINGLY HAPPEN UPON THE SECRET LIFE OF
objects. One day, some years ago, I was out on the mountains herding
cattle. I had walked for hours and I lay down on the mountainside
to rest. It was a gloomy day of muted light. Just as I was about to
arise, I looked over my shoulder across the broken limestone pave-
ment to see a small limestone version of the Egyptian Sphinx
looking across at me. I gazed at it for a while, enthralled again by
all the shapes of natural sculpture with which these stone moun-
tains are bestrewn. I eventually got up and walked on; then I
turned back for one more look, but try as I might, I could not find
the sphinx again. Whatever light, vision and space had conspired to
render that image explicit among the stones had now vanished.

For the new infant, becoming acquainted with objects is a real
adventure. The other day I watched a new lamb interrogate a
group of daffodils on the hill outside my window. She seemed
amazed at how a rush of breeze could make those yellow aliens
dance. Like the little lamb, to the human eye there is no end to the
mystery of objects. Forced by fire and tension from beneath and
carved by glacier, time and weather above, the forms of a landscape
are primal sculpture. Though it is hard to analyse, the surrounding
shape of the place where we live must exercise considerable in-
fluence on the rhythm and weather of our minds; perhaps outer
sculpture does influence the inner sculpture we call thinking.

Thought is our great mirror and lens of vision. Though it might
carry a world, a thought is light. Perhaps this is one of the reasons
why even the simplest objects remain mysterious to us. Everything
we feel, think and do is mediated through thought: thinking is the

air in which the mind dwells. The wonder of an object is that it is not a thought. A thing is first and foremost itself. An inconsequential pebble picked up on the side of the road has preceded us by anything up to four hundred million years, and its face will be brightened still further by rain that will fall here thousands of years after we have vanished. We might change things in the world, yet the most minimal, seemingly insignificant object outlasts us.

THE DAZED STONE

The beauty of a composed intricacy of form; and how it may be
said . . . to lead the eye a kind of chase.
WILLIAM HOGARTH

AN OBJECT LOVES SPACE. WITHOUT SPACE, THE SHAPE, COLOUR and presence of the object remain unseen. Most of the objects in the world lie buried under earth or under water. As a child I remember being fascinated by this as I watched my uncle and father clearing land. In levelling a field, the ground would be opened, the tightly packed layers of caked earth broken and freed; then sometimes an inner mound would reveal where a huge rock lived inside the earth. They'd dig around it, and then with crowbars they'd hoist the stone up out of its lair. For days and even weeks afterwards, the stone looked dazed and estranged, standing unsheltered and alone in the severance of wind and light, a new neighbour in the world of eyes, weather and emptiness. Some stones seemed to take ages before they began to look comfortably at home in the outside world. As they slowly took on the accretions of weather and its erosive engravings, time enabled them to forget the underworld. In a sense this is the disturbance, the revelation and strange beauty that a new piece of sculpture causes in the world.

Sculpture arrives; it makes an entry, draws attention to itself and

invites the eye to take it into account and rearrange its inner world accordingly. Sculpture is different from all other art. Whether it is stone, metal, clay, wood or external assemblage, it is a sensuous concrete thing, another object in the world – to be seen, touched and placed. Usually a piece of sculpture inhabits stillness, yet the stillness is not dead or vacant. It is a stillness that is shaped with presence. In a way, a piece of sculpture is a still dance. Recently I gazed at a majestic piece by Barbara Hepworth. Its pleasing green shape had a simple aperture near the top; the whole dignity of its restrained elegance reminded the heart of some vital form, perhaps something lost or something dreamed that is still to come. Sculpture can have this poignancy when the shape and stillness of the silent thing stirs something in the heart that thought could never dredge up.

The arrival of a piece of sculpture changes the space. Though we dwell all the time in space, we are often blind to the wonder of its emptiness and how it allows each thing to be there. When the sculptor is working on a piece of stone, she might be releasing the hidden shape within it, as Michelangelo believed. What she certainly is doing, however, is altering the conversation between space and matter. As the word voices silence, so shape states still- ness. Space gathers itself differently around the piece of sculpture. Our eyes are drawn to the piece, but they also register how it charges space with the emotion of its presence. Sculpture sculpts space, that silent and still continuum that allows us to be and in every moment bestows upon us the privilege of whereness. Space is faithful to us in a primal way; it offers the 'where' that permits us to be here. It does not have crevices that we could fall through to disappear into nowhere. A piece of sculpture can render space visible and vocal. It frees the eye and the heart to glimpse the embrace of the invisible.

Sculpture also suggests and sometimes unveils the mystery that resides inside what we blandly call 'matter'. Humans are so easily contented, addicts of the familiar, willing to remain satisfied with

outside description. Yet all around us so-called 'matter' is brimming with secrets in its inner dance of alteration. In a beautiful sculpture called *The Stone Within*, the Japanese sculptor Isamu Noguchi brings out the colours, textures and inner light of the basalt rock. Noguchi said of this piece: 'To search the final reality of stone beyond the accident of time, I seek the love of matter. The materiality of stone, its essence, to reveal its identity – not what might be imposed but something closer to its being. Beneath the skin is the brilliance of matter.' The inner secrets of stone cannot be pre-empted. Everything depends on that precarious moment, where and how the sculptor starts. Perhaps in no other art does the moment of beginning hold the future so definitively. Noguchi puts it this way: 'In working stone, the primary gesture, the original discovery, the first revelation, can never be repeated or imitated. It is the stroke that breaks and is immutable. No copy or reproduction can compare.'

ARCHITECTURE: THE DESIRE TO DWELL IN BEAUTY

WHEREAS SCULPTURE SEEMS LIKE STILL DANCE, THE SHAPES OF architecture have been compared to 'frozen music'. Architecture is one of the most public and permanent stages on which a culture displays its understanding of beauty. Much of our sense of the beauty of an ancient culture derives from the ruins of their architecture. In its Greek roots, the word 'architecture' literally means 'weaving of a higher order'. A whole world-view is woven through and becomes visible in great architecture. The shapes of our dwelling places have always inspired human creativity. Of all the inhabitants of the earth, the ones with the most complex and reflexive interiority also have the most complex dwellings to reveal and shelter interiority.

Beautiful architecture like Chartres Cathedral elevates the soul and mirrors its heritage and possibility. Yet architecture can also reveal some of the secrets that lie at the heart of beauty. When architecture manages to mirror the inner order of nature, the result is frequently beautiful. We respond intuitively to the order, harmony, proportion and rhythm that great architecture incarnates. The creative architect pulls his design from that concealed order which underlies all difference and fragmentation. Yet we are easily deceived by nature: simply because it is always there, we become blind to its intricate and dynamic weave of structures and how it works through laws that are simple yet profoundly subtle. As Claude Bragdon says: 'We are all participants in a world of concrete music, geometry and number; a world of sounds, odours, forms and motions, colours, so mathematically related and coordinated that our pygmy bodies, equally with the furthest star, vibrate to the music of the spheres.' Beautiful architecture in its design enters into this rhythm of order and renders it visible in the proportions, tensions and harmonies of building.

Goethe said: 'A noble philosopher described architecture as frozen music . . . we believe this beautiful idea cannot be more aptly resurrected than by calling architecture music that has merged into silence.' One of the most exciting contemporary architects who manages to make that music flow is Santiago Calatrawa. His brilliance lies in his mastery of art, sculpture, architecture and engineering combined with an incredible ability to express all of these competencies in his works. He shows a profound understanding of the principles of natural order that are inherent in beauty. The result of course is that Calatrawa overcomes the false division between integrity and function, between beauty and use. His buildings and bridges function wonderfully but they also become huge, new presences of beauty in their environments. People look up and see matter that is usually staid and still completely embracing a soul-elevating design which dances.

Etched as they are against the stillness, shapes that dance can

evoke great beauty. Yet the stillness is never absolute: in waves and particles light is the continual dance which adorns the countenance of the earth with colour. Music too breaks the silence and the stillness through waves of sound. These are the vital thresholds where the wonders of beauty arise. The angel of these thresholds is the imagination.

6

IMAGINATION: BEAUTY'S ENTRANCE

Beauty as an explosion of energy perfectly contained.
RICHARD HOLMES on Coleridge's concept of beauty

'TEANNALACH'

A FRIEND OF MINE WHO OWNS AN ART GALLERY TOLD ME THIS story. There was an exhibition in the gallery and a poet of no small renown had come in to view it. Just when he was finished a farmer arrived. This farmer came to the gallery about once a year. He lived on the shores of Loch Corrib. The gallery owner had great interest in and respect for him and so he introduced him to the poet. The poet then revisited the exhibition with the farmer, pointing out all the intricacies and hidden symbolism of the exhibition. The farmer listened carefully but said nothing. When they were finished, the farmer said to the poet: 'Thank you very much. That was really interesting. You showed me in those paintings things I would never have noticed myself. You have a wonderful eye; it is a

great gift and I envy you your gift. I don't have that gift myself but I do have Teannalach.' The poet thanked him but was mystified as to what Teannalach was. The farmer said: 'I live beside the lake and you always hear the ripple of the waters and the sound of wind on the water; everyone hears that. However, on certain summer days when the lake is absolutely still and everything is silent, I can hear how the elements and the surface of the lake make a magic music together.' So the story rested until one day a neighbour of the farmer was in the gallery. The owner told him the story and asked him what Teannalach was. The neighbour paused for a while and smiled: 'They have that word all right up there where he lives. I have never seen the word written down. And it is hard to say what it means. I suppose it means awareness, but in truth it is about seven layers deeper than awareness.'

I love that story for its imaginative richness and its gentle art of displacement. The farmer disclosed his gift, a capacity for profound attention that could pierce the silence and hear the unheard music of the lake. That 'Teannalach' is a distinctive and unique local word testifies to a certain tradition of such listening. What kind of echoes might the word hold? Could it be an abbreviation of *teanga na locha*, the tongue or the language of the lake? Or could it be *an tsean loch*, the ancient lake – perhaps the lake beneath the lake? The story also underlines the hiddenness of beauty, a beauty that dwells between the worlds which cannot be reached with known language or bare senses. It only reveals itself when the mind's attention is radical and the imagination is finely tuned.

THE CELTIC IMAGINATION: EXPERIENCE AND THE 'WEB OF BETWEENNESS'

Thus beauty was revealed to man as an occurrence on the boundary.

HERMANN BROCH

BECAUSE WE TEND TO SEE OUR EXPERIENCE AS A PRODUCT, WE have lost the ability to be surprised by experience, the sense of the mind as a theatre where interesting sequences of complex drama are played. Whether we like it or not, the depths in us are always throwing up treasure. For the awakened imagination there is no such thing as inner poverty. It is interesting how contemporary English has the phrase: 'to have an experience', with the suggestion of possession, property and ownership. In the folk culture of the Celtic Imagination, experience was not a thing to be produced or to be owned. For the Celtic Imagination the focus was more on the experience as participation in something more ultimate than one's needs, projection or ego: it was the sacred arena in which the individual entered into contact with the eternal. Experience in this sense was an event of revelation. In such a world, experience was always lit by spirit; the mind was not a closed compartment 'processing' its own private impressions, the mind always had at least one window facing the eternal. Through this window wonder and beauty could shine in on a life and illuminate the quiet corners where mystery might be glimpsed. A person's nature was revealed in experience; it was also the place where gifts arrived from the divine. Naturally, experience was one's own and not the experiences of someone else. However, it was understood as being much more than the private product and property of an individual. Expressed in another way, there was a sense that the individual life was deeply woven into the lives of others and the life of nature. The individual was not an isolated labourer desperately striving to garner a quota of significance from the world.

In the intuitive world-view of the Celtic Imagination, the web of belonging still continued to hold a person, especially when times were bleak. In Catholic theology, there is a teaching reminiscent of this. It has to do with the validity and wholesomeness of the sacraments. In a case where the minister of the sacrament is unworthy, the sacrament still continues to be real and effective because the community of believers supplies the deficit. It is called

the *ex-opere-operato* principle. From the adjacent abundance of grace, the Church fills out what is absent in the unworthiness of the celebrant. Within the embrace of folk culture, the web of belonging supplied similar secret psychic and spiritual shelter to the individual. This is one of the deepest poverties in our times. That whole web of 'betweenness' seems to be unravelling. It is rarely acknowledged any more, but that does not mean that it has ceased to exist. The 'web of betweenness' is still there but in order to become a presence again, it needs to be invoked. As in the rainforest, a dazzling diversity of life-forms complement and sustain each other; there is secret oxygen with which we unknowingly sustain one another. True community is not produced; it is invoked and awakened. True community is an ideal where the full identities of awakened and realized individuals challenge and complement each other. In this sense both individuality and originality enrich self and others.

THE WORLD BETWEEN

THE HUMAN EYE ALWAYS SEES TWICE IN THE ONE LOOK: THE THING and the emptiness. This difference is registered by the eye and conveyed to the mind. Because the eye discovers and guarantees the world, it has little difficulty schooling the mind in the habit of separation. The instinct of the eye is not to trust sequence. The eye prefers to insist on the loneliness of the object. No object intensifies the neighbouring emptiness like the human body. The eye underlines this separation. Because the mind knows the passion and difference of the interior world locked inside the body, it easily comes to believe the individual is an island. The conviction that each individual is separate and utterly alone makes us blind to that subtle world that dwells between things.

Because the eye loves to hit its glimpse at the centre of a thing, it

has no radar to pick up this in-between world. Though it may not be seen directly, the eye of the imagination will often be drawn to the edges of things where the visible and invisible worlds coalesce. There is a subtle and unknown intimacy around each of us which is usually more evident in our homes. The things we have, the clothes, furniture, paintings, music, books, rooms, all are infused with us. In truth, there is no distance between us and the things we live among. This nearness is intensified a thousand times when it comes to the people close to us.

There is no map for this invisible territory, yet sometimes its force completely engages your heart. The atmosphere between you and a friend takes on a life of its own; though both of you influence its rhythm and shapes, neither of you ultimately controls it. Indeed, it is fascinating how much we can awaken in each other. There are some people in your life with whom you felt a wonderful affinity the moment you met them. The more they told you, the more you felt as if they were talking from a common world you had some-how secretly shared before you ever came to know each other. Within the newly discovered affinity, so much can be assumed and intuited. Nothing needs to be said, tested or proved. You sense each other's spirit and in some inexplicable way, you do know each other. Trust is not a question; you settled into an embrace of belonging that seemed to have always held you. Sometimes this interim world – this invisible territory – knows more than we do, even things we have yet to discover as we continue to imagine who we are.

NO-ONE WANTS TO REMAIN A PRISONER IN AN UNLIVED LIFE

But beauty interrupts restrictions in every place and thing.
STEPHEN DAVID ROSS

THIS IS ONE OF THE SACRED DUTIES OF IMAGINATION: HONOURABLY to imagine your self. The shortest distance in the world is the one between you and yourself. The space in question is tiny. Yet what goes on in this little space determines nearly everything about the kind of person you are and about the kind of life you are living. Normally, the priority in our culture is to function and do what is expected of us. So many people feel deep dissatisfaction and an acute longing for a more real life, a life that allows their souls to come to expression and to awaken; a life where they could discover a different resonance, one which echoes their heartfelt dreams and longing. For their short while on earth, most people long to have the fullest life they can. No-one wants to remain a prisoner in an unlived life. This was the intention of Jesus: 'I have come that you may have life and have it to the full.' Of the many callings in the world, the invitation to the adventure of an awakened and full life is the most exhilarating. This is the dream of every heart. Yet most of us are lost or caught in forms of life that exile us from the life we dream of. Most people long to step onto the path of creative change that would awaken their lives to beauty and passion, deepen their contentment and allow their lives to make a difference.

YOU ARE NOT SIMPLY THERE: YOU IMAGINE WHO YOU ARE

> This above all: to thine own self be true,
> And it must follow, as the night the day,
> Thou canst not then be false to any man.
> SHAKESPEARE, *Hamlet*

THE WORLD NEVER COMES AT YOU ALL AT ONCE. SOME experiences barely register; others strike you. In the midst of everything, there is one experience that you cannot escape. This is an

experience you are having literally every moment, namely, that this is you, in this body, here in the world, now. If someone were to ask you which fact you could not doubt, you would declare this to be the clearest and most intimate fact you know. Yet the strange thing is that the nature and meaning of this fact is neither clear nor obvious. In other words, whoever you consider yourself to be is also the result of your own imagination. You are not simply here. Neither are you definitively and forever 'you'. You develop and change constantly; each new experience adds to you and alters your shape and image. You imagine who *you* are. Of all imaginative work this is the most intimate and creative. It is also a powerful and yet vulnerable position to be in regarding yourself. It seems that there is a stranger who has somehow stolen into your life, one who knows all your intimate feelings and thoughts and has gained control of how you understand your life and see yourself. By now this stranger has gained power over you. Your every thought is vulnerable to the stranger's outlook and consideration. It is an unbelievable way to live: to be tied for ever in this caged inner conversation. The irony is of course: the stranger is you.

No person is a finished thing, regardless of how frozen or paralysed their self-image might be. Each one of us is in a state of perennial formation. Carried within the flow of time, you are coming to be who you are in every new emerging moment. Life is a journey that fills out your identity and yet the true nature of a journey remains largely invisible. Inside each journey a secret harvesting is at work. It is as though the beginning of a journey offers the pilgrim a mirror where something is glimpsed, something that is beginning to form as an image. Over the course of the journey the image fills and fills until finally at the end of the journey the empty mirror has become a living icon of spirit. When the new baby arrives there is barely a blur in the mirror, then at the end of its life when the person lies down to die, the mirror has filled, the image has taken on the depth of a great icon. Now there

is a reversal and transfiguration. As the spirit departs it looks into the deathbed and sees barely a blur because it has filled with the invisible harvest of life's experiences, transfigurations and memories, its inner narrative.

A GOOD STORY KNOWS MORE THAN ITS TELLER

NOWADAYS EVERYONE IS CONSCIOUS OF THEIR OWN STORY. PEOPLE identify themselves with their stories. The story is rarely presented for what it is: a selective version. Rather the version is taken for fact and the fact takes on a mechanical and repetitive life of its own. Often when confronted with this kind of self-presentation, one has the difficulty of trying to correlate a fairly banal, predictable biographical script with an individual who seems infinitely more interesting and complex. Literature is the domain where story belongs. In good literature a story is always working on several levels at once; it holds within it a suggestiveness of the other stories that it is not; it has an irony and ambivalence about its own identity and posture and immunizes itself against take-over by any definitive reading or interpretation. From this perspective, it seems that much of what passes for story in contemporary spirituality and psychology is more reminiscent of tabloid pastiche than real story. Even the pre-literary tradition of oral culture had complex tapestries of story that left the most subtle openings into the resonance fields of myth and mystery.

A human life is the most complex narrative of all; it has many layers of events which embrace outside behaviour and actions, the inner stream of the mind, the underworld of the unconscious, the soul, fantasy, dream and imagination. There is no account of a life which can ever mirror or tell all of this. When telling her story all a person can offer is a sample of this complexity. The best stories suggest what they cannot name or describe. They deepen respect

for the mystery of the events through which identity unfolds. Consequently, respect for oneself should mean that if one wants to tell one's story, it should be worthy of telling. Since story is now widely used in psychology, spirituality and sociology, a deepening of the mystery of what a story is would serve to illuminate the beauty that dwells deep in the individual life. As the Jewish writer and human rights campaigner Elie Wiesel once said, God created man because he loved stories.

The Imagination Sees Through a Thing to the Cluster of Possibilities Which Shrouds It

A REAL NARRATIVE IS A WEB OF ALTERNATING POSSIBILITIES. THE imagination is capable of kindness that the mind often lacks because it works naturally from the world of Between; it does not engage things in a cold, clear-cut way but always searches for the hidden worlds that wait at the edge of things. The mind tends to see things in a singularly simple, divided way: there is good and bad, ugly and beautiful. The imagination, in contrast, extends a greater hospitality to whatever is awkward, paradoxical or contradictory. The German philosopher Hans-Georg Gadamer, in an interview shortly before his death last year, said: 'The integrity of a society demonstrates itself in how that society engages with contradiction.' The imagination is both fascinated and stimulated by the presences that cluster within a contradiction. It does not perceive contradiction as the enemy of truth; rather it sees here an interesting intensity. The imagination is always more loyal to the deeper unity of everything. It has patience with contradiction because there it glimpses new possibilities. And the imagination is the great friend of possibility. It always sees beyond facts and situations, to the cluster of possibilities in which each thing is shrouded. In a

sense, this is what beauty is: possibility that enlarges and delights the heart. Nothing opens up the mind like the glimpse of new possibility. When everything has become locked inside a dead perspective and the consensus is that a cul-de-sac has been reached, new possibility is an igniting spark. This dead identification is made frequently every day in all kinds of situations. For example, the love and affinity between two people becomes sidelined into a repetitive and wearying pattern. They become stuck in a helpless symmetry of conflict. In a company boardroom a project that had great potential becomes suddenly frozen around some unforeseen impossibility. Or something happens to a person that is devastating; or some failure occurs that draws judgement and shame. In all of these instances, the rational mind would devote itself to direct engagement with the situation and soon find itself overwhelmed by inevitability. All of its efforts at direct analysis and understanding, even its efforts to directly loosen the context or break free from it, would only serve to further entangle it.

Frequently the imagination can bring completely new eyes to such a situation. This is often evident in the workplace. The work team in a company or school have lost their vision and creative intention. The energy has lapsed and their work has lost its flow of desire. Things have become stagnant and lifeless. The leader can see no way out. Then a new person comes in and takes over the leadership. She refuses to inherit the bank of dead perception which preceded her. She refuses the language everyone has been locked into. She refuses to use the old descriptions. She trusts her own energy and instinct. Her fresh imagination enables her to see beyond the accepted freeze. Where others saw only a cul-de-sac, she sees a new pathway, one perhaps more precarious and uncertain but at least initially one that offers a way out to fresh pastures. As she begins to perceive this more deeply, her language strives to mirror it. When others begin to glimpse it, new possibilities awaken. The old grid of frozen inevitability gradually melts and people are suddenly finding new inspiration, motivation and

creativity. After a while, a dead situation has been transfigured into a place of invitation and excitement.

IMAGINATION: THE DIVINE STRAIN IN US

The imagination may be compared to Adam's dream –
he awoke and found it truth.

JOHN KEATS, 22 Nov. 1817. Letter to Benjamin Bailey

THE DIFFICULTY IN BEING HUMAN IS THAT ONE CAN NEVER BE merely human. Whether we like it or not, each one of us has kinship with the divine. This kinship can remain dormant for a long time or it can find other forms of expression. Sooner or later, it will assert itself in a form that is no longer possible to ignore. The divine is one of the most intimate and unpredictable dimensions of the human heart and there is no way of foreseeing when or how it might awaken. The source of our creative longing and passion is the Divine Imagination.

It is puzzling that in the Western world we have concentrated on the divine intellect and the divine will. Yet the breathtaking flow of difference in the world suggests the beauty of the Divine Imagination which we have utterly neglected. When we bring in the notion of the imagination, we begin to discover a whole new sense of God. The emphasis on guilt, judgement and fear begins to recede. The image of God as a tabloid, moral accountant peering into the regions of one's intimate life falls away. The notion of the Divine Imagination brings out the creativity of God, and creativity is the supreme passion of God. When we bring in the missing dimension of imagination, the perspective changes and we get a glimpse of true beauty, the glorious passion, urgency and youthfulness of God. This portal of insight always needs to be balanced against the unknown in God which remains

beyond the furthest dream of the mind's light.

God created the world because God had to create. The world was not created to satisfy some desire for experiment. One of the concepts from the classical period was the idea of the 'pleroma', or the urgent fullness of God. There was such a fullness brimming in the divine presence that had God not created, he would have imploded. God had to come to expression. Just as the true artist is always haunted by the desire to bring the dreams of the imagination to expression, the failure to follow one's calling to creativity severely damages one's spirit. Sins against creativity exact huge inner punishment and as artist, God had to follow his imagination and reach towards expression. In his *Letter to Artists*, the present pontiff says: 'None can sense more deeply than you artists, ingenious creators of beauty that you are, something of the pathos with which God at the dawn of creation looked upon the work of his hands.'

Everything that is – every tree, bird, star, stone and wave – existed first as a dream in the mind of the divine artist. Indeed, the world is the mirror of the divine imagination and to decipher the depths of the world is to gain deep insights into the heart of God. The traces of the divine imagination are everywhere. The beauty of God becomes evident in the beauty of the world. I once asked a brilliant young sculptor who her favourite sculptor was and she said: 'the divine sculptor'. The curvature of mountains, the angular stillness of rocks, the variations on the seashore, the white graffiti of stars on night's high black wall, all belong to God's masterpiece; and like any great work of art, it invites endless contemplation. It has an inexhaustible depth and a fluency of presence that can meet us in all the different phases of our awareness with ever surprising invitations. The divine imagination has infused the things of the world with secret depths. We are neither strangers nor foreign bodies in a closed-off world. We are the ultimate participants here – the more we give ourselves to experience and strive for expression, the deeper it opens before us.

WE ARE MADE IN THE IMAGE AND LIKENESS
OF THE DIVINE IMAGINATION

The beauty of art is beauty born of the spirit and born again.

G.W.F. HEGEL, *Aesthetics*, vol. 2

EACH TRADITION IS AN IMMENSE ARCHIVE OF EXPERIENCE, MEMORY and wisdom. There are beautiful treasures in the Christian tradition and one of the keenest insights is that we are 'made in the image and likeness of God'. We are from God and we carry in our minds and hearts the ripple of the divine mind. There are depths that keep watch in us, depths we have not created. When the neglected dimension of the Divine Imagination is brought in, we could restate that equivalence and say: we are made in the image and likeness of the Divine Imagination. The individual imagination is not its own invention: its source is elsewhere. The intuition, passion and luminosity of the individual imagination are infused with the urgency of the divine. Thus when we enter into our creativity, we are in the rhythm of the divine creator.

At the deepest level, creativity is holiness. To create is to further the dream and desire of the creator. When the world was created, it was not a one-off, finished event. Creation is a huge beginning, not a finished end. Made in the image and likeness of the Divine Imagination, human creativity helps to add to creation. The unfinished is an invitation to our imagination. This is what happens in experience: the unfinished reaches towards us in order to come to form and expression. Experience is also how we develop and grow. The human self is not a finished thing, it is constantly unfolding. Experience is, then, essentially creative. Everything we feel, think and do, even the smallest thing, expresses and unfolds the dream of God. No human presence is neutral for there is some deeper, hidden level at which all creativity comes together. Beyond the obvious psychological and social levels, the life and death of each of us exerts a secret influence on everyone else. There is

a community of spirit but it is more subtle than overt social community. This is the realm of ultimate creativity. It is the arrival point – the harvest place of human presence and activity. There is an illuminating sentence by St Paul: 'Videmus nunc per speculum in aenigmate, tunc autem facie ad faciem' – now we only see in a glass darkly, then we shall see face to face. Perhaps after death we will be given a glimpse of how everything holds together and how each thing that happens to us fits precisely in the blueprint of our creative destiny.

Each of Us Has Inherited a Treasure-house of Wonders

I would like to be able to take a photo of a dream.

HÉLÈNE CIXOUS

TIME BECOMES RESTLESS IN US. THE HUMAN HEART IS FULL OF quickening. Each pulse beat draws us towards new frontiers. In every moment we see and feel more than we can ever know. If we were to live everything, we would be too much for ourselves. Yet the life within us calls out for expression. This is what creativity serves. It endeavours to bring some of our hidden life to expression in order that we might come to see who we are. When we are creative, we help the unknown to become known, the visible to be seen and the rich darkness within us to become illuminated. No human being is ever actually there. Each of us is emerging in every moment. When we discover our creativity, we begin to attend to this constant emergence of who we are. Our creativity is excited by what is new, different and concealed within us. While the outside world has long settled for who we are in terms of name, personality and role, when we creatively engage our life, we enable the signature, taste and imprint of our uniqueness to emerge. This is

what begins to emerge when we come to the desk and look into the mirror of the white page. Beneath that white page, in the stillness, a harvest of untouched possibility waits.

Every heart is full of creative material. There are depths in us hungering towards the light. Many writers continue to excavate their childhood. For a writer, childhood can be a Grimms' forest of treasures, wonders and shadows. Childhood is that time of silence when the deepest impressions become imprinted. Everything a new infant glimpses is a first intimation of mystery. The world is seen as if God were just creating it; it has the fresh scent of recent arrival. Later in life, when we begin to write, this is the kind of raw freshness and excitement of first intimations that we are seeking to recapture. The creative gift remains faithful to that rich strangeness of the world and the intimate strangeness of the self. As we journey through life, we gather a world around the heart. When creativity awakens, we discover that nothing is truly complete or closed in life. The deeper we attend to the soul, the more we realize what a treasure-house we have inherited. For instance, the discipline of creative writing brings us towards the depths of our inheritance but holds it away from us too; it only allows us to approach at an oblique angle. This prevents us from rifling our inheritance through second-hand psychological analysis or spiritual labelling.

THE GIFTS THE IMAGINATION BRINGS

I feel assured I should write from the mere fondness and
yearning I have for the Beautiful even if my night's labours
should be burnt every morning and no eye ever shine on them.
JOHN KEATS, 17 Oct. 1818. Letter to R. Woodhouse

- The imagination is like a lantern. It illuminates the inner land-scapes of our life and helps us discover their secret archaeologies. When our eyes are graced with wonder, the world reveals its wonders to us. There are people who see only dullness in the world and that is because their eyes have already been dulled. So much depends on how we look at things. The quality of our look-ing determines what we come to see. Too often we squander the invitations extended to us because our looking has become repetitive and blind. The mystery and beauty is all around us but we never manage to see it. Similarly with the inner world: the imagination is the eye for the inner world. When the imagination awakens, the inner world illuminates. We begin to glimpse things that no-one speaks about, that the outer world seems to ignore. When the inner world brightens, we discover a new confidence and a surer grounding in the world.

- The imagination has retained the grace of innocence. This is no naïve, untested innocence. It knows well the shadows and troughs of the world but it believes that there is more, that there are secret worlds hidden within the simplest, clearest things. The imagination is not convinced by the world of external fact. It is not persuaded by situations that pretend to be finished or closed. The innocence of the imagination is willing to see new possi-bilities in what appears to be fixed and framed. There is a *moreness* to everything that can never be exhausted.

- The imagination retains a passion for freedom. There are no rules for the imagination. It never wants to stay trapped in the expected territories. The old maps never satisfy it. It wants to press ahead beyond the accepted frontiers and bring back reports of regions no mapmaker has yet visited.

- The imagination keeps the heart young. When the imagination is alive, the life remains youthful. This is often evident in a writer

or artist who is old in years but is still incredibly vital in soul and mind. Sometimes in old age an artist can do her most creative work. It is quite fascinating to see how the inner harvest of years will not succumb to weariness or complacent predictability. The harvest of experience brings invitation to new risk and experiment. Even near the end of a life everything can come alive in new and unforeseen forms. The urgency, restlessness and passion of youth are all there as though everything is about to begin anew.

- The imagination awakens the wildness of the heart. This is not the vulgar intrusive wildness of social disruption. It is the wildness of human nature. Social convention domesticates and controls us; it also imprints deeply on the interior life and would turn our one adventure in the universe into a programme of patterned social expectation. We rarely break free; indeed, we are generally not conscious of how smoothly we slide along the rails of social ordering. The awakened imagination desists from this domestication. It returns us to our native wildness, to the natural and seamless fluency of our own nature. Other worlds come into view and we are invited to risk new and original ways of dwelling in the world.

- The imagination has no patience with repetition. The old clichés of explanation and meaning are unmasked and their trite transparency no longer offers shelter. We become interested in what might be rather than what has always been. Experimentation, adventure and innovation lure us towards new horizons. What we never thought possible now becomes an urgent and exciting pathway.

- The imagination offers wholesomeness: heart and head, feeling and thought come into balance. To follow the mind alone inevitably leads to an isolated and lonesome life. When we follow

the heart alone, it can lead to sentimentality and the marshlands of blurred emotion. An awakened imagination brings the warmth and tenderness of affection into the life of thought; and it brings clarity and light of thought to the flow of feelings. This is how a great piece of literature claims us. We enter into the life of a character. Our empathy and our minds are engaged by the depth and complexity of the character's heart and by the quest of his mind for vision and meaning.

- The imagination offers revelation. It never blasts us with information or numbs us with description. It coaxes us into a new situation. As the scene unfolds, we find ourselves engaged in its questions and possibilities, and new revelation dawns. Such revelation is never a one-off hit at the mind. The knowing is always emerging. The imaginative form of knowing is graced with gradualness. We know this from our experience with a favourite painting. Each time we stand before that painting, it will reach us where we are in our life now, but in a different way from how we saw it the last time. While we sleep each night, the imagination offers us different sequences of showings. The imagination speaks to us in dreams. Our dreams are secret letters that we send to ourselves each night. The dream is never a direct message. Its meaning is always concealed in its actions and figures. It offers us a startling but oblique glimpse at what is going on in our life. If we want to see more, the dream waits for us to decipher its story and the more ready we become, the more it will reveal to us. The imagination reveals truth in such a way that we can receive and integrate it.

- The imagination works through suggestion, not description. Description is always direct and frequently closes off what it names. Suggestion respects the mystery and richness of a thing. All it offers are clues to its nature. Suggestion keeps the mystery open and extends us the courtesy of inviting us to see the thing for

ourselves. It offers us the hospitality and freedom to trust the integrity of our own encounter with a thing. This is how a work of art can allow itself to be seen in so many different and often conflicting ways. It does not foreclose on the adventure of revelation. This point is clearly expressed by the English poet Don Patterson in his account of the difference between an aphorism and a poem: 'The principal difference ... is that the aphorism states its conclusion first. It is a form without tension, and therefore it is simultaneously perfect and perfectly dispensable. There is no road, no tale, no desire.'

• The imagination has a deep sense of irony. It is wide awake to the limitation of its own suggestions and showings. Because the imagination inhabits the province of possibility, it is well aware that the image it presents could indeed be otherwise. The imagination keeps this distinction open and thus enlarges the breathing-room for the gifts it offers.

• The imagination creates a pathway of reverence for the visitations of beauty. It opens up diverse ways into the complex and lyrical forest of experience. To awaken the imagination is to retrieve, reclaim and re-enter experience in fresh new ways. As Bill Stafford says: 'You are the only world expert on your own experience.' There is no-one else to illuminate our experience but ourselves. To put it in liturgical terms: each of us is the priest/priestess of our own life and the altar of our imagination is the place where our hidden life can become visible and open to transfiguration. Keats said it so perfectly: 'I am certain of nothing but the holiness of the Heart's affections and the truth of Imagination ... – whether it existed before or not – for I have the same Idea of all our Passions or Love they are all in their sublime, creative of essential Beauty.' The call to the creative life is a call to dignity, to a life of vulnerability and adventure and the call to a life that exquisite excitement and indeed ecstasy will often visit.

The passion of the imagination is nourished from a deeper source, namely, Eros. The force of Eros keeps the thresholds of our lives vital, dangerous and inviting.

7

ATTRACTION: THE EROS OF BEAUTY

THE EXCITEMENT OF ATTRACTION

A space must be maintained or desire ends.
ANNE CARSON

THERE IS A LOVELY DISARRAY THAT COMES WITH ATTRACTION. When you find yourself deeply attracted to someone, you gradually begin to lose your grip on the frames that order your life. Indeed, much of your life becomes blurred as that countenance comes into clearer focus. A relentless magnet draws all your thoughts towards it. Wherever you are, you find yourself thinking about the one who has become the horizon of your longing. When you are together, time becomes unmercifully swift. It always ends too soon. No sooner have you parted than you are already imagining your next meeting, counting the hours. The magnetic draw of that presence renders you delightfully helpless. A stranger you never knew until recently has invaded your mind; every fibre of your being longs to be closer. You have fallen into the vortex of Eros

where words become gossamer light and kisses kindle fires. You want to erase distance and become one with the flame. You grow innocent and careless. And Eros can take many forms. Sometimes it can be slow, subtle and indirect, building quietly without anyone else even suspecting. Sometimes it can come at you.

It is always astonishing how love can strike. No context is love-proof, no convention or commitment impervious. Even a lifestyle which is perfectly insulated, where the personality is controlled, all the days ordered and all actions in sequence, can to its own dismay find that an unexpected spark has landed; it begins to smoulder until it is finally unquenchable. The force of Eros always brings disturbance; in the concealed terrain of the human heart Eros remains a light sleeper.

Eros Awakens the Spring

CREATION IS IMBUED WITH EROS. EACH LANDSCAPE, EACH SEASON has its own quiet Eros. In contrast to the glory of autumnal colour which is like the flaming of a final twilight, winter is a chaste season. Nothing flourishes. Every field and tree is cleaned back to its bare form. The night of winter comes in clear and sure. Against the bleak grey whatever muted colour endures seems ghost-like. But as ever, the circle travels on to its own beginning. And just when the amnesia seems absolute, the first tones of spring commence their infant flaming. Within a short while the exiled Eros of nature stages a magnificent return. From the dark under-life of cold fields, infinite tribes of grass ascend. Skeleton trees allow themselves a shimmering of leaves. Flowers arrive as if this were the place they had always dreamed. Having travelled through thousands of miles of sky and ocean, swallows return to their favourite holiday nests in outdoor sheds. Local birds become passionate architects high up in the network of trees. The terse

silence of winter has given way to the symphony of spring. Eros has awakened. The shadow-dream of winter is coming to life in every corner. Birth is the inner and outer song of spring. If winter is the oldest season, then spring is the youngest season. The Eros of the earth calls forth the beauty of spring.

TERRA ILLUMINATA

THE BEAUTY OF THE DIVINE MIND DREAMED A CREATION THAT CAN never be lonesome simply because it is always in conversation with itself. Even high in the mountains you can come upon a field which through the centuries has grown intense with the personal elements of its own silent conversation: every spring, absent flowers return again to their familiar sanctuary beneath huge persistent stones whose surfaces are always deepening ever so slightly with the restless engraving of wind and rain. Far away from the industry and interference of human hands, such a field has always been quietly at work, enriching the constellation of its own countenance. In traditional farming, the farmer never simply used the land. The farmer also lived among his fields. Sometimes he experienced a deeper affinity with his fields than with his neighbours. He was alert to the slightest change in their countenances; his heart anticipated the variations that each new season added.

Eros is a divine force. It infuses all the earth. Yet, too often, in our culture Eros is equated with lust and sexual greed. But it is a more profound and sacred force than this. Eros is the light of wisdom that awakens and guides the sensuous. It is the energy that illuminates the earth. Without it, the earth would be a bare, cold planet for Eros is the soul of the earth. In the embrace of Eros the earth becomes a *terra illuminata*. Amidst the vast expanse of fields and seas, the providence of Eros awakens and sustains the longing of the earth. This is the nerve source of all attraction, creativity and

procreation. Eros is the mother of life, the force that has brought us here. It constantly kindles in us the flame of beauty and the desire for the Beautiful as a path towards growth and transformation.

CALLING TO EACH OTHER

But the boundaries of time and glance and I love you are only aftershocks of the main inevitable boundary that creates Eros: the boundary of flesh and self between you and me.

ANNE CARSON

THE CALL OF EROS IS AT THE HEART OF THE HUMAN PERSON. Although each of us is fashioned in careful incompletion, we were created to long for each other. The secret of our completion can only be found in the other. Huge differences may separate us, yet they are exactly what draw us to each other. It is as though forged together we form one presence, for each of us has half of a language that the other seeks. When we approach each other and become one, a new fluency comes alive. A lost world retrieves itself when our words build a new circle. While the call to each other is exciting and intoxicating in its bond of attraction, it is exceptionally complex and tender and, handled indelicately, can bring incredible pain. We can awaken in each other possibilities beyond our wildest dreams. The conversation of togetherness is a primal and indeed perennial conversation. Despite the thousands of years of human interaction, it all begins anew, as if for the first time, when two people fall in love. The force of their encounter makes a real clearance; through the power of Eros they discover the beauty in each other. Stretching across the distance towards each other, they begin to awaken all the primal echoes where nothing can be presumed but almost everything can be expected.

Eros can be a hugely complex force that sometimes inclines

towards gravity and darkness. Eros can pull life towards the edges and depths where death lurks. From ancient times a kinship has been acknowledged between Eros and Thanatos, the death instinct. Surfing the tides of Eros one comes to feel that the life-force of joy could surge through all limitations, even death; or indeed there is such a homecoming in Eros when one succumbs to its force and abandons self in the sweet dying of complete release.

THE BEAUTY OF SKIN

We are made immortal by this kiss, by the contemplation of beauty.
RALPH WALDO EMERSON

THE INSTINCT, RHYTHM AND RADIANCE OF THE HUMAN BODY come alive vividly when we make love. We slip down into a more ancient penumbral rhythm where the wisdom of the body claims its own grace, ease and joy. The act of love is rich in symbolism and ambivalence. It arises on that temporary, total threshold between solitude and intimacy, skin and soul, feeling and thought, memory and future. When it is a real expression of love, it can become an act of great beauty which brings celebration, wonder, delight, closeness and shelter. The old notion of the soul being hidden somewhere deep within the body serves only to intensify the loneliness of the love act as the attempt of two solitudes to bridge their distance. However, when we understand that the body is in the soul, intimacy and union seem unavoidable because the soul as the radiance of the body is already entwined with the lover.

LOVE NOTES

Your clear shoulder
When the clothes have gone
Seems so sure of us.

Gently, hands
Caress and kindle
The glow, the skin
Delights to know.

Your tongue,
A tiny peninsula
Curves, stretches
Longing to give way.

Currents swell, calm,
Flow blue flamed
And sea sweat
Beads flesh.

Scruples of hair
Linger across your eyes,
Order tossed to the wild.

Sounds entwine,
Say our names,
The cry becomes
A whisper to
Breathe clay open.

And the return
Is from a distant kingdom,
Where there were
Neither mirrors
Nor eyes.

One could write a philosophy of beauty using the family of concepts which includes glimpse, glance, touch, taste and whisper, all of which suggest a special style of attention which is patient and reverent, content with a suggestion or a clue and then willing through its own imagination to fill out the invitation of beauty. We know this in our own experience. When we become uncertain in love, we wonder if our partner loves us or not. We fear the well may have run dry and our insecurity deepens. The smallest whisper of love can restore confidence and sureness.

THE BEAUTY OF LOVE:
EVERY RISK FOR GROWTH WILL BE REWARDED

Since once (livelong the day) my prayer measured
A love along your face, I've raged and variously
Had all smiles and butchery daily acquainting
You of the springing bloodshot and the tear.
Since there (spun into a sudden place to discover)
We first lay down in the nightly body of the year,
Fast wakened up new midnights from our bed,
Moved off to other sweet opposites, I've bled
My look along your heart, my thorns about your head.

W.S. GRAHAM, 'Two Love Poems'

NONE OF US COMES TO A NEW RELATIONSHIP WITH EMPTY HANDS. We carry within us powerfully the images of the masculine and the

feminine. The images of the father and the mother are in the blood and in the mind, the images of those who have loved us and we have loved and the damaged images where we were wounded. Because they have been carried across an endless landscape of years, those images have become set in the mind and have become the lens through which we tend to view the masculine and the feminine. Frequently, it is difficult for us to *see* each other through the net of patterns that entwines us. Yet the magic of new love can be the energy it releases. We become urgent and passionate. New thresholds open and the grace of a new beginning becomes possible. Life quickens with fresh invitations when we can recognize and celebrate the complexity and delight of the feminine and the masculine.

Love is a great shelter within which vulnerability can be shown and gradually healed. The awakening and growth of love is quite fascinating. It seems to arrive from nowhere. This calls two strangers from the crowd. Up to that point they have known nothing of each other. The one did not even know the other existed. The space between them was as clear as the space between two stones in a field. Around each individual form there is no imprint or trace of the life of the other. They are distant and foreign to each other, free of each other. Then Eros shoots his arrows and the delightful wound of attraction opens. They become a shelter for each other; as Yeats says:

> When my arms wrap you round I press
> My heart upon the loveliness
> That has long faded from the world.

Cut clear from the anonymity of the crowd, these two people are already taking leave of their status as strangers. They begin to approach each other. This act of approaching is instinctive and excited; but it is also innocent. Gradually they come to learn the narrative of each other's lives, the subtle nuances of a personality become visible.

Yet to love someone is an art. It does not come simply or cheaply but is a lifetime's work. It remains a huge risk to entrust the fragile barque of identity to the wide and precarious depths of another person's life. There will be storms. There will also be times when the emerging beauty of the voyage will bring unexpected joy. Deeply buried hurts will resolve and release themselves. Shakespeare distils this in Sonnet 30:

> But if the while I think on thee (dear friend)
> All losses are restored, and sorrows end.

Healing light will flow into the unknown region of the heart. It is as though twilight were awakening in the inner night. It is astounding how love can change a person. Where there was fear, courage begins to dawn. Trapped confusion gives way to fresh clarity. In old walls, unexpected doors open and the heart awakens with the desire 'to live everything'.

The decision to enter into a lifelong commitment is to cross a decisive threshold. This decision focuses the two lives and cuts them clear from everyone else in the world. Goethe speaks of how commitment not only deepens the unity between two people, but also invites providence to open towards them with new gifts and the special shelter of even greater kindness. They have taken a huge risk. In the world of business risk is always precarious and when one is in the arena of quantity, a risk can mean one will lose everything. In the world of soul, I have seldom seen anyone take a risk for growth that was not rewarded a thousand times over, for to trust to experience is to grow, to learn, to develop.

Yet to choose is to stand out, to cut oneself off from the shelter of the group and future possibility, it is an invitation to steer a direct course into an unknown future. When one becomes so visible and definite, one leaves cover and becomes visible to other forces, forces which might be quite hostile. This is the poignancy at the heart of the commitment ceremony. The two new pilgrims set out on their

unknown voyage. They want to begin, to take the first steps of their new life in the house of wise and intuitive shelter, the house of God. They join together first inside the circle of blessing, which their friends draw around them. The grounding recognition here is that the journey ahead is a great adventure. It is also a step into the unknown, a journey for which there is no map. Anything could befall them on the way.

TO THE HOUSE OF BEAUTY TO BLESS THE JOURNEY

TIME LIVES DIFFERENTLY IN THE HOUSE OF GOD. WHEN YOU DRIVE through a city, town or village, the house of God stands out. It is unlike any other house. The contrast was infinitely clearer in former times. Many modern churches lack architectural beauty; they imitate the surrounding blandness. In former times when people were much poorer, they struggled sometimes for decades to build a church. Resources and moneys were gathered from every corner in order to erect a beautiful house where the divine presence could trust itself among us, a beautiful house where the reverence of great ritual could at special times unveil the glory of the divine. Beauty in its ultimate presence is divine glory. I have had the delightful experience of travelling through some small French village and visiting a local church. Outside the day is seared with summer light. Then you enter the beautiful kept-darkness of the church. Magnificent stained glass absorbs the white fire of outside light; it harnesses the fire into its narrative of colour. And among the sleep of dark stone a sequence of cobalt blue, indigo or golden yellow comes alive. To the pilgrim who breaks his journey to come in and pray, they offer shy yet beautiful light that restores your seeing. And you remember who you are. For a while you come to sense the providence that secretly shapes and guides your life. Your

burdened mind relents and your soul comes to ease in the shelter of the divine.

In a great religious tradition, the house of God is a special place. The church, the temple, the mosque is where a community gathers to hear God. Cumulatively, over years the interior becomes threaded with the desires, intimacies and longings of a community. The interior of God's house is not a vacant space; it is the place where the spiritual Eros of a community collects. This interior is richly textured with the aura of those who have worshipped there. When one enters there one does not simply enter a building; rather one enters unknowingly the gathered memory. This house is a living archive of transcendence. This is the space where the voice of God became audible, where that tranquillity which the world cannot give waits to comfort the mind. People have come into this house with burdens of heart that could find healing nowhere else in the world. They have come in here for shelter when storms have unravelled every stitch of meaning from their lives. And they have come in too to give thanks for blessings and gifts they could never have earned. The house of God is a frontier region, an intense threshold where the visible world meets the ultimate but subtle structures of the invisible world. We enter this silence and stillness in order to decipher the creative depths of the divine imagination that dreams our lives. Somewhere in this kept-darkness the affection that created us waits to bless and heal us.

THE SANCTUARY OF SUBTLE PRESENCE

In silence we must wrap much of our life, because
it is too fine for speech.
RALPH WALDO EMERSON

THIS SANCTUARY HOLDS A SPECIAL PRIVACY. WITHIN THIS EMBRACE there is no barrier between you and the intimacy of the divine heart. Nor is there a barrier between you and the dead. The outside world is relentless in its urgency and stress; the politics of the obvious dominates everything. Subtle presence is largely unable to register its companionship with us. The dead are abandoned in their graveyards to grow deeper into the stillness of the forgotten. But in this sanctuary their subtle presence hovers nearer; here is where time deepens to reveal its eternal embrace. For eternal life is eternal memory. In its natural silence and deep rituals, space opens here to coax the eternal more fully among us. Within this sacred space, time loses its linearity, its loneliness. It opens up and suggests itself as an ancient circle of belonging in which past and future, time lived and time to be lived, form ultimate presence. From ancient times people have understood the house of God to be the sacred ground from where it is wise to begin a journey: initiation as the journey of life in Spirit, and requiem as the beginning of the invisible journey.

In all our talk about the institutional church in the West, in our anger and disappointment at its theological blindness and abuse of power and person, we have fatally forgotten the harvest of healing presence that dwells in the house of God. In our desperate search for meaning and healing, we rush through our towns and cities on our way to work, therapy or doctors. We pass by these huge sanctuaries of absolute presence, totally oblivious of the divine welcome that awaits us, a welcome that is waiting to embrace us and call us.

A BLESSING BRIGHTENS THE ROAD

THIS SANCTUARY IS THE PLACE WHERE THE NEW COUPLE INVOKE blessing and protection on the fragile world of 'betweenness' that

has begun to develop and grow from that clear space where once they were strangers to each other. In some intuitive way, it is as though this sacred beginning already knows more than them. The beauty of a blessing always issues from a deeper place in time. Though the words are intoned on a particular day on a special occasion, the light of the blessing reaches towards them from eternal time where memory and future live within the one circle. The blessing of their journey already knows more about the journey than the new couple do. The Celtic Imagination had a profound sense of how a blessing could awaken and evoke the deepest potential of a situation. The Celts understood that all beginning risks the unknown; a blessing was intended to be a shelter of light around the pilgrim and the place. A blessing brightens the road; the heart is no longer completely vulnerable to the dark. The journey can lead anywhere; it can even bring new guests to the earth.

NEGLECTED BEAUTY:
THE WONDER OF CREATING A NEW LIFE

WE MAY REFLECT ON HOW IMAGINATION AND CREATIVITY CALL beauty forth; how the reverence of the creative eye can discern beauty in the most unlikely guises. Yet so often we forget that one of the greatest miracles of beauty is the event of bringing a child into the world. Outside of your work and its creative force, the beautiful places you have seen, the compassion you have offered, the insights you have achieved, the sufferings you have managed to endure, those you have loved, the miracle each day of the world's beauty ebbing towards your attention, even the beautiful Unease of God – none of these can compare with the unbelievable presence of your own flesh and blood smiling up at you in the face of a little baby.

WOMAN: WOMB OF BEING

THERE IS NO OTHER WAY INTO THE WORLD EXCEPT THROUGH THE body of the woman. Woman is the portal to the universe. She is also the womb of Being. Each person in the world commenced life as a minuscule trace within the depths of the mother whose womb is the space where that trace expands and opens to assume human form. In terms of one's later identity and destiny abroad in the world, this is the time of ultimate formation and influence. In human encounter, there is nothing nearer than this; no two humans can ever come closer than when one is forming inside the other's depths. Naturally the relationship is hugely imbalanced: the one is a complete person, the other is minuscule and is just beginning a journey towards identity through absorbing life from the mother. Yet within the night of her body, each is helplessly open to the other. No man ever comes nearer to a woman. No woman ever comes nearer to a woman. This intricate nurturing and unfolding into identity takes place below the light in the physical subconscious of her body. The mother sees nothing. The whole journey is a hidden one. It is the longest human journey from the invisible to the visible. From every inner pathway, the labyrinth of her body brings a flow of life to form and free this inner pilgrim. Imagine the incredible events that are coming to form within the embryo: how each particle of growth is like the formation of a world from fragments.

THE PURE CRY THAT ENCIRCLES THE RIPPLE OF BEGINNING

TO BE A PARENT IS TO BE INVITED INTO THE NATURAL DEPTHS OF divine creativity. Mothers and fathers inhabit the secret of God's heart. They open a sacred door in the soul for a most vulnerable

and intimate stranger to enter and inherit the earth. Though it comes to be through the gradual rhythms of nature in that warm space between two lovers, the creation of a child is an event that takes place on the cliff-edge of Nothingness. From the infinite and unknown Nowhere of the invisible world, someone is brought into Being. The stranger comes from eternity into time, from the pitch black night of Otherness into the dawn of a human countenance, from the penumbral depth and silence of the earth into the word-filled, wave-shaped music of consciousness. When two lovers lie down to consummate their hunger for each other, somewhere a pore opens in the infinite and their love surges beyond their names, hearts and minds to assume an independent human form. Regardless of who they are, where they go, how they live or love or suffer, from now on the form of this child will always be between them. In some instinctive surge, they have unknowingly entered that place outside memory and dream. In the deepest well of the night their pure cry, like a moon-glimpse, encircles a ghost ripple of beginning. Drawn within the pulse of time, the ripple secretly structures itself into the faint spiral of visibility, an embryo soul.

Being a parent is also the unromantic endurance of watching over, providing and caring for your child. In psychological and spiritual circles people talk of overcoming the ego. Being a loving parent is work that guarantees the transformation of the ego for in the work of rearing children the limits of your selfishness, need and smallness are continually challenged. Somehow you find within your heart a love that is willing to stretch further and further. In this sense, the work of parenting is profoundly blessed work. Some people pray in words; in the work of raising children, parents pray every day with every fibre of their being. The world of your child takes up the horizon of your heart. When you bring a child into the world, you become vulnerable in a new way. You have become unprotected against the world, unprotected now in a place where nothing can cover or shelter you. And yet protection is all you long for: protection for your child. When he had his first child, a friend

told of his joy but also of how surprised he was to find himself thinking so much about his own mortality. Somewhere in his nature, he saw himself as a protective frontier between the world and the tiny infant. The sight of a newborn baby evokes fragile beauty: the miniature fingers and toes, the soft, new skin with its special scent and the first tracings of expression on the new face. Indeed, the beauty of the newborn infant can stir gentleness in the hardest heart.

Even the most caring parents will leave inevitable trails of damage. This is a natural part of the 'dark industry' of imperfection and brokenness that lies within every one of us. But it remains true that deep behind the visible surface of our society there are incredible, unseen people who give everything they are and everything they have to their children. They are the secret priests and priestesses who work away unostentatiously in the vineyards of soul-making. Although often arduous and painful, ultimately it is tender, vulnerable work, a work of fragile yet wondrous beauty.

The Surprise of Hearing What You Mean to Your Parents

A GLIMPSE CAN HOLD A WORLD. A FRIEND OF MINE OFTEN TALKS TO parents of children who are preparing for the sacrament of confirmation. Such events are great family occasions. My friend always recommends that each parent separately takes the child away quietly before the day comes. The child would be invited to do something they loved or go somewhere they liked. But the parent would use the occasion to tell their child how they feel about him/her. Given that an adolescent already has huge resistance to anything resembling articulated parental love, this needs to be done swiftly, almost like an insert of phrases that achieve entry before the child can reject them: 'I have wanted to say this to you for a long

time. You're going to cringe for a few moments ... But it won't take long. I just want you to know that we are really crazy about you. When I am away at work or travelling, I am always thinking about you. You are the centre of our lives. If anything were ever to happen to you, we would never get over it. And anything you ever go through, we will always be there for you. In the whole world, there is one door you can always come back to – no matter what happens to you in the world – and that door is here at home. We are so proud of you and we love you more than you will ever know. Now let's go and do . . .' Then cut it. Leave the words there. Go on and do what you had planned. This moment might be difficult, but it is one of the most valuable gifts a parent can give their child. The power of the word is amazing. The child will return to the words and never forget them. Often in the future during times of bewilderment and confusion, these words will be played and re-played. And it makes such a difference, especially in an unsheltered time, to recall words of recognition, affirmation and unconditional love. They help build that inner sanctuary where poise and belong-ing come to dwell.

The structures of convention in our world set the standards which are admired. They frequently operate according to the preferences of fashion and acceptance. Convention always excludes those who cannot or will not obey its imperatives. It tends to attack and belittle their way of being. The convention of marriage is often used to castigate the single parent. This is deeply unfair. For many wounded reasons a relationship can become impossible. Even with the best will in the world, it can emerge that two people would destroy each other, and even their children, if they were to remain together. They decide to separate and it falls to one of them to take the children. It is a daunting task to raise children on one's own. The normal work and endurance is doubled. The parent has not a moment of peace. I know many single parents who are quietly, day in, day out living lives of celebration, sacrifice and encouragement. They manage to keep the relationship difficulties in their hearts

and not allow their anger and hurt to leak out onto their children or let it alienate them from the estranged parent. Single parenting is work of great care and sheltering and those who find themselves in this situation deserve far more support and recognition.

AFTER BIRTH: SHE INHERITS NEARNESS, HE INHERITS DISTANCE

EVERY BEGINNING IS OPAQUE. IT OCCURS IN A NEST THAT IS hidden, below the light. The womb is an archive of beginnings. It knows how to receive and nurture beginning. In a way, all later unfolding and growth is the task of truly inheriting beginning. For everyone on earth, woman is the beginning. We begin in woman. To inherit the feminine is an invitation and challenge to each of us. For the little girl-child this inheritance begins with an instinctive, subconscious affirmation: this is what I have to become – what my mother is – I will become a woman. For the boy-child this inheritance gradually structures itself into a negation: this is what I cannot become; though I have found form and dwelt within woman, it is impossible for me to become woman. This is perhaps where the silent lonesomeness of the masculine begins. The male child is thrown into the aloneness of his identity. He must acquaint himself with distance. He has to journey outwards, across space to find the father, to learn the presence and art of becoming a man. In primal contrast to the womb, to the deepest interior of the woman where he formed, he now has to approach the man. This is contact from outside. Regardless of how open, loving and gentle the father is, the child can at best only draw alongside an enclosed world. He has never been within it. The burden for him is longing, clarity and distance. For the girl, there is an equally tender and no less complex endeavour to decipher her identity. Formed within woman, her journey to become a woman is natural and instinctive. There is a

natural continuity between her origin and identity. There are questions she must never face. Unlike the male, she is not confronted with discontinuity. She does not inherit the rupture. Rather than distance, she inherits nearness. Perhaps this is the source of the visceral immediacy, the ability to experience the inner rhythm of life, which the feminine enjoys and suffers. Her burden is to delineate the shape of her own identity against the breath-closeness of the mother-woman. For both male and female this is a lifelong journey of integration. If it becomes a single-focus issue for either, it can cause huge disruption and a crisis of identity. In this context, it is worth noting that Eros is also the force in us that loves wisdom.

THE BEAUTY OF WISDOM

She walks in beauty, like the night
Of cloudless climes and starry skies;
And all that's best of dark and bright
Meet in her aspect and her eyes:
Thus mellow'd to that tender light
Which heaven to gaudy day denies.

LORD BYRON

FEMINISM HAS DONE MUCH TO LIBERATE WOMAN FROM THE shackles of patriarchal culture. It has opened up a new language of recognition of the female and retrieved the wisdom of the feminine from neglected and forgotten traditions. The art of knowing is the heart of wisdom. Knowledge is the key that opens the treasure-houses of presence and possibility. Indeed, beauty itself is a profound invitation to a new kind of knowing. The experience of beauty illuminates everything around it. It awakens deeper dimensions in the seeing of the heart and the mind. Naomi Wolf expresses this in 'The Beauty Myth':

A woman-loving definition of beauty supplants desperation with play, narcissism with self-love, dismemberment with wholeness, absence with presence, stillness with animation. It admits radiance: light coming out of the face and the body, rather than a spotlight on the body, dimming the self. It is sexual, various, and surprising. We will be able to see it in others and not be frightened, and able at last to see it in ourselves.

Traditionally, we have reserved the title 'wisdom' for the highest form of knowing. Wisdom is knowing which embraces the truest feeling of the heart and the most profound seeing of the mind. Wisdom illuminates the deepest nature of things. Such breadth and depth of seeing is no accidental glimpse into the secret of things. It takes long years to gather wisdom, or to come in to wisdom. This is why we so frequently hear the phrase 'ancient wisdom'. It is Eros that draws us towards wisdom. In its depth, darkness and achieved poise, wisdom is the style of knowing that Eros loves. When knowing has been refined in the fires of all the seasons of spirit, it earns the title 'wisdom'. It is an affirmation and recognition of the beauty of the feminine that in the overwhelmingly patriarchal Judaeo-Christian tradition wisdom was recognized as being feminine.

Wisdom is bright, and does not grow dim.
By those who love her she is readily seen,
And found by those who look for her.
Quick to anticipate those who desire her, she makes herself
 known to them.
Watch for her early and you will have no trouble;
You will find her sitting at your gates.
Even to think about her is understanding fully grown;
Be on the alert for her and anxiety will quickly leave you.
She herself walks about looking for those who are worthy of her

And graciously shows herself to them as they go,
In every thought of theirs coming to meet them . . .

<div align="center">Book of Wisdom 6: 12–17</div>

She it was I loved and searched for from my youth;
I resolved to have her as my bride,
I fell in love with her beauty.
Her closeness to God lends lustre to her noble birth,
Since the Lord of All has loved her.
Yes, she is an initiate in the mysteries of God's knowledge,
Making choice of the works he is to do . . .

<div align="center">Book of Wisdom 8: 2–4</div>

The writer identifies wisdom and beauty here. Later on there is the beautiful sentence: 'For nothing is bitter in her company' (Wisdom 8: 16). Wisdom is not just special knowledge about something. Wisdom is a way of being, a way of inhabiting the world. The beauty of wisdom is harmony, belonging and illumination of thought, action, heart and mind. A friendship with wisdom is the key to the door of Providence. Nowhere is that sense of the Eros of wisdom and the shelter of providence more tested than in suffering. True beauty must be able to engage the dark desolations of pain; perhaps it is on this frontier that its finest light appears?

8

The Beauty
of the Flaw

> Breakage, whatever its cause, is the dark complement to the act
> of making; the one implies the other. The thing that is broken
> has particular authority over the act of change.
>
> Louise Gluck

Through a Blurred Surface:
The Glimpse of the Essence

I LOVE THE WORD 'ESSENCE'. IT HAS MYSTERY, HEART AND
luminosity. It reminds me of the way a cloud can open over a
dark Conamara lake and turn it into a shimmering mirror of silver
brightness; for a few moments the lake illuminates. The essence of
a thing is always elusive and hidden. The dream of art and prayer
is to come nearer, even to slip through to dwell for a while in the
vicinity of the essence. Daily life is blurred. We live between end-
less layers of darkening and occasionally brightening veils, but for

the most part we remain outside the walls of what Kant affection-
ately called: 'the thing in itself'. We manage merely to live in the
neighbourhood of things. Their essence remains beyond our reach.
The essence of a person is even more elusive. The medieval mind
used the word 'ineffable' to suggest the essence of individuality.
Your essence is the utter 'isness', the utter 'youness' of you.

A lovely friend in London, an eminent philosopher and
psychotherapist, told me once that when his second child was born
he was granted, for one moment, a pure glimpse of the child's
essence. Often during his child's life, there have been such moments
and even now in the dark-lands of adolescence, where conversation
is scarce and where monologue frequently dims into single
syllable glowering, the father is still given the occasional clear
view. Through the blurred, awkward surface the beautiful
radiance of his son's soul becomes briefly visible. This view always
recalls him to a sense of the hidden eternal light of his child's
life.

After the Bleak Journey, the Hidden Door into the Bright Field

I always feel like an escaped prisoner.
HENRI CARTIER-BRESSON

IT IS HEART-RENDING TO SEE PEOPLE WHO HAVE NO RESPECT FOR
themselves and are unaware of any light or beauty in their lives. We
have a sacred responsibility to encourage and illuminate all that is
inherently good and special in each other. This can have an in-
credible lifelong effect, especially on children: to encourage them to
dream and live so that their dreams might come true. Sadly, many
people do not even suspect that deep behind the veils of anxiety,
emptiness and labour, there dwells a beauty of essence. How have

they become so exiled? What evicted them from the inner sanctuary of their own presence?

Tragically, it does seem possible for a person to utterly destroy their sense of inner beauty. Sometimes this is the result of being badly hurt. How ironical it is, when someone inflicts hurt on us and then departs, that we continue inflicting the same hurt on ourselves, over and over. The ripple of deep hurt continues to beat and beat against the mind. At some deep unconscious level these people become blind servants of a certain pattern of inner destructiveness. Gradually they lose sight of beauty and light. It is as though they find themselves pinned in by all the negative and sore wounding of their lives, encircled by the psychological forces they have set loose on themselves. It is a slow and painful task to break free from the wounded and wounding circle of one's own anxiety. As always in the world of the mind, recognition is a huge transformative force.

When we enter into this world of vulnerability, we stand at a precarious threshold. Anything could happen to us. We are brought through such times by grace alone. In the inner work of personal integration, memory offers us the light by which to decipher the hand of providence secretly leading us through these forlorn and desperate landscapes. It is the paradox of spiritual growth that through such bleak winter journeys we eventually come through a hidden door into a bright field of springtime that we could never have discovered otherwise. This is the heart of the mystical. It is not about building protectionist armour of prayer and religion; it is, rather, the courage for absolute divestment. In the sheer vulnerability of Nothingness everything becomes possible in a new way, but there is an immense temptation to flee back to the shelter of old complacency. Now could be the most important moment in life to steel our courage and enter the risk of change. Meister Eckhart says: 'Stand still and do not waver from your emptiness; for at this time you can turn away, never to turn back again.'

To Discover the Divine Blueprint
in Your Soul

Neither in environment nor in heredity can I find the exact
instrument that fashioned me, the anonymous roller that
pressed upon my life a certain intricate watermark whose
unique design becomes visible when the lamp of art is made to
shine through life's foolscap.

VLADIMIR NABOKOV

THE HEART OF ALL CREATIVITY IS THE AWAKENING AND
flowering of individuality. The mystery and magic of being an
individual is to live life in response to the deep call within, the call
to become who we were dreamed to be. In primal terms, it is the
call to discover and realize the divine blueprint in the soul. This is
where true freedom awaits us. Freedom is not simply the absence
of necessity; it is the poise of soul at one with a life which honours
and engages its creative possibility. There is no other presence in
creation that has such potential for freedom as the human self. Yet
like seagulls in the unsheltered cold and ferocity of the ocean, we
often nest out on the cold ledges of famished extremity and neglect
to remember the meadow where the flowers await. Naturally, there
will be times when truth of heart demands that we live on the
ledges. To remain there, however, resembles an addiction to misery.

To be an individual is to 'stand out' from the group or the system
and such separation always entails vulnerability. Deep in our nature
there is a desire to belong, to fit in. Our bodies are fashioned from
the clay and it is strange for the body to be a separate object able to
move around in space, no longer umbilically linked to the earth.
Perhaps this desire to fit in is the draw of ancient gravity, the desire
of the separated clay to be one with the earth again. This gravity of
belonging is also evident in the animal world. Animals love to take
shelter in each other and dwell together within the embrace of the
herd.

My desk faces a window onto the moors where each day a flock of sheep graze. These Conamara sheep are Zen-like. They dwell utterly here among the mountains and seem to look on the humans as a transient intrusion. The freedom of the human individual is also the loneliness of never being finally able either to submerge its mind in the silence of the earth or melt into the simple innocence of the herd. Indeed, the great irony is that the human becomes most destructive when it reneges on its individuality and succumbs to the herd-mind. A person often does things within the web-instinct of a group that he would never even countenance as an individual. Some dark, primeval rhythm awakens to release a force of destruction that is anonymous and relentless. It is no wonder that the classical tradition had the dictum: eternal vigilance is the price of liberty. The vigilance of the critical intellect enables us to recognize the temptation to regress into herd instinct and to take responsibility for our choices. Faithfulness to individuality is at the heart of compassion and creativity.

More often than not, we feel so enmeshed in the life we have that the prospect of change appears remote or impossible. Thus, we continue on the tracks that we have laid down for ourselves. We are unable to think in new ways and we gradually teach ourselves to forget the other horizons. We unlearn desire. Quietly, over time, we succumb to the dependable script of the expected life and become masters of the middle way. We avoid extremes and after a while we no longer even notice the pathways off to the side and no longer sense the danger and disturbance that could be experienced 'out there'. We learn to fit our chosen world with alarming precision and regularity. Often it takes a huge crisis or trauma to crack the dead shell that has grown ever more solid around us. Painful as that can be, it does resurrect the longing of the neglected soul. It makes a clearance. Again we can see the horizons and feel their attraction. Though we may wince with vulnerability as we taste the exhilaration of freedom, we feel alive! 'Oceans' by Juan Ramón Jiménez captures this beautifully:

I have a feeling that my boat
has struck, down there in the depths,
against a great thing.
 And nothing
happens! Nothing . . . Silence . . . Waves . . .

– Nothing happens? Or has everything happened,
And are we standing now, quietly, in the new life?
 (translated by Robert Bly)

The awakening of individuality is a continual unfolding of our presence. Individuality is not a thing or a position, nor the act of fixed or stolid identity. Individuality is the creative voyage of aloneness in which the gifts and limitations of real presence emerge. The nature of the beginning inevitably holds the rhythm of the future. The secret of individuality is powerfully suggested by the act of birth. We come to the earth in an intensely vulnerable way, for birth is an act of separation. We are cast out into the emptiness as the cord is cut, yet the wound of connection remains open for the visitation of beauty.

EMERGENCE:
BREAKING THE SHELL FROM INSIDE

The sadness and despair of beauty laid bare.
HERMANN BROCH

WE USED TO HAVE HENS ON THE FARM. EVERY YEAR CERTAIN HENS would offer themselves for the adventure of love and motherhood. The sequence of events usually began when a hen would distinguish herself through accentuated 'clucking'. The adult powers intuited that she was having a passionate liaison; consequently, she

was chosen to sit for weeks on a collection of eggs. With the warmth of her feathered body she hatched the eggs. If the weather was very cold and the eggs were almost hatched, my mother would bring them in beside our kitchen fire. Then over days the new chicks would begin to emerge from the eggs. Again the journey was signalled through sound. You would hear the little chicks' beaks faintly tapping at the inside of the shell. Then the sound would become louder and gradually from the inside the shell would be cracked open. The plastic-like inner sealing of the shell would appear. You would see the little beak push against it, almost the way a finger does inside a balloon. Then the sealing would break and the next thing a wet little yellow-haired, greased-up chick would waddle out, looking wet and miserable and fumbling in its movements. After a while it would dry and become the sweetest little creature adorned in a fine fur of golden feathers.

When we are wounded, we close up. Rather than soft, porous skin growing back over the opening, we decide to grow a shell. This idea came to expression in the following poem:

FOSSIL

> No
> Don't cry
> For there is no
> One to tell,
> A mild shell
> Spreads
> Over every opening
> Every ear
> Eye
> Mouth
> Pore
> Nose
> Genital,

A mildness of shell
Impenetrable
To even
The bladed scream;
Soon
All will be
Severed echo,
And the dead
So long
So unbearably long
Outside and
Neglected
Will claim
Their time.

After being hurt, it is natural and indeed necessary that we draw back inside the shell. No-one can force us to emerge and risk growth. Indeed, the probability is that under pressure the retreat will go deeper and the shell only become harder and tougher to crack. Once we recognize how control and self-protection rob life of all vitality and rhythm, we will find ourselves slowly advancing towards the threshold of risk and trust once more. Because life is so short and its invitations so thrilling, it is such a waste to become absent from life. The memory of the birth of new life through the wall of a shell has always remained for me an image of transformation. When the new life had found its form within that sealed darkness, the dream of light awakened it. In an absolute risk for the unknown and the unseen light outside, the chick broke its only shelter, destroyed its nourishing protection, to stand naked and tiny in a foreign world. And sure enough, within a short time, it becomes a joyous and excited participant in the possibilities of its new life. Although there are no guarantees in the kingdom of risk, nature shows us, time and again, that it is precisely at that moment of greatest risk, the moment when everything could be lost, that the

greatest change happens. A new life opens out into a new world that could not have even been dreamed before this. It is difficult to find the courage and vision at the points of deepest wounding to believe that new risk can take us into new life. But there is no alternative. When we remain sealed away inside the shell, we are no longer able to hear our own life. Even the voices that really care for us sound like severed echo. We will grow only more deeply lost, unable to hear even the whispers of the heart.

To Create Beauty out of Woundedness

Beauty triumphs over the suffering inherent in life.
NIETZSCHE

WHEN WE DECIDE TO EXPLORE OUR LIVES THROUGH CREATIVE expression, it is often surprising to discover that the things that almost destroyed us are the very things that want to talk to us. It could be years later; time makes no difference in the inner sanctum of this encounter. The wound has left its imprint. And yet after all this time the dark providence of the suffering wants to somehow illuminate our lives so that we can now discover the unseen gift that it bequeathed. The labour and discipline of creativity refines our blemished seeing, and gradually an unexpected gift comes to light. Because creativity demands patience, skill, expectation, desire and openness, it leads us to another place where we learn to see in the dark. Nothing is said directly in a creative work; it is obliquely suggested. Perhaps creative expression is a way of telling something indirectly that we could never tell out straight.

Beauty is not all brightness. In the shadowlands of pain and despair we find slow, dark beauty. The primeval conversation between darkness and beauty is not audible to the human ear and the threshold where they engage each other is not visible to the eye.

Yet at the deepest core they seem to be at work with each other. The guiding intuition of our exploration suggests that beauty is never one-dimensional or one-sided. This is why even in awful circumstances we can still meet beauty. A simple instance of this is fire. Though it may be causing huge destruction, in itself, as dance and shape and colour of flame, fire can be beautiful. In human confusion and brokenness there is often a slow beauty present and at work.

The luminous beauty of great art so often issues from the deepest, darkest wounding. We always seem to visualize a wound as a sore, a tear on the skin's surface. The protective outer layer is broken and the sensitive interior is invaded and torn. Perhaps there is another way to image a wound. It is the place where the sealed surface that keeps the interior hidden is broken. A wound is also, therefore, a breakage that lets in light and a sore place where much of the hidden pain of a body surfaces. Unlike the natural openings in the body, a wound is an unexpected, foreign opening. Some accident or dark intention forced the breakage of surface. A wound awakens and focuses the reserve of the immune system. The over-riding desire of the body is to seal the opening, to heal and restore its inner darkness. Yet the wound takes its time to heal. While the wound is open, new light flows into the helpless dark and the inner night of the body weeps through the wound. In the rupture and pain it causes, a wound breaks the silence; it cries out. It ruptures through the ordinary cover of words we put on things. Each wound has a unique shape and signature. Woundedness is one of the places where normal words and descriptions break down. We know the distance words have to travel whenever we attempt to tell someone of the pain we feel. It is no wonder then that the wound as the sore point of vulnerability cries out for some new form in which to express itself. As we have seen, the beauty of great poetry and music is often infused with pathos.

The beauty that emerges from woundedness is a beauty infused with feeling; a beauty different from the beauty of landscape and the cold beauty of perfect form. This is a beauty that has suffered

its way through the ache of desolation until the words or music emerged to equal the hunger and desperation at its heart. It must also be said that not all woundedness succeeds in finding its way through to beauty of form. Most woundedness remains hidden, lost inside forgotten silence. Indeed, in every life there is some wound that continues to weep secretly, even after years of attempted healing. Where woundedness can be refined into beauty a wonderful transfiguration takes place. For instance, compassion is one of the most beautiful presences a person can bring to the world and most compassion is born from one's own woundedness. When you have felt deep emotional pain and hurt, you are able to imagine what the pain of the other is like; their suffering touches you. This is the most decisive and vital threshold in human experience and behaviour. The greatest evil and destruction arises when people are unable to feel compassion. The beauty of compassion continues to shelter and save our world. If that beauty were quenched, there would be nothing between us and the end-darkness which would pour in torrents over us.

HIDDEN WHERE NO-ONE COULD FIND YOU: THE MONASTIC CELL IN THE HEART

Give unto them beauty for ashes, the oil of joy for mourning,
the garment of praise for the spirit of heaviness.
ISAIAH 61:3

EACH SHAPE OF VULNERABILITY HAS A DIFFERENT ORIGIN. WHEN I was in priestly ministry I once came to know a woman who had just got news that she was soon going to die of cancer. We worked together for about a month. She was a woman in late middle age. She had a very caring husband and four grown-up children who adored her. It is a privilege to be invited to inhabit such a threshold

with a person in the last weeks of their life. Time takes on a huge urgency. Superficial façades drop aside. There is nothing left to lose or protect. Some of my friends often say they would love to die quickly. They would fear the loneliness of a long, lingering departure: so much better to die without knowing it. Yet this can be such a precious time. The blur of distraction and defensive pretension can give way to real conversation and true encounter. It can become a time for the essence of a person to shine through. As illness wears out the covering of the body, the soul shines forth. As this woman came to trust me, I discovered that she had not really talked to anyone for over thirty years. Early on in her marriage, something had broken down irreparably between herself and her husband. She simply lost what she had with him and could not get it back. There she was inside this home, the mother and the heart of it. She learned to go through all the external motions and she became an utterly convincing domestic actress. But inside she was lost. Gradually she began to accept that there was no path outwards. Then she made a decision to live her intimate life inwardly. She undertook the journey. She went inwards as far as she could and over the years she managed to build some kind of hermit cell within her own heart. And that was where she really dwelt. When she began to talk about herself, it was clear that she spoke from a refined interiority. In a sense, she was not a mother living in a suburban house with husband and children. She was someone who had long since departed to an interior monastery that nobody had discovered. And when death began to focus more clearly around her, she was not afraid. Death was no stranger to her. Having had to build a sanctuary where no-one ever visited, she had come to know the mind of death. She was not thrown by the cold clarity of death's stare or the unravelling force of its singular eye. Nor was there any bitterness in her. She had allowed as much transfiguration as she could. Against the hidden pathos of her life's distance, she had no resistance. She had garnered a fragile beauty from isolation.

'Níl Saoi Gan Locht'

WHILE VULNERABILITY MAY BE THE SOURCE FROM WHICH THE beauty of a work of art emerges, the work of art itself inevitably has some vulnerability in its form. There is an old Irish proverb, 'Níl saoi gan locht' – there is no craftsman without a flaw. Though every work of art dreams of being perfect, there is always some flaw and one rarely meets an artist who is happy with her work. This restless and divine dissatisfaction is imagined by the novelist Hermann Broch, who portrays Virgil's dissatisfaction with his *Aeneid*; he wants to destroy it. I once had the unexpected privilege of spending an afternoon with one of the greatest poets writing in English, R.S. Thomas. During our conversation he was talking about his life as a priest among his people and of his love of being outside in the landscape. At one point he said that if he had been able to stay inside more and remain at his desk, he might have become a great poet. As he was a very serious man, there was no trace of irony or space to counter the claim. But I was amazed that such bleak self-critique could dwell alongside such magnificent and accomplished work. In the end every artist is haunted by a few central themes. Again and again, they return to the threshold of that disturbance and endeavour to excavate something new. This is the magnetic draw at the heart of the wound, the secret force of a silent hunger whose infinite longing is to find its unique voice. When the heart of that force finds its true form, a masterpiece emerges. Elaine Scarry says, 'The beautiful thing seems – is – incomparable, unprecedented; and that sense of being without precedent conveys a sense of the "newness" or "newbornness" of the entire world.'

THE SLOW WORK OF INTEGRATING THE FLAW

I am everything you lost. You can't forgive me.

AGHA SHAHID ALI, 'Farewell'

BEAUTY'S LIGHT COMES UP SLOWLY AND SHYLY ALONG THE EDGES of limitation, confusion, anxiety and helplessness. In such a terrain one would expect anger, resentment, bitterness or destructive negativity. Yet a spirit and atmosphere of graciousness often emerges when the human heart reaches into its own nobility and allows the destructive reaction to disappointment and hurt to open into something more healing and creative. Regardless of outer circumstances and even inner turbulence, we always have the freedom to choose differently. This is a difficult freedom. In many instances, it may be beyond our reach. However, the freedom to choose graciousness is a freedom no-one can take from us. We will always dwell on the frontier of our own limitations and weakness. Each of us is deeply flawed somewhere. We are made of clay and our clay is haunted by gravity. Frequently the flaw can be a point of pure negativity and destructiveness. When the flaw is that severe, it needs to be decisively engaged. Nevertheless, life can take a wonderfully creative turning when we choose to integrate the flaw. It need no longer be a force that diminishes or damages. We can discover the freedom every so often of abandoning the speed and stress of the linear route. The flaw will take us down boreens and pathways we would otherwise never have travelled. We begin to discover new landscapes. Although the journey becomes slow and frequently arduous, through the fractured lens of more vulnerable vision we learn to see neglected corners of the heart that have long awaited the affections of our eyes. We come to remember again that we were not sent here for worldly achievement alone. We find that we are being gently rescued from the illusion of progress, and fragile dimensions of the exiled soul begin to return. In a similar vein Rilke wrote: 'Winning does not tempt that man.

This is how he grows; by being defeated decisively by constantly greater things.'

Howard Rheingold has written of how, in Japanese culture, the presence of the flaw intensifies the depth of an object's beauty. The crack in a vase might be prized as a beautiful signature-moment in which the spirit of the emerging object and the humane heartfulness of the artist criss-crossed. The presence of the flaw personalizes and deepens the beauty and character of a thing. The Japanese have a special word to describe this: 'wabi'. Indeed, this personalization of time as beauty also finds expression in the word 'shibui', the beauty of ageing. Rather than being a fall away from beauty, ageing can be the revelation of beauty, the time when the inherent radiance becomes visible.

The shape of each soul is different. An individual is a carefully fashioned, unique world. The shape of the flaw that each person carries is also different. The flaw is the special shape of personal limitation; angled at a unique awkwardness to the world, it makes our difficulty and challenge in the world different from that of others. When we stop seeing the flaw as a disappointment and exception to an otherwise laudable life, we begin to glimpse the awkward light and hidden wisdom that the flaw holds. As we look deeper, we begin to realize that the flaw might be the first window into a world of difference that we rarely notice. Maud Gonne was an animating force in Yeats's inspiration; in his poem 'Broken Dreams', he writes:

> You are more beautiful than any one,
> And yet your body had a flaw:
> Your small hands were not beautiful . . .

> Leave unchanged
> The hands that I have kissed,
> For old sake's sake.

The Mirror in the Unknown

Whoever cannot seek
the unforeseen sees nothing,
for the known way
is an impasse.
HERACLITUS

THE FLAW SEEMS TO BE THE POINT OF FIXED OR CONSTANT vulnerability, the place where the hope of order is fractured. The revelation of someone's flaw startles and fascinates the social world for it is usually viewed as a helpless, fateful exception to an otherwise ordered life. Yet when viewed against the mystery of the strange and unknown world within, the flaw invites our understanding and compassion. Amidst the infinite diversity of creation, no thing stands out like the human being. Nothing else here is quite as surprising and strange. Because we belong to the human fold we become prisoners of our own familiarity. There is nothing in the world as intense as a human person: each one of us is inevitably and helplessly intense. An individual is a creature in whom difference has come alive. In him difference is everything. Unlike a stone or a tree, it is as if the individual has an inner mirror where he can gather and glimpse himself. This inner mirror is cast at an angle to the mind. It is a small mirror which for the most part remains blurred. When the inner mirror clears, it is but for a millisecond. No-one achieves a full, direct view of himself, only the merest glimpse as swift as a thought. Yet this glimpse grounds everything about your life and illuminates your work, friendships, destiny and identity. All are secretly dependent on that concealed splinter of mirror. It makes everything that happens to you yours; without it, you would simply be an empty receptacle for experiences. You would have no home within you, no place where your life gathered, no source and no centre. The loss of the mirror would reduce you to a sequence of perception, an assembly of qualities. Its absence would make you anonymous.

THE UNKNOWN DWELLS IN RECESSES
OF THE HUMAN HEART

THE DEPTH AND SUBSTANCE OF OUR TALK ABOUT OURSELVES AND who we are is feeble. Listening to much of the language of contemporary psychology and religion, you could not be blamed for imagining that some analyst had actually managed to turn the mind inside out and had decoded it. Most talk about the self disappoints because it presents not the deep, autonomous and unknown inner world, but cipher figures that are easily recognizable as members of some psychological syndrome. Psychology tends to over-identify the flaw with deficiency. The unknown is not simply out there, outside us. The unknown dwells in the recesses of the human heart and becomes especially explicit in our flaws; consequently the true language of the self is hesitant, shadowed and poetic. There is no direct, analytical description of a soul. Even all the epic poetics of a language would not be large or deft enough to embrace the mystery of one human soul. 'I Am Not I' by Jiménez expresses this clearly:

I AM NOT I

I am not I.
 I am this one
Walking beside me whom I do not see,
Whom at times I manage to visit,
And whom at other times I forget;
The one who remains silent when I talk,
The one who forgives, sweet, when I hate,
The one who takes a walk where I am not,
The one who will remain standing when I die.

<div align="center">(translated by Robert Bly)</div>

<div align="center">187</div>

IF OTHERS COULD SEE INTO YOU?

THE IMAGINATION SENSES THE COMPLEX DEPTHS THAT LIE concealed beneath the surface persona. From this perspective, it becomes clear that in many of our interactions with others, we are barely there. One becomes deeply aware of this in time of trouble. Though racked by emotional torment, you can still continue to function. Sometimes indeed this very façade is what enables us to endure and overcome troubles. Shakespeare wrote: 'There's no art to find the mind's construction in the face'. It is a wonderful grace to be shielded and covered from the world, especially in difficult times.

Imagine how impossible it would be if the inner life were visible. When you came into the office, everyone would look up and be able to read exactly what was in your heart as though your skin were transparent. If our inner wounds were visible to the curious eyes of strangers, we would never achieve healing. Put simply, if interiority were directly visible, society as we know it would be impossible. The conventions we observe would lose their authority and confrontations with others would become the norm. People-watching would take on a new and disturbing significance. Gossip would emerge from the nether region of surmise and exaggeration to achieve the status of fact. The standard of the normal person could never be employed again. Without the restraint of body-covering, raw individuality would leak into the social matrix from every corner. Were the threshold between the inner and outer world to disappear, the life of each person would become a permanent, external theatre and the façade of the exterior would become very fragile. This breakdown would call a new kind of society into being. No facts about yourself and none of your thoughts or feelings could be concealed. Yet the meaning of what was now visible could be complex and hidden. Such transparency would be terrifying – an inner life lived out in the open before everyone's eyes. In such a world the idea of friendship would certainly be

different. Perhaps this transparent world is where the pre-born and the dead live.

The Darker Beauty Dawns More Slowly

One does not become enlightened by imagining figures of light,
but by making the darkness conscious.

CARL JUNG

BECAUSE YOU ARE OPAQUE TO YOURSELF, YOU ARE NEVER FINISHED with yourself: this is the quest for meaning. You never own yourself and stand constantly at new frontiers wondering what lies beyond. There is a beauty in discovery that deeply satisfies us. When you discover something new about yourself, you become more grounded and free. It is delightful when you find out more of your hidden light, when the radiance inside you glimmers through in new, unexpected colours. Without being narcissistic or arrogant, you are quietly nourished by the discovery of the beauty – the diversity – that dwells in you. But discovery can also be difficult. When you begin to excavate the darker beauty of your complexity, you may become startled by your own strangeness.

Framed with our own thought-world, routines and expectations, only rarely do we get a glimpse of how strange we actually are. We usually ignore and avoid the ever-present and curious strangeness that dwells in each individual. Each of us is aware at some time of our own strangeness. At night our dreams throw up peculiar shapes and figures. Sometimes even the most respectable people, the veritable pillars of society, have a fascinating night-life. They are up to things in their night-time dream-world that would not even cross their minds during the day. When they lose their grip on the day and sleep takes them, they become wild other people in their dreams. The ancient Greeks believed that the figures in our dreams

were real. They left the body during the night and came out into the world to act out their stories but returned before the person awoke. When you consider where we go and who we become in dream, it is often an achievement to show up for breakfast in the morning!

Strangeness attracts the imagination. It is drawn to the fissures in behaviour where strangeness becomes visible. One of the intriguing areas here is where the failure of another person becomes the occasion for revelation of oneself. Failure becomes a ruthless mirror where the false façade of morality and values is questioned and exposed. Joseph Conrad evoked this dilemma in 'Heart of Darkness' and in *Lord Jim*. The failure of an admired character or mentor subverts the belief system of the key character. Dostoevsky also explored this theme in epic fashion in *The Idiot*, where a saintly figure and a criminally destructive one are locked in mutual fascination. Sometimes the tame and the strange become very attracted to each other.

Part of the beauty of the act of discovery is the integrity of its desire for wholeness. Your soul will not want to avoid or neglect the regions of your heart that do not fit the expected. When you trust yourself enough to discover and integrate your strangeness, you bestow a gift on yourself. Rather than annulling a complex part of your heart which would continue to haunt you, you have thrown your arms around yourself to embrace who you are. This is at the heart of holiness. Holiness is not complacent refuge in the glasshouse of pale pieties. To be holy is to enter the dense beauty of passionate complexity. In his classic book *On the Idea of the Holy*, Rudolph Otto said the experience of the holy is at once 'tremens et fascinans', trembling and fascination. And Edgar Allan Poe said: 'There is no exquisite beauty without some sense of strangeness in its proportions.'

THE BEAUTY OF AN IDEAL:
A CALL TO YOUR DEEPEST CREATIVITY

For with a wound I must be cur'd.

SHAKESPEARE

WHEN YOU BECOME VULNERABLE, ANY IDEAL OR PERFECT IMAGE you may have had of yourself falls away. Many people are addicted to perfection and in their pursuit of the ideal they have no patience with vulnerability. They close off anything that might leave them open to the risk of hurt. An ideal is certainly a beautiful thing and part of the crisis in Western culture is due to the erosion of ideals. With the revelation of corruption in so many political and religious domains, our perception of ideals has become tinged with cynicism. Yet no society can endure without the sense of honour, dignity and transcendence enshrined in its set of ideals. Also in one's individual life the sense of excellence in the ideal encourages you to realize what is best in you, to reach beyond your limitations to a level where something new and surprising emerges. Every poet would love to write the ideal poem. Though they never achieve this, sometimes it glimmers through their best work. Ironically, the very beyondness of the idea is often the touch of presence that renders the work luminous. The beauty of the ideal awakens a passion and urgency that brings out the best in the person and calls forth the dream of excellence.

The beauty of the true ideal is its hospitality towards woundedness, weakness, failure and fall-back. Yet so many people are infected with the virus of perfection. They cannot rest; they allow themselves no ease until they come close to the cleansed domain of perfection. This false notion of perfection does damage and puts their lives under a great strain. It is a wonderful day in a life when one is finally able to stand before the long, deep mirror of one's own reflection and view oneself with appreciation, acceptance and forgiveness. On that day one breaks through the falsity of images

and expectation which have blinded one to one's spirit. One can only learn to see who one is when one learns to view oneself with the most intimate and forgiving compassion. Such a glimpse of one's essence can utterly rejuvenate a life and enable one to find the hidden wisdom in the beauty of the flaw.

Death is the great wound in the universe; it is the ultimate vulnerability that overshadows every footstep.

9

THE WHITE SHADOW: BEAUTY AND DEATH

But: for me, death is past. It has already taken place. My own. It
was at the beginning . . . Of course death also has a future for me.
But I am not expecting death. I am expecting to cross it, to spend it.

HÉLÈNE CIXOUS

THE PATHOS OF BEAUTY

BEAUTY SHINES WITH A LIGHT FROM BEYOND ITSELF. LOVE IS
the name of that light. At the heart of beauty must be a huge
care and affection for creation, for nowhere is beauty an accidental
presence. Nor is beauty simply its own end. It is not self-absorbed
but points beyond itself to an embrace of belonging that holds
everything together. Yet not everything is beautiful and in a broken
world occasions of beauty point to possibilities of providence that lie
beneath the surface fragmentation. When we endeavour to view
something through the lens of beauty, it is often surprising how
much more we can see.

Beauty is such an attractive and gracious force precisely because it is so close to the fractured side of experience. Beauty is the sister of all that is broken, damaged, stunted and soiled. She will not be confined in some untouchable realm where she can enjoy a one-sided perfection with no exposure to risk, doubt and pain. Beauty dwells in the palace of broken tenderness. This is where the pathos of beauty shines forth. Pathos is the poignancy that comes alive in our hearts in the presence of loss.

No life is without its broken, empty spaces. In the West of Ireland almost each village has some story of a haunted room in a house. This is a room where the strain of an otherworldly, ghostly presence is felt and there is always a narrative to sustain such an appearance, some story of woundedness or loss. That haunted room somehow stands outside time; it holds a memory that never lessens with the passage of years. The memory remains a wounded presence. Somewhere in every life there is such a haunted room. Like cursed treasure, all the losses of one's life seem to gather there. Pathos arises when something in the sequence of present experience brings us into direct contact with the burn of past loss. Socially the surface of our culture is fascinated with the break-up of relationships and the glamour of new partnerships. But the camera eye has loyalty only to the moment and always moves on. Little true attention is given to the secret, private death which the end of a relationship can bring. The deeper radiation of intimate tissue is concealed. Externally, an impression is given that one has already 'moved on', as the signal phrase has it. The truth is slower, more painful; when you have truly loved, it can take a long time to 'move on'. Pathos can awaken when, for instance, you unintentionally find yourself back in the same place or landscape where you shared a special time with your beloved. You may hear a piece of music which immediately turns your thoughts to one previous moment of love. Old loss rekindles as you know this time, this place; this joy can never be recaptured.

To Learn How to Inhabit Loss

If our two loves be one, or thou and I
Love so alike that none do slacken, none can die.

JOHN DONNE, 'The Good-morrow'

PATHOS IS ESPECIALLY PRESENT IN GRIEF. WHEN SOMEONE YOU love has died, it takes a long time to learn the art of inhabiting the loss. One of the loneliest times in this journey is when you have to clear the person's wardrobe and decide what to do with their personal effects. When you see again the objects of their affection, the clothes they never again will wear, these things become receptacles of your sense of loss for they are link-objects still connecting you to the departed. In this sense they become 'sacred objects'. There is some corner of the heart that remains faithful to all that we have loved. Even years after a loss, the sight or scent of something associated with the departed can still quicken the heart. The tragedy is, the longer you live, the more friends you lose. As the world grows older, the ruins of loss multiply and the textures of pathos deepen. Dietrich Bonhoeffer, the theologian, has a powerful passage in his *Letters and Papers from Prison* about being faithful to the vacancy of loss:

The Unfilled Gap

Nothing can fill the gap
When we are away from those we love and it would be
Wrong to try to find anything

Since leaving the gap unfilled preserves the bond between
Us. It is nonsense to say that God fills the gap.

He does not fill it but keeps it empty, so that our communion
With another may be kept alive even at the cost of pain.

The beauty of pathos is tenderness, a testimony to affection and care and recognition that love is always vulnerable. Pathos is the enduring witness to where our hearts have dwelt. This is evident in our relationship to our home. A home is not simply a building; it is the shelter around the intimacy of a life. Coming in from the outside world and its rasp of force and usage, you relax and allow yourself to be who you are. The inner walls of a home are threaded with the textures of one's soul, a subtle weave of presences. If you could see your home through the lens of the soul, you would be surprised at the beauty concealed in the memory your home holds. When you enter some homes, you sense how the memories have seeped to the surface, infusing the aura of the place and deepening the tone of its presence. Where love has lived, a house still holds its warmth. Even the poorest home feels like a nest if love and tenderness dwell there. Conversely, the most ornate, the grandest homes can have an empty centre. The beauty of a home is ultimately determined by the nature of its atmosphere, by the texture and spirit of those who dwell there. A house is like a psyche in the patterns of spirit it absorbs and holds. The art of memory is its secret weaving, how it weaves together forgotten joy and endured sorrow.

DEATH: THE FIRST TIME YOU LOSE THE WORLD

I find my bearings where I become lost.
HÉLÈNE CIXOUS

IN OUR TRADITION, THE LONELINESS OF DEATH IS USUALLY described with reference to those around the deathbed and the heartbreak that death brings. Yet for the one dying, how lonely it must be to lose the world. This is the first time that it is about to happen. All difficulty and sorrow up to now still happened in the world, in the home or some other familiar places. No matter how

intense the devastation of the pain was, one still continued here, picked up the rhythm of one's life and continued on. There are things of primal familiarity so deep that we never notice them. Being here in the world is a wondrous gift. Because we have always been here, we never render the surprise and shock of 'being here' explicit. From day to day we assume fully the role of being here; there is no elsewhere to consider as a destination. And because we are always in our bodies, we never gain distance. Every feeling, thought, delight, danger and confusion we have experienced, we experienced them all in this one body. The body is the inestimable gift that grounds our memory, perception and imagination. The horror of death is that we are in the same moment forced out of both worlds. We lose the world and we lose ourselves. There can be no greater distance on earth than that between the moment when life ends and the new moment when our post-life begins. The distance is infinite because of the utter break in physical continuity. We know nothing of what it is like to step onto that other shore. And it is incredible that no-one has ever been able to cleanly return to explain the journey. This raw factuality renders the loss of the world poignant and helpless. We may 'rage, rage against the dying of the light', but we cannot hold our grip here. Like the fall of sleep, it comes over us. However, this sleep will allow us no dreams and will never let us through to morning.

This is forced eviction from the world and from the body, the only home we know. To ordinary human eyes it seems to be a total and definitive eviction. Once evicted, we can never return. Within the whole sequence of life's narrative, there is no cut like death. Every other ending in life is gathered forward into some other new beginning. The end of childhood is the beginning of growth into adulthood. The loss of a friendship can become the space for a new love or for a sorrow that can blight your life. One way or the other, the narrative continues. Not so with death. The continuity ends. The line of a life is left suspended from a cliff-edge. Everything is gone.

THE CHOREOGRAPHY OF DEATH:
THE SILENCE AND STILLNESS

Nothing for us there is to dread in death.

LUCRETIUS

WHEN SOMEONE WE LOVE DIES, IT IS STRANGE COMING TO TERMS with their disappearance. At death it becomes clear how invisible a person's life really is. The body still remains somewhat visible. But it has already become empty and is crossing the threshold into its own transformation. The crucial event is that the life of the person has now departed. Like a candle blown out, the flame has vanished. This was the old philosophical question: where does the flame go, when the candle is blown out? In one, unseen swiftness the life goes out. We see nothing. It seems that the essence of a person, the spirit which pervades every pore and cell and is expressed in every thought, feeling and act, can withdraw in one sweep like a wave from the shoreline. It is strange that something which was invisible in the first place can actually vanish and cause the ultimate collapse of everything: the memory, the breath, the body, the thoughts, the knowing, the Eros, the dreams and the eyes and the touch. Nowhere else in creation does an ending take so much with one stroke. Quantitatively in terms of objects there are larger endings. Yet because the object called the human body holds a world that death stops, it is an incredible event. Death is the end of a world; it unravels a unique geography of feeling, tenderness, creativity, sorrow, doubt and shadow; it all comes apart like a piece of knitting unravelling, stitch by stitch.

'THE MOST REMARKABLE THING I EVER HEARD'

IF SOMEONE WERE TO ASK ME: WHAT IS THE MOST REMARKABLE thing you have ever heard? I would say: the most remarkable thing

I ever heard is, there is death. When we were children there was an old woman who minded us now and again. She lived across the river and it was a real treat when we were brought to visit her. She was like a grandmother to us. Though everyone was poor, she could always manage to have some surprise put aside for us. Then one day, she died. It was the first time I heard of death. To a child's mind, it was the most incredible news. She was gone and would never come back. We would never see her again and no-one could say where she had gone. They talked of heaven, but it seemed like a feeble fairytale when pitted against her vanishing. I could not believe it. Death had come out of nowhere and taken her. I had never once even suspected that there was such a thing as death. It came as a pure shock. To think that everyone had known about death all along and that they could continue working and talking while knowing this awful end, this bleak disappearance awaited each of us. To a child's mind it was a massive breakage of innocence. What struck me too was how silently death came to take her.

One would surely have expected that such an intensely dramatic event would have been accompanied by a great whirl of sound and colour, and yet the opposite happened. Death was not an action; it was an anti-act. It came silently and left an awful silence in its wake. There is deep silence in death. It can carry out its task without invitation or warning. Death needs no word to frighten or force anyone. In silence it takes you into a silence from which no echo returns. From the moment of your beginning, through all days and climates of mood and dream, the music of your heart has never stopped. Sending its rhythm along vein and bone, it has held you alive and present. Even when you visited deep into the realm of silence, your heart's music never ceased. Only death's silence will stop it.

Death is also the master of stillness. Everything that has life moves. Raised on a farm, we learned early to notice the slightest movement against the spread of the landscape. The hill-man's eye

could spot something stirring far off on the other side of a hill; it may have been a hare, a rabbit, another animal or a bird. The eye was trained to the rhythm of the place. Against the backdrop of this familiar landscape, if an animal seemed too still, that alerted the eye too. The animal could be sick or dead. In the world of nature, life moves, but death makes still. When you first see the remains of someone who has died what strikes you is how a presence that was always astir with voice, gesture and gaze is suddenly enveloped in cold stillness. Your eye wants to believe the person is merely asleep. You imagine you glimpse the chest stirring with breath. You stare deeper and your eyes recoil from the unnatural stillness. A neighbour who lived near two elderly ladies told me how he was called to the house as one of them had been taken ill. As soon as he came into the kitchen, he realized the woman was dead. Poignantly her sister was holding her hand, shaking her and calling her name over and over as if trying to awaken her from sleep. The neighbour gently calmed her and explained that her sister had gone. Her inability to register had been due to shock and also to the inability to see her loss. In a way, it was a natural response. She had never seen her sister dead before. It is a tremendous shock to come upon a loved one freeze-framed in that stillness.

To Help a Person to Die: The Most Beautiful Gift

THE ACT OF DYING IS A HUGE PERSONAL EVENT. NOTHING ELSE that you do in your life will bring such change. In no other experience is the transformation as ultimate and irreversible. In no other experience in your life do you have the opportunity to become invisible. Your death will make you permanently invisible. You will become free of the human gaze and free of place. While you are alive you are always somewhere. Through death you will be no

longer bound to any location. Death is the absolute and irreversible event of change. Friends and family who surround the departing one are confined to the outer perimeters of the event. There is a journey beginning here but it is not a physical journey. It is a real journey: someone is leaving and will not be returning. Yet the journey is into an interior and it is an invisible journey. At birth the journey here creates the traveller, the invisible becomes visible. At death the return journey re-creates the traveller, the visible becomes invisible again.

We prefer to avoid talk of death. It is amazing that aside from minimal and superficial reference, the theme of death is absent from most of our conversation. Our culture avoids it too. Where time is money no-one really wants to focus on that edge where time runs out on you. Our education system never really considers it; we have no pedagogy of death. Consequently, death is something we are left to deal with in the isolation of our own life and family. When death visits, there is no cultural webbing to lighten the blow. Death can have a clean strike because the space is clear. Against this background, it is not surprising that we are never told that one of the greatest days' work we could ever do in the world is to help someone to die.

THE DEATHBED AS ALTAR

> Death is the mother of beauty; hence from her,
> Alone, shall come fulfilment to our dreams
> And our desires.
>
> WALLACE STEVENS, 'The Deathbed as Altar'

THE IMAGE OF THE DEATHBED FRIGHTENS US. WE END UP THERE because someone we love is departing. But we don't really know what we should do. As well as being distraught with sadness, we

are unsure and awkward. We usually resort to cliché or rush for religious ritual. Yet some people instinctively reach into the heart of the event and extract the treasure.

Over a year ago, a group of students from a university in Ireland went to work in London for the summer. One member of the group, a young American, stayed here to study for autumn exams. One weekend he was visiting relatives in London and phoned his friends to arrange to meet up. But tragedy had just struck the group. The night before, they had been at a party and one of them had tried Ecstasy for the first time. Shortly afterwards, he went into convulsions and was brought to hospital, where he slipped into a coma. The young American went straight to the hospital. All of the group was there with the parents of the young man. A doctor came in and explained that everything possible had been done but the young man was brain dead and he had come to unplug the life-support machine. Everyone was numb and helpless. Just as the doctor was about to unplug the machine, the young American student said: 'Wait.' Showing sensitive leadership, he said: 'This is our friend. Let us take some time before we do this. Let each of us spend a special private moment with him and whisper something special in his ear to bless him on his journey.' They took the time. Each one blessed him. Then they waited and let the silence settle for the event to become sacred, and for their presence to deepen and become a real circle of shelter around their friend, and only then was he released into his journey.

A deathbed is such a special and sacred place: a deathbed is more like an altar than a bed. It is an altar where the flesh and blood of a life is transformed into eternal spirit. Rather than being unsure, anxious and bungling, we should endeavour to be present there with the most contemplative, priestly grace. Regardless of the shock and pain of our grief, our whole attention should be dedicated to the one who is setting off on their solitary journey. We will have plenty of time later to engage our own grief. Now we need to provide the best shelter, the sweetest love, the most sensitive listening

and the most wholesome words for the one who is dying. This is the most significant time, the last moments of time on earth. Therefore, it is vital to attend and listen. Perhaps there are last things a person wishes to say, things from long-forgotten past times he always wished to say but never could. Before the great silence falls, he might desperately need to tell something. And there may be things that need to be heard. Perhaps someone around that deathbed has waited all their life to hear something vitally healing and encouraging and perhaps these are the hours in which it might be heard.

WHEN DEPARTURE BECOMES TRANSFORMING PRESENCE

Death . . . the undiscover'd country.
SHAKESPEARE, *Hamlet*

I AM NOT SUGGESTING THAT THE DEATHBED BE CONVERTED INTO a clinical monastic cell. Indeed the situation around a deathbed can often be raw and wholesome with surrealistic splashes of black humour. In and through all of this, however, it is vital to provide an atmosphere whereby the deeper levels of what is happening can emerge and be engaged. A deathbed is not a dead place; it can be a place of intense energy. A woman told me recently that holding her father-in-law in her arms as he slipped into eternity was an incredibly transformative experience for her, more transforming in fact than the birth of her two children. She felt privileged and honoured to be with him at his end.

When the activity of departure becomes a liturgy of real presence, amazing things can happen around a deathbed. I have seen reconciliation happen here that no-one could have predicted that anyone would ever have been able to effect. I have seen frozen

years of silent cohabitation, where nothing was shared or said, break like a shell and the essence and warmth of two hearts embrace before the final silence. It is amazing so near the bleak frontier to see how words can become jewelled. Words that come alive here often go on to accompany lives with shelter and grace. For the person who is dying, wholesome words can be an enormous encouragement and shelter. As we have seen, it is a privilege to be present when someone embarks upon the journey into the silence. If you attend reverently and listen tenderly, you will be given the words that are needed. It is as if these words make a raft to carry the person over to the further shore. We should not allow ourselves to settle for being awkward and unsure around a deathbed. There is vital and beautiful work to be done there. When you realize that the dying person needs and depends on your words and presence, it takes the focus off your limitation and frees you to become a creative companion on that new journey. One of the most beautiful gifts you could ever give is the gift of helping someone to die with dignity, graciousness and serenity.

DEATH AS TRANSFIGURATION:
YOUR SOUL HAS NO FEAR OF DEATH

> Therefore, be cheer'd;
> Make not your thoughts your prisons.
> SHAKESPEARE

WE AVOID THINKING ABOUT DEATH BECAUSE IT MAKES US AFRAID. There is no-one to intercede with, no-one that could call off your death. When we view death in a purely physical way, it is that frightening ending where a life is stopped and cut off. However, it is possible to see death in a different and more creative way. To view death as an abrupt, dumb stop is unfair to the beauty, struggle

and growth of a life. It seems unlikely that life would choose us so carefully, bring us through so much and then simply offload the whole harvest of journey over a cliff. That in one sudden, dead moment all growth, memory and presence cease seems to fall out of rhythm. So much could not have been so carefully built to be simply destroyed in a second. Something more profound and ultimate is happening behind the veil. This idea is expressed well by the Chilean poet Gabriela Mistral: 'No, I don't believe that I will be lost after death. Why should You have made me fruitful, if I must be emptied and left like the crushed sugarcanes? Why should You spill the light across my forehead and my heart every morning, if You will not come to pick me, as one picks the dark grapes that sweeten in the sun, in the middle of autumn?'

The imagination has an eye for the invisible. And the real event in death takes place in the realm of the invisible. At a deathbed the merely physical eye sees an old man, worn and weary, breathing his last. At a deeper level, however, this death is an event where the inner life of this person is gathering and refining itself to slip through the door of air. No-one dies poor or empty. The subtle harvest of memory collects here: all the days and places of a life, all the faces, the words and thoughts, the images, all the small trans-figurations that no-one else noticed, all the losses, the delights, the suffering and the surprises. All the experiences of a life collect together in their final weave. No-one knows how they will die. When the time comes, it would be so consoling to be in the embrace of loved ones. Yet for many people this is not the case; they die alone or are hurled unexpectedly into eternity by accidents, murder or war. One can only hope, despite the awful outer circumstances, that somewhere in the interior, invisible level where the dying happens, serenity and grace prevail.

The soul is the real container of an individual's life. The eye always assumes that it is the physical body that holds a life. However, rather than the soul being simply a component or presence within the body, the soul surrounds and pervades the

body. The body is in the soul. This means that the soul has a different kind of knowing than the mind and its thoughts and feelings. While the knowing of the mind is limited by frontiers, the soul has no frontiers. At death, the mind is up against the last and ultimate frontier. It will attempt to understand and, with dignity and hope, accept what is ending and what is coming. However, the soul knows in a different way. The soul is not afraid. It has no reason to be afraid, for death cannot touch the soul.

When the River Reaches the Cliff-edge

ALL THROUGH YOUR LIFE YOUR SOUL TAKES CARE OF YOU. DESPITE its best brightness, your mind can never illuminate what your life is doing. You are always in a state of knowing, but that knowing, while often lucid and deep, is more often faltering and shadowed. At times you feel immensely present in your life, rooted in what is happening to you, utterly there. At other times you are only vaguely in your life; things are blurred, confusion or distraction owns your days. In such times you remain attached to the earth by only the slightest thread. Yet through all these times, your soul is alive and awakened, gathering, sheltering and guiding your ways and days in the world. In effect, your soul is your secret shelter. Without ever surfacing or becoming explicit, your soul takes care of you. Never once while you are here does your soul lose touch with the eternal. Your soul makes sure that God's dream for you is always edging towards fulfilment even when at times the opposite seems to be the case. At times of immense suffering or the most ecstatic joy, your life breaks through the shadowing and you come to sense that something else is minding and guiding you. This is the nature of the consolation and infinitely tender embrace your soul always provides for you. If this is true of the flow of your days, how much more tender must that caring be at the

time of your death when the river reaches the edge of the cliff?

At the deepest heart of your life, in your soul, there is no fear of death. Your soul is well prepared for the arrival of death for it knows that death cannot destroy you. It will change you, and change you beyond recognition to those you leave behind, but death cannot disassemble you.

All through your life, the most precious experiences seemed to vanish. Transience turns everything to air. You look behind and see no sign even of a yesterday that was so intense. Yet in truth, nothing ever disappears, nothing is lost. Everything that happens to us in the world passes into us. It all becomes part of the inner temple of the soul and it can never be lost. This is the art of the soul: to harvest your deeper life from all the seasons of your experience. This is probably why the soul never surfaces fully. The intimacy and tenderness of its light would blind us. We continue in our days to wander between the shadowing and the brightening, while all the time a more subtle brightness sustains us. If we could but realize the sureness around us, we would be much more courageous in our lives. The frames of anxiety that keep us caged would dissolve. We would live the life we love and in that way, day by day, free our future from the weight of regret.

NOT ONE MOMENT OF YOU WILL BE LOST IN THE CROSSING

> When night asks
> who I am I answer, *Your own*, and am not lonely.
> LI-YOUNG LEE

AT THE TIME OF DEATH, THE SOUL KNOWS HOW TO PROTECT ITS precious cargo. While death will stop and empty the body, the soul will ferry your essence into eternal life. Not one moment of you will

be lost in the crossing. Eternal life is the province of the soul; this is where the soul is at home. For your soul, then, death is indeed a homecoming. Naturally the soul will feel the sadness of withdrawal from the visible world. Ultimately, however, physical death must also be an adventure for the soul. There must be excitement for the soul at the edge of such transformation, and joy in bringing the bright essence of a life's harvest into eternity. Perhaps this is the reason why at a deathbed you often notice that another presence takes over. The taut lonesomeness of the death struggle eases; below the personality and physical body some other level of the person's spirit has awakened. You look at the dying and sense that they are now beginning to belong more fully to the unseen world. Indeed, they will often tell you that they have just glimpsed the countenance of some long-departed friend or family member. Already their vision is altering. Now they are beginning to see the eternal tracings of the invisible world. It can be an incredible thing to really look into the eyes of the dying. Often you see such beauty dawning there. It is as if the whole tenderness and dispersed beauty of the person's life focuses in their eyes.

If we befriend the mystery of the soul, then we sense the secret depths to our life. And if we come to trust these depths and realize that here is where the significance of our life dwells, then we come to awaken more and more to our true life. Fear, falsity and the struggle for image cease to absorb us. We learn to live *in* the world but grow sure that we are not simply *of* the world. To awaken to the soul is to enter a new rhythm of dignity. Despite awkwardness, confusion and negativity, this rhythm of soul-elegance will continue to prevail. And when the invitation of death arrives, we will be given the strength and light to transfigure our fear. Strange as it may sound, we will come to trust death as the deeper dignity within us carries us through the travail of departure. At death the infinite within us will come good: there is no need to be afraid.

In the House of Eternal Belonging
Birth and Death Are One

> Our birth is but a sleep and a forgetting:
> The Soul that rises with us, our life's Star,
> Hath had elsewhere its setting,
> And cometh from afar;
> Not in entire forgetfulness,
> And not in utter nakedness,
> But trailing clouds of glory do we come
> From God, who is our home:
> Heaven lies about us in our infancy!
>
> WORDSWORTH, 'Ode. Intimations of Immortality'

NO THOUGHT CAN TAKE AWAY THE STRANGENESS OF DEATH. However you approach it, the fact that death awaits us but that its time and form remain unknown is strange. Nothing else that waits for us will make such a claim on us. Death weights the future. Imagine if you could say 'I am glad that my death is behind me' – what a different world you would be speaking from. Unfortunately, death dissolves subsequence and allows no afterwards and it assumes such power because it lies out of reach further down the line. In fact, it marks the end of the line. Perhaps if we could get beyond thinking of time as a line of life and life as a lifeline, we might be able to salvage a more hospitable understanding of death.

No sooner have we arrived on earth than we become excited hostages of the future. Our thoughts, words and actions are never neutral. Meanwhile behind us the future we have just traversed piles up. Claimed by the continuous generosity and promise of the future, we forget where we have come from. We forget our birth and we hardly ever think further back to the time before our birth. When we do think of birth in this way, an unexpected kinship emerges between death and birth. Each is the intimate and ultimate

gateway. Birth is appearance; death is disappearance; or the reverse, for all we know. This kinship is unforgettably portrayed in the opening paragraph of Nabokov's *Speak, Memory*:

> The cradle rocks above an abyss, and common sense tells us that our existence is but a brief crack of light between two eternities of darkness. Although the two are identical twins, man, as a rule, views the prenatal abyss with more calm than the one he is heading for (at some forty-five hundred heartbeats an hour).

If we could see time as a circle, we might be better able to see how birth and death belong within the one embrace. Could it be that where we come from at birth is where we return to at death? When we think of birth and death together, death begins to lose its terror as an unknown abyss where the intimacy of a life is erased. If the light and beauty of who we are was dreamed and created in that realm before birth, then death is surely bringing us home to the house of our eternal belonging. And if everything we are is a gift from that home of dream, then our return will be a celebration of all we have awakened, realized and lived. Perhaps, deep within us there will be no great surprise at our return, for there may be a silent dimension of the heart which through all the years has never forgotten where it came from. Perhaps this is why beauty touches us so deeply. When beauty touches us, we remember who we are. We realize that we have come from the homeland of beauty.

Each life is enfolded within a circle of time and if we imagine this circle as porous, occasionally, as we journey through our days, time suddenly deepens and all fragmentation coheres as we slip into eternal presence. Eternal time dwells deep in ordinary time. As we say, such moments become timeless and what is timeless does not pass away; it lives for ever. Eternity is then not to be considered as an infinite quantity of days. There is the image of eternity as an endless desert. Once every hundred years a raven comes and takes away one grain of sand and eternity will last until all the sand is

removed. Caught between the shadowing and brightening of our days, we can have no clear view, yet our glimpses of the eternal world would suggest that it is not a matter of infinite quantity so much as a pure refinement of presence. And maybe this is the unseen gift that death will bring, namely, a refinement that trans- figures us in order that we may dwell completely in eternal presence. Again this would not be foreign to us. Indeed the times of deepest delight in life are those moments when everything comes together and we feel divinely alive. Time opens and the eternal enfolds us. Though we slip back again into the breakage of days and moments, we never lose that feel of the eternal.

'BEHOLD, I AM MAKING ALL THINGS NEW'

MEMORY IS THE PLACE WHERE OUR VANISHED DAYS SECRETLY gather. Already within the passage of time there is a harvesting of our experience. Without memory, you would not be who you are. All that has happened to you in your life awakens and unfolds your individuality. All that has hurt you, gladdened you, deepened you and challenged you tells you who you are. Your experience is your most intimate creation. No-one else knows your experience in the way you do. No-one else sees what has happened to you in the same way as you see it. Something that seems trivial to another could be heart-rending to you. When you love someone and come to know them, you learn to tune your heart to the rhythm of their sensitivity. Through all your time together, this attunement becomes the ground of your ability to understand, forgive and care for each other. When someone you love is dying, your sorrow is for the loss of them and the loss of the world they carry. Eternal life must mean that neither the person nor their world is lost. Eternal life must mean the continuity beyond death of that individual life and that individual world.

Eternal life must also mean that one day we will be together again with the ones we love. This is the beauty of the notion of resurrection. In much contemporary thinking there is the tendency to view death as a simple dissolution whereby the body returns to mother earth and the spirit slips into the air to become one with the universe. While this claims a certain elemental continuity, it cannot be described as the eternal life of the individual. This view would accept death as a reversal and unravelling of the mysterious and intricate weaving of an individual life and it seems to offer very little. Indeed, all it delivers is a bland description of death as an elemental physical process. The intimacy and mystery of the individual life is merely loosed into anonymous, vague energy. In contrast, the resurrection promise is the continuity of the individual life in transfigured form. We will be ourselves. We will recognize each other and we will be together, reunited for eternity.

'I Wonder If There Is Grass in Heaven'

MUCH OF OUR CHRISTIAN THEOLOGY HAS PRESENTED HEAVEN AS an idealized realm somewhere at the outposts of infinite space. Heaven has to be as distant as possible from the shadow-lands of human imperfection. The distance also seemed to account for the absence and silence of the dead. Such a distant, pure region was always too abstract for the folk-mind. I remember one delightful conversation where the abstraction was punctured. When I was a child I heard an old neighbouring woman ask my father: 'Paddy, I wonder if there is grass in heaven?' With my child's eye I could imagine a sweep of green after-grass breathing in the silver realm of heaven! If we were to imagine heaven as a state rather than a place, we could say that heaven is as near as God and there is nothing as close as God. Heaven is not elsewhere. It is here, in the unseen, beside us.

Similarly, the dead are not distant or absent. They are alongside us. When we lose someone to death, we lose their physical image and presence, they slip out of visible form into invisible presence. This alteration of form is the reason we cannot see the dead. But because we cannot see them does not mean that they are not there. One of the oldest and most beautiful metaphors to convey this change of level is the journey of the larva to become a butterfly. Once it is a butterfly it cannot go back and re-enter the world of the larva. As larva it was bound to earth and water; now as butterfly it inhabits the air. It can fly overhead, look down and remember where and who it has been but not even for one second can it partake again in the image or form from that realm. Transfigured into eternal form, the dead cannot reverse the journey and even for one second re-enter their old form to linger with us a while. Though they cannot reappear, they continue to be near us and part of the healing of grief is the refinement of our hearts whereby we come to sense their loving nearness. When we ourselves enter the eternal world and come to see our lives on earth in full view, we may be surprised at the immense assistance and support with which our departed loved ones have accompanied every moment of our lives. In their new, transfigured presence their compassion, understanding and love take on a divine depth, enabling them to become secret angels guiding and sheltering the unfolding of our destiny. Those who die come closer to the source of everything creative.

LIKE THE MUSIC OF A RIVER THE INDIVIDUAL LIFE FLOWS THROUGH DEATH

I have immortal longings in me.

SHAKESPEARE, *Antony and Cleopatra*

IN ONE OF THE MOST BEAUTIFUL PASSAGES IN THE BIBLE THE LORD says:

> Then I saw a new heaven and a new earth ... Here God lives among men. He will make his home among them; they shall be his people and he will be their God; his name is God-with-them. He will wipe away all tears from their eyes; there will be no more death, and no more mourning and sadness. The world of the past has gone. Then the One sitting on the throne spoke: Now I am making the whole of creation new ...
>
> REV. 21: 1–5

When the individual life flows towards death, it also flows through death. It travels like the music of the river. Sustained by its passion and belonging and within the sureness of its flowing, the river is alive. It has a future and urgency for new possibility. It has no fear of death and yet at the end of its flow, a river always seems to be dying into the huge embrace of the ocean. Yet there is no break between the end of the river and its flowing life. The song of its end continues to sing back up the river towards the first moments of its visible infant-flow. At death the music of the heart becomes one with the unheard eternal melody.

To the Place Where God and Death Are One: Towards the Contemplative Journey of Beauty

DEATH IS THE GREAT SHADOW THAT DARKENS EVERY LIFE. IT IS A huge mystery. Though your future is unknown and its content uncertain, one thing will certainly come: death. It is the only certain and absolutely intimate event. Yet we know so little about it. Within a culture the contemplatives are the ones who probe this

event. The subtext of the contemplative life is the continual attempt to build a creative companionship with your own death. All fear is rooted in the fear of death. All illusion is the attempt to disguise death. The contemplative mind is willing to school itself in the primal silence of death. It endeavours to turn that bleakness into a welcoming tenderness. It is as though the gaze of kindness causes the abyss to relent and yield some shelter. The courage of the contemplative mind pushes the fragile barque of thought and faith out into the anonymous stillness and vacant silence of the abyss. The contemplative strives for a depth-resonance, a depth-recognition at the outer/inner extreme where death, transience and eternity issue from God. Maybe life and death are one in God. The contemplative wishes instinctively to reach the absolute source: the spring of essence, the well of origin. In this circle all is one, nothing is broken. The crevice that brings duality, opposition and otherness has not yet opened. It is to this numinous region that the contemplative mind is drawn. Joan Chittister writes: 'It is Beauty that magnetizes the contemplative, and it is the duty of the contemplative to give beauty away so that the rest of the world may, in the midst of squalor, ugliness, and pain, remember that beauty is possible.'

Death casts a white shadow. It is the shadow of light bleached by Nothingness. All our days, actions, words, and finally our very bodies, vanish into the light. If death had the final word, then beauty would be reduced to a transient, ghostly presence. The heroism of the contemplative endeavour is the attempt to reach through to that final threshold and enter that fierce conversation between Death and Beauty. The irony is that death brings out the fire and fibre at the heart of beauty. Within the white shadow, the gentle eyes of beauty can out-stare the unravelling eyes of death.

To Watch a Person Become More Beautiful as They Near That Kingdom

> But is that beauty, is that beauty death?
> No, it's the mask by which we're drawn to him,
> It is with our consent death finds his breath;
> Love is death's beauty and annexes him.
>
> DENIS DEVLIN, 'The Colours of Love'

THE CONTEMPLATIVE IS THE ARTIST OF THE ETERNAL: THE ONE who chooses to listen patiently in the abyss of Nothingness for the whisper of beauty. Only at that severe frontier does it emerge in the knowing in the bone that yes, Love is stronger than Death. It is overwhelming sometimes to watch a person become more and more beautiful as they near the kingdom of death. Though the body is worn, the countenance becomes infused with radiance. The words and the silences are enveloped in a new dignity and freedom. You begin to realize that already the graciousness of the eternal is infusing the last remnants of a life. Below the vicissitudes and vagaries of loss and transience is the primal affection, the Divine Beauty which holds everything. In that embrace, memory is always new possibility and all possibility comes finally home to memory.

Ultimately, the contemplative journey discloses that there is no need to be afraid of death. When the heart finds its contemplative radiance, the darkness of death shall have no dominion. The beauty of God is that sure embrace where eternal life is eternal memory.

10

GOD IS BEAUTY

> Indeed, the nature of the gods, so subtle . . .
> LUCRETIUS

KINSHIP WITH THE BEYOND: LOVE OF BEAUTY

OUR VALLEY OPENS OUT ONTO THE OCEAN. AS CHILDREN walking to school each morning we often wondered at how the ocean seemed to rise up towards the line of the horizon. Out there fishing boats seemed higher up. This elevation into the beyond only made the ocean more mysterious. The sea was always treated as a mystery. The old people used to say: everything that is on the land is in the sea; if you ever saw a mermaid on the shore, you had to be very careful because she would try to get you to come between her and the ocean, then she would drown you. There were also stories about lost treasures and secret villages under the sea. All this mystery was echoed in a memorable poem we learned in school. It had the unforgettable first line: 'Tháinig long ó

Valparaiso': a ship arrived from Valparaiso. The very sound of the word 'Valparaiso' conjured up images of all that was foreign and exotic, a dream-world which had mysteries and wonders beyond our wildest imaginings. Somewhere on the other side of our ocean its waves were breaking on the magical kingdom of Valparaiso.

The human heart is always drawn beyond the here and now. Human presence never finally gathers anywhere; we are never simply or clearly here. No-one stands up straight and direct in the world, each of us is leaning forward into the future that is rising towards us. In its very structure, the body strains towards the beyond: the eyes and the hands reach out, the voice and the words, the Eros and the listening are all drawn beyond. Thoughts are of course the ultimate pilgrims; this means that the beyond is also within us and this is the source of desire in us. At the centre of the mind's mirror there is a splinter of horizon that never allows us to see anything without some trace of desire in it. The beyond is constantly beckoning us in dream, thought and feeling; it protrudes into the present and into presence. This is what makes us urgent, passionate and open. This ardent kinship with beyond is at the heart of our love of beauty.

Beauty addresses us from a place beyond; it captures our complete attention because it resonates with the sense of the beyond in us. Beauty is the ideal visitation; it settles at once into the 'elsewhere' within us. It is as if we are in exile and home comes to visit us for a while. This is some of the completion and satisfaction we feel in the presence of the Beautiful. When the ship draws in to the pier, we discover that it has brought the treasures of Valparaiso along with it!

THE HEART: PRISM FOR BEAUTY

If we go down into ourselves, we find that we possess
exactly what we desire.

SIMONE WEIL, 'To Desire without an Object'

AS FARAWAY LIGHT YIELDS ITS HARVEST OF COLOURS WHEN IT
passes through a prism, beauty opens out its radiance when it shines
through the human heart. The heart is the place where beauty
arrives; here is where it can be felt, recognized and shared. If there
was no heart, beauty could never reach us. Through the heart
beauty can pervade every cell of the body and fill us. To use a word
that feels like it sounds: this is the *thrill* of beauty through us.
Perhaps this is why we sometimes feel the absence of beauty in our
lives; we have allowed the prism to become dull and darkened;
though the light is near, it cannot enter to have its inlay of beauty
diffused. Sometimes absence is merely arrested appearance.
Compassion and attention keep the prism clear so that beauty
may illuminate our life. Prayer of course is the supreme way
we lift our limited selves towards the light, and ask it to shine
into us.

THE HEART AS TABERNACLE

THE HEART IS WHERE THE NATURE, FEELING AND INTIMACY OF A
life dwell and without heart the world grows suddenly cold. In its
desire for beauty, it reaches towards the beyond. This poignant
straining suggests that beauty is the homeland of the heart. When
it can dwell in beauty the heart is home. The human heart is the
masterpiece of the primal artist. When God created it, it was
fashioned for an eternal kinship with beauty; God knew that the
human heart would always be wedded to him in desire; for

the other name of God is beauty. The heart is the tabernacle of divine beauty. St John of the Cross puts this poetically:

> I did not have to ask my heart what it wanted
> because of all the desires I have ever known,
> just one did I cling to
> for it was the essence of all desire:
> to know beauty.

BEAUTY: THE RADIANCE OF THE ETERNAL

> The nature of love is this, that it attracts to beauty and links the
> unbeautiful with the beautiful.
>
> MARSILIO FICINO

WHILE BEAUTY GLADDENS OUR HEARTS, IT MAKES US LONELY TOO for what cannot be. True beauty is woven through the heart of life and is ever engaged with forces of ignorance, darkness, ugliness and negativity; yet domination and power are not beauty's way. Beauty works from within these conflicts of forces and her brightening may or may not appear. Where beauty seems absent, she is often hidden and still at work in the slow industry of transformation. So much of beauty is not immediately apparent and indeed it could take a long time before it becomes visible. It often takes a lot of struggle and committed attention and generosity, even sacrifice, in order to create beauty. This work of beauty is slow and patient; it is the transformation through which the darkness of suffering eventually glimmers with the learned refinement of true radiance. The soul that struggles for the emergence of beauty reaches towards God and labours on that threshold between visible and invisible, time and eternity. The possibility and promise of this threshold is caught wonderfully by Marguerite Porete, the twelfth-century mystic:

> Such a Soul often hears what she hears not,
> and often sees what she sees not,
> and so often she is there where she is not,
> and so often she feels what she feels not.

For thousands of years this theme has inspired artists. The dark, haunted image of Jesus on the cross is made to yield some shimmer of its incomprehensible light. Dostoevsky suggested this too, when he said: 'Perhaps it is beauty that will save us in the end.'

GOD: KEEPER OF TRANSIENCE

THOUGH WE LIVE IN TIME, BEAUTY SEEMS TO VISIT US FROM outside time, from eternity. Beauty turns vanishing time into something precious; it makes the moment luminous and indeed timeless. Yet one of the most agonizing aspects of beauty is that it does vanish. What we do not know or feel barely touches us, does not sadden us when it vanishes. However, beauty awakens, envelops, inspires and delights us; an experience of beauty turns a certain sequence of time into something unforgettable. Yet it still vanishes. The Japanese have the word *aware* to describe the ephemeral nature of beauty. The poet Gerard Manley Hopkins is haunted by the same vanishing:

> How to keep – is there any, any, is there none such, nowhere
> known some, bow or brooch or braid or brace, lace, latch or
> catch or key to keep
> Back beauty, keep it, beauty, beauty, beauty, . . . from vanishing
> away?
> 'The Leaden Echo and the Golden Echo'

This is always the pathos at the end of autumn as colour dies into

winter; it is also the pathos of each life whose moments of beauty are forming and dissolving like music. If we see God as the Keeper of Transience, then somewhere in the eternal world there is a door without our name on it, the repository where the unfathomed beauty of our chain of days still lives. If eternity is the deeper nature of time, then the vanishing is not a final loss or emptiness. Vanishing is disappearance through visible surface into eternal embrace. We cannot lose what is eternal. Meister Eckhart is trenchant on the limitation and falsity of time: 'Time is what keeps the light from reaching us. There is no greater obstacle to God than time.'

The Visible and the Invisible

IN BEAUTY WE WERE DREAMED AND CREATED, AND OFFERED A LIFE in a world where beauty arises to awaken, surprise and call us. The outer unfolding of our lives is internally sustained and ordered by this invisible beauty. Furthermore, whenever we awaken beauty, we are helping to make God present in the world. Consequently the rituals and liturgies of religion can be occasions where beauty truly comes alive. The beauty of God is reachable for everyone and can be awakened in all dimensions of our experience. This also calls us to love and respect the world and to care for the earth.

On the surface, beauty confers grandeur on order, attractiveness on goodness, graciousness on truth and Eros on Being. Thomas Aquinas and the medieval thinkers wisely recognized that beauty was at the heart of reality; it was where truth, unity, goodness and presence came together. Without beauty they would be separated and inclined towards destructive conflict with each other. Accompanied by beauty, truth gains graciousness and compassion. Beauty holds harmony at the heart of unity and prevents its collapse into the most haunted chaos. In the presence of beauty, goodness

attracts desire and beauty makes presence luminous and evokes its mystery. There is a profound equality at the heart of beauty; a graciousness which recognizes and encourages the call of in-dividuality but invites it to serve the dream and creative vision of community. Without beauty the Eros of growth and creativity would dry up. As Simone Weil says: 'Desire contains something of the absolute and if it fails ... the absolute is transferred to the obstacle.'

BEAUTY AND CREATIVITY AS BIRTH

Who would have thought my shrivelled heart
Could have recovered greenness?
GEORGE HERBERT, 'The Flower'

ONE OF THE MOST LUMINOUS DOCUMENTS OF CLASSICAL antiquity is the *Symposium* of Plato. It is a reflection on the notions of love, goodness and beauty. For Plato beauty was not a private experience of self-indulgence or pleasure. Beauty was internally related to love and goodness. The basic human drive is the desire for the Good. In the beginning Love was born of beauty, 'from then on the ability to love beauty has created all the good things that exist for gods and men'. Plato understands love as a spirit that works on that threshold between the divine and the mortal. At the heart of the *Symposium* there is a constant recognition of creation as the urgent arena of creativity. The heart of human identity is the capacity and desire for birthing. To be is to become creative and bring forth the beautiful:

All humans are pregnant, physically and spiritually, and when we reach our prime, our nature desires to give birth. Nature is not capable of giving birth in the ugly, but only in the beautiful. Now

this is a divine act, and this pregnancy and birth impart immortality to a living being that is mortal. But it is impossible for these things to come about in the inharmonious. The ugly clashes with all that is divine, while beauty is in harmony with it. Therefore the role of the goddess of childbirth is played by beauty. And because of this, whenever something pregnant approaches the beautiful it becomes gentle and pours out gladness both in the begetting and the birth. But whenever it approaches the ugly, it shrinks into itself, sullen and upset. It turns away, is repelled, and refuses to give birth. It holds back and carries the burden of what it has inside itself with pain. In fact, within the pregnant one, who is teeming with life, there is a violent fluttering before the beautiful, through which it will be released from the great pain of childbirth which it has . . .

Beauty is the goddess of birth. In her presence the passion and inner fullness of the gift flows forth in confidence and sureness. And it is through love that we reach a deeper perception of the true nature of beauty. In the *Phaedrus*, Plato has that remarkable passage where he describes how the soul awakens in the presence of beauty and recovers and grows her eternal wings; gravity and finitude can no longer contain her. According to Plato beauty encourages and invites creativity to unfold. When the soul reaches beyond all fragmentation and entanglement God will come to birth in it. Meister Eckhart says that it is of little consequence whether God exists or became incarnate if he does not come to birth in the soul.

WHEN THE LIGHT OF YOUR NEGLECTED BEAUTY SHINES

What my God's form may be, yourself you should perceive,
Who views himself in God gazes at God indeed.
ANGELUS SILESIUS

EVERYTHING THAT IS, IS IN GOD. THERE IS NOTHING OUTSIDE GOD. In some haunted yet tender way, God is also the most intimate dimension of every human mind and, in a sense, the most natural thing in the world is God. There is no distance or barrier between us and God. When there are barriers creating distance between us, they are our barriers, not God's. God is like a light within the heart that nothing can extinguish. We can never lose God because God is twinned eternally to the soul. Once we awaken to the beauty which is God, there is a great sense of homecoming. The mercy of God is subversive affection that sees through our weakness until it illuminates again the reflection of beauty which is our essence. Regardless of who we are or what we have done, we never lose our dignity before God's eyes. When the gaze of God falls on us, the light of our neglected beauty shines through the mirror of soul.

The beauty of God is the warmth of the divine affection. You did not invent yourself or bring yourself here. In terms of human time, the mystery of your individuality was dreamed for millions of years. Your strange and restless uniqueness is an intimate expression of God and who you are says something of who God is. You cannot divest yourself of your immortal clothing. The two longings deepest in your heart – the longing to love and to be loved – are not merely psychological needs; at a more profound level, they are the stirring of God within you. Your capacity to care is God; it is your beauty. Therefore, divine closeness is the secret of human vulnerability. We are not vulnerable simply because we are child-like adults in an imperfect world. We are vulnerable because we carry in us a deep strain of God's caring. Our love for our friends and family, our concern for the world and for the earth, our compassion for the pain and desperation of others are not simply the product of an 'unselfish gene' within us, they issue from that strain of God in us that prizes above everything the kindness, the compassion and the beauty that love brings. Anywhere: in prayer, family, front line, hospital, brothel or prison, anywhere care comes alive, God is present.

We Are Already at the Feast

> For his bounty,
> There was no winter in 't, an autumn 'twas
> That grew the more by reaping.
>
> SHAKESPEARE, *Antony and Cleopatra*

TO PARTICIPATE IN BEAUTY IS TO COME INTO THE PRESENCE OF the Holy. It is we who exile ourselves from God. Everything we feel, think and do is already happening within the divine shelter. To know this is to know one's real beauty.

Though the human mind is intense with difference and variety it is shadowed by divisions and imbalance. God is pure verb, a permanent event, an eternal surge, a total quickening. Beauty's diversity only deepens the flow of God's presence; nothing is held back. This sense of lyrical presence is expressed vividly by the sixteenth-century mystical poet Angelus Silesius. He put many of Meister Eckhart's insights into poetic form. His little poem 'The Rose' captures the grace and simplicity of pure presence and integrity:

> The Rose is without *why*
> She blooms because she blooms
> She does not care for herself
> Asks not if she is seen.

The poem is also a huge vindication of identity, the freedom and clarity of simply being yourself. Nothing else is needed. It is a poem of profound trust in the act of being. This makes for a pure clearance. There is no outside intrusion, no pressure to measure up to outside expectations. Nor is there any sense of inner division. The rose is content to be a rose: she is what she is. At another level the poem can be read as a hymn to the freedom of nature, how it avoids the oppressive clutter of intentionality and concept. And

the rose is flourishing; she is at one with herself in the grace of growth. Nature as a whole performs for no man. How vastly different this is to the way we live our lives.

Sometimes the urgency of our hunger blinds us to the fact that we are already at the feast. To accept this can change everything: we are always home, never exiled. Although our minds constantly insist on seeing walls of separation, in reality most of the walls are mere veils. In every moment, everywhere, we are not even inches away from the divine presence.

Spirituality has to do with the transfiguration of distance, to come near to ourselves, to beauty and to God. At the heart of spirituality is the awakening of real presence. You cannot produce or force presence. When you are truly present, you are there as you are: image and pretension are left aside. Real presence is natural. Perhaps the secret of spiritual integrity has to do with an act of acceptance, namely, a recognition that you are always already within the divine embrace.

Rather than trying to set out like some isolated cosmonaut in search of God, maybe the secret is to let God find you. Instead of endeavouring to reach out in order to first find God, you realize you are now within the matrix and the adventure is the discovering of utterly new and unspoken dimensions of the inexhaustible divine; this brings with it a new sense of ease with your self and your solitude. John Keats wrote rapturously about this: 'Though the most beautiful Creature were waiting for me at the end of a Journey or a Walk, though the carpet were of Silk, the Curtains of the morning clouds; the chairs and Sofa stuffed with Cygnet's down, I should not feel – or rather Happiness would not be so fine as my Solitude is sublime. Then instead of what I have described, there is sublimity to welcome me home' (Letter to G. and G. Keats, Oct. 1818).

GRACE

Treat Things Poetically.

RALPH WALDO EMERSON

GRACE IS ONE OF THE MOST MAJESTIC WORDS IN THEOLOGY. IT suggests the sublime spontaneity of the divine which no theory or category could ever capture. Grace has its own elegance. It is above the mechanics of agenda or operation. No-one can set limits to the flow of grace. Its presence and force remain unmeasurable and unpredictable. Grace also suggests how fluent and seamless the divine presence is. There are no compartments, corners or break-ages imaginable in the flow of grace. Grace is the permanent climate of divine kindness. It suggests a compassion and under-standing for all the ambivalent and contradictory dimensions of the human experience and pain. This climate of kindness nurtures the sore landscape of the human heart and urges torn ground to heal and become fecund. Grace is the perennial infusion of spring-time into the winter of bleakness.

Divine grace works without a programme; it does not labour under the leaden intention of a pre-existent, fixed plan. Meister Eckhart states: 'God has no why, but is the why of everything and to everything': *deus non habet quare sed ipsum est quare omnium et omnibus*. This is a subversive and liberating statement. It liberates God from entanglement in the mesh of our needs, speculations and moralistic agenda. This quality of the divine presence should be highlighted especially in a digital culture dominated by the mechanics of function. The claim 'God has no why' makes a wonderful clearance in a culture where most objects and modes of presence are either expression or functions of something else. In our times it is quite exceptional for a thing simply to be itself. The same is true of people. A slick politics of presentation and deliberateness now dominates most forms of presence and it is actually quite disarming to hear someone speak from their heart with no eye to

the best camera angle. Such direct immediacy seems almost innocent and unsophisticated, yet it is so refreshing and real.

A God without a why is a God who is lyrical and full of grace, a God who has no other intention than simply 'to be'. To learn that art of being is to become free of the burden of strategy, purpose and self-consciousness. God dwells totally in fluency of presence.

A large amount of human seriousness constructs itself around the question *why*? Answering this question often brings us into the labyrinth of psychological motivation, judgement, adulation or blame. A God without a 'why' sounds delightfully light and light-hearted, a God of humour without all the mental armour of deliberateness, caginess or expectation. There is that famous phrase in Exodus in response to the query of who God might be. God replies: 'I am who am.' The 'I-am-ness' of God is everything in God. Without a why God is never a self-target of Descartes's ultra-self-conscious: 'I think, therefore, I am'. The 'I-am-ness' is its own witness and vindication.

THE INCONCEIVABLE MADE INTIMATE

God created us for the limitless alone.
MARSILIO FICINO

EACH HEART HOLDS A DIFFERENT WORLD AND OFTEN ITS NET OF desires is entangled and confused. At other times, things clarify and the God of beauty makes everything luminous. Most of the time, however, God remains a question. And within its private silence, each heart follows the question across landscapes no-one else sees.

From the earliest religions onwards the divine has been imaged in terms of mythic or ancestral stories. It is interesting here that the divine is never seen as a purely abstract force, like energy for instance. The divine is always portrayed with human qualities

naturally writ large on an epic scale. Greek mythology is a wonder-world of epic portraits. The Gods combine power and personality as they stretch within the chains of necessity. The transition then to philosophical reflection considers God as abstract. As Christianity awakens out of Judaism, it emerges into a vibrant world of imaginative thought that inherits both traditions and somehow manages to think them together. Indeed, this concept of God is one of the finest achievements of Christian thought. Over centuries, in conversation with the greatest minds of medieval and classical antiquity, Christian thought developed a notion of God as person and stayed faithful to both mythological and philosophical thinking. God is not an invisible, anonymous abstract force. Poetry and philosophy are one here.

NOT 'WHAT IS BEAUTY?' BUT 'WHO IS BEAUTY?'

THE SENSE OF GOD AS A PERSON HAS DIMINISHED CONSIDERABLY IN the Western Christian tradition. New Age spirituality, fundamentalism and mainstream religions all speak of God as a force; either a soft benevolent force, a hard force or a moral force. And yet, perhaps, the sense of divine intimacy and warmth, the sense of divine imagination and the suggestion of the numinous depths of God then become empty. God could become a nameless, bland energy. The beauty of the notion of person is the way it gathers the horizontal and the vertical into one form or centre. This is the way we picture the infinite. It ranges from the deepest depths to the highest summit and it extends on every side, endlessly. When we imagine God as person, it gives all this infinity personality, warmth and intimacy. The cosmos seems no longer anonymous or echoless. The Christian tradition has been very careful to nuance the concept of person in relation to God. When we acknowledge God as person, we sense an actual someone to whom we can relate. Given that one

of the most beautiful things about being human is the ability to encounter another person, it is natural that we should want that experience with the deepest source of everything also to be intimate and personal. The notion of an infinite person who is pure love means we are using the term 'person' in a transfigured sense; there is no control or despotic power here, rather a sublime quickening of our every potential for passion, creativity, compassion and freedom.

Our exploration of beauty has considered many of the forms in which beauty appears. These forms included places, things, events and experiences. However, when we speak of God as beauty, we are speaking of the beauty of *who-ness*. The *who* question is the most numinous and mysterious of questions. The self is unlike any other thing in the world: though it appears in time and space, it is beyond them. The *who-ness* of someone can never be finally named, known, claimed, controlled or predicted. The *who* is beyond all frames and frontiers and dwells in the mystery of its own reflexivity and infinity. *Who* has no map. When we claim that God is beauty, we are claiming for beauty all the adventure, mystery, infinity and autonomy of divine *who-ness*. Beauty is the inconceivable made so intimate that it illuminates our hearts.

THE SPACE BETWEEN IS SPIRIT

THE NOTION OF THE DIVINE PERSON ALSO GROUNDS THE DEPTH and intimacy of human affection. If you listen to your affection or attraction to someone, you can sense that there is more than the two of you there. There is also present a third force – the affection itself as a threshold where your two lives meet and engage each other. This finds primal expression in the notion of the Trinity. The affection between Son and Father is so utterly alive as to be not merely a bond but an other person, the Holy Spirit. That constant,

passionate spill-over of pure affection is the Spirit. This is the Spirit of affection in which we live and move in each moment and it is at the heart of the Christian notion of God. The Holy Spirit holds the tension of God, and is both the abyss and summit of the knowing between Father and Son. The Son is the first Other in the universe. The Spirit is that secret path of affinity that holds the kinship warm even in the coldest, most negative spaces between Self and Other. What is utterly alien to you can eventually yield a glimpse of affinity with you. Between every separate thing, beneath the slow time-film that rolls forth each day and night, in the cold unknown between strangers, in the limbo land of numbed indifference and even in the vast distance between centuries and their lost memory, there exists another world, an invisible world where all this separation and distance is embraced. The Holy Spirit presides there, holding together that vast terrain of the 'between'. It can be somewhat misleading to overemphasize *the* Holy Spirit. Perhaps the meaning might emerge more clearly if we occasionally referred to all that space between simply as holy Spirit. The space between seems empty to the eye; yet to the imagination it is vibrant with pathways towards beauty. Divine space has a latent grandeur. The Holy Spirit is the spirit of primal Eros, the between that is forever quickening, the source of all the gifts that turn up in our lives.

PROVIDENCE FORE-BRIGHTENS OUR PATH

Our love is
a sister of the light;
deftly, she unwinds
our shadowed nets.

THE GIFT COMES FROM THIS IN-BETWEEN WORLD THAT KNOWS and holds much of the geography of our destiny, a secret climate of profound kindness that sends us bouquets of light and colour when we experience forlorn times. The attentive wisdom of this in-between world is what we call providence. It is a foreknowing that is always at work, watching out for us. Providence is the power of latent blessing that fore-brightens our pathway. The providence that shelters and guides us knows infinitely more than we can about who we are, where we are going and what we require in order to become who we were dreamed to become. It is only when we look back that we can discern how we were being secretly minded; we discern the meaning in something that was opaque and difficult and we begin to see how it deepened our sensibility and refined our spirit. Providence shelters our hearts and blesses our lives with beauty.

Providence is another name for the kindness of God. If we could realize how wise the providence around us is, it would give us immense confidence on our journey. The irony is that we don't need to worry. We can take a lot more risks than we realize. It is interesting to ask: what are the limits you have set for your life? Where are the lines of these limits? Why do you think you cannot go beyond them? How real are they? Did you construct these limits out of anxiety and fear? If you were to go beyond your most solidly set limits, what difference would it make to your life? What are you missing by remaining confined?

The awakening to the beauty of your creativity can totally change the way you view limits. When you see the limit not as a confining barrier but as a threshold, you are already beyond. The beauty of imagination helps you to see the limit as an invitation to venture forth and view the world and your role in it as full of beautiful possibilities. You become aware of new possibilities in how you feel, think and act. The interim, the in-between world is brisk with possibility. And possibility is the gift of creativity.

ALL BEAUTY IS A GIFT

The cause of this fair gift in me is wanting.

SHAKESPEARE, Sonnet 87

MANY OF THE MOST LUMINOUS GIFTS OF OUR LIVES ARRIVE AS complete surprises. A gift is the most beautiful of intrusions. It arrives undeserved and unexpected. It comes ashore in our hearts carefully formed to fit exactly the shape of a hunger we might not even know we had. The gift comes with no price tag, no demand that puts us under an obligation. Every gift has an inner lamp that casts a new brightness over an undiscovered field of the heart. In this light we discover and bring to birth something new within us. Regardless of how carefully we examine the path of its arrival, the eyes of our mind can never unveil the true source of the gift. The gift keeps its reason secret. Some unexpected path opened in the interim world and the gift was already on its way towards us.

Sometimes it is difficult to know when you are getting a gift. Its arrival is often a shock; at the beginning it might seem to be the furthest thing from a gift that you could imagine. Looking from now, we cannot glimpse the shape of our destiny; its subtle weave only comes to light in retrospect. There is so much about ourselves that we do not know. After Freud's descriptions of the sub-conscious, we tend to imagine that the subconscious holds all kinds of misshapen forms. We forget that the darkness of the unknown within us is also a fecund soil urgent with seeds of new possibility. The beauty of the gift is the secret way it awakens us to growth. Without alerting our anxiety or forcing confrontation, the gift has placed us on the path of change almost before we realize it. And much of the change in our lives happens through struggle and pain. We are confronted with an unattractive direction that we have to take. For weeks or months we have to travel through limbo; the comfort and security of our familiar belonging lies far behind us. Where we will belong next has not yet become clear. The days

become a struggle of endurance. Yet when the light and the ease return, we recognize the change that has been achieved. The gift bequeaths change in a completely different way. Quietly it undoes the knots of false netting that had us entangled and before we have time to realize what has happened, we find ourselves released into a new fluency. Like a parent to the soul, the gift carries us carefully over torn ground until our feet stand free in a serene place where we can recognize that we have been blessed.

Every life is blessed with a different sequence of gifts. Often the gift arrives secretly and you only find it later. Or perhaps you are looking back over time as you would look through an old drawer and you come upon something that you had put away ages ago. You rediscover the gift and enter again into its wonder. This is one of the lovely capacities of memory: the reawakening of new blessing through the rediscovery of old gifts in forgotten corners. It is this prospect that animates faith.

FAITH: THE ATTRACTION TO DIVINE BEAUTY

Fornocht do chonac thú
a áille na háille
Naked have I seen thee
O Beauty of Beauty

PATRICK PEARSE

FAITH IS ATTRACTION TO THE DIVINE. FOR TOO LONG FAITH HAS been presented as a weak form of knowledge. Yet whilst faith seems feeble in the realm of evidence and proof, beauty always attracts us. It strikes our sensibility in a way that makes us respond. Our response to beauty is unlaboured. Even in unknown ways, our lives are charged with attraction towards divine beauty. The infinity of the beauty which is God is a feast for the soul. The beauty

of God increases and deepens our own beauty. We enter the secret symmetry of the Divine Imagination.

When we consider faith as a response to Divine Beauty, we begin to glimpse its creativity and passion. Faith is no blind piety but a primal attraction, the deepest resonance of the self drawn to the elegance of its ancient origin. Faith has its own aesthetic of dignity, light and proportion. Something in us senses and knows how perfectly the contours of the soul fit the divine embrace. It is the deepest dream of the soul to be in the intimacy of Divine Beauty. At that depth an atmosphere of elegance presides. Such a profound attraction turns the body into a force-field of divine quickening. The whole self is taken up in the embrace of the divine tenderness. The classic image for this encounter of God and the soul is that of the Lover and the Beloved. It is majestically expressed in the Canticle of St John of the Cross:

> Upon a gloomy night
> With all my cares to loving ardours flushed,
> O venture of delight!
> With nobody in sight
> I went abroad when all my house was hushed.
>
> In safety, in disguise,
> In darkness up the secret stair I crept,
> O happy enterprise!
> Concealed from my eyes
> When all my house at length in silence slept.
>
> Upon that lucky night
> In secrecy, inscrutable to sight,
> I went without discerning
> And with no other light
> Except for that which in my heart was burning.

It lit and led me through
More certain than the light of noonday clear
To where One waited near
Whose presence well I knew,
There where no other presence might appear.

Oh night that was my guide!
Oh darkness dearer than the morning's pride,
Oh night that joined the lover
To the beloved bride
Transfiguring them each into the other.

Within my flowering breast
Which only for himself entire I save
He sank into his rest
And all my gifts I gave
Lulled by the airs with which the cedars wave.

Over the ramparts fanned
While the fresh wind was fluttering his tresses,
With his serenest hand
My neck he wounded, and
Suspended every sense with its caresses.

Lost to myself I stayed
My face upon my lover having laid
From all endeavour ceasing:
And all my cares releasing
Threw them amongst the lilies there to fade.

(translated by Roy Campbell)

This canticle expresses the divine Eros of mystical love. It has all the elements of the private world of tenderness, belonging, excitement, waiting and union which a great love poem would wish to have. It

is a poem about ultimate freedom, an absolute leavetaking of limited identity, an arrival at a field beyond care and worry. This is beautifully caught in the utter surprise of the image of the lilies in the last line, which echoes of course that passage where Jesus enjoins us not to worry: 'Behold the lilies of the field; they neither spin nor weave, yet I say unto you that Solomon in all his glory was not clothed like one of these.' Once you taste of the divine, you can never fully return to anything else. For to find and love God is an extraordinary adventure. God is the true love of the soul; in the divine embrace all Eros is transfigured.

THE SENSUOUSNESS OF GOD

THE SENSUOUS IS SACRED. FOR TOO LONG IN THE CHRISTIAN tradition we have demonized the sensuous and pitted the 'dim senses' against the 'majestic soul'. This turned God into an abstract ghost, aloof and untouchable; and it made the senses the gateways to sin. But the world is the body of God. Hopkins is the great poet of God's beauty. He writes:

> Glory be to God for dappled things . . .

> All things counter, original, spare, strange; . . .
> He fathers-forth whose beauty is past change:
> Praise him.

Everything can be an occasion of God. The elemental presence of the divine is everywhere: wind, water, earth and fire witness to the urgency, passion and tactility of God. From these elements God fashioned the universe. It is not that God is reduced to a force of nature or that aspects of nature become mere images of God. Nature is divine raiment; the touch and flow and force of God

touches us here but the divine presence is not exhausted by this. Both sensuousness of nature and our senses make the divine presence visible in the world. Nature was the first scripture, and at the heart of Celtic spirituality is this intuition: to be out in nature is to be near God. When we begin to awaken to the beauty which is the Sensuous God, we discover the holiness of our bodies and our earth.

WILD ELEGANCE

The rose which here on earth is now perceived by me,
Has blossomed thus in God from all eternity.
ANGELUS SILESIUS

BEAUTY INVITES US TOWARDS PROFOUND ELEGANCE OF SOUL. IT reminds us that we are heirs to elegance and nobility of spirit and encourages us to awaken the divinity within us. We are no longer trapped in mental frames of self-reduction or self-denunciation. Instead, we feel the desire to celebrate, to give ourselves over to the dance of joy and delight. The overwhelming beauty which is God pervades the texture of our soul, transforming all smallness, limitation and self-division. The mystics speak of the excitement of such unity. This is how Marguerite Porete describes it: 'Such a Soul, says Love, swims in the sea of joy, that is in the sea of delights, flowing and running out of the Divinity. And so she feels no joy, for she is joy itself. She swims and flows in Joy . . . for she dwells in Joy and Joy dwells in her.' Because the nature of the heart is desire for beauty, to discover that it is so ardently desired by the one it desires brings overpowering joy.

The Christian tradition, loaded down with heavy institutional and moralistic accretions, has forgotten and neglected the Beautiful Dance that God is. The Sufi tradition has remained faithful to the wild elegance of the divine through its dancing dervishes. In the Hindu tradition, the Gods also dance.

When we acknowledge the wild beauty of God, we begin to glimpse the potential holiness of our neglected wildness. As humans, citizens and believers, we have become domesticated beyond belief. We have fallen out of rhythm with our natural wildness. What we now call 'being wild' is often misshapen, destructive and violent. The natural wildness as the fluency of the soul at one with beauty is foreign to us. The call of the wild is a call to the elemental levels of the soul, the places of intuition, kinship, swiftness, fluency and the consolation of the lonesome that is not lonely. Our fear of our own wildness derives in part from our fear of the formless; but the wild is not the formless – it holds immense refinement and, indeed, clarity. The wild has a profound simplicity that carries none of the false burdens of brokenness or self-conflict; it flows naturally as one, elegant and seamless.

DIGNITY AND DIVINE COURTESY

COURTESY IS THE UNACKNOWLEDGED HEART OF CIVILITY; IT IS A disposition towards others which is graceful, polite, kind and considerate. Courtesy also includes some sense of old-world formality; it is the opposite of coarseness and self-presuming familiarity. Courtesy invites dignity. Dignity is one of the most beautiful qualities in presence. The true style of the soul is dignity. Where dignity prevails, there is an atmosphere of confidence, poise and sureness. A person of dignity is aligned with the beauty within; this is why dignity is unassailable from without. Dignity does not intrude or force itself. God gives us life and the world in each moment; he gave us these gifts with the other precious gift, the gift of freedom. Divine courtesy gives graciously and never intrudes on the dignity of our freedom. The most precious and personal gifts of our lives arrive with no divine signature or code of instructions. In that sublime space where God holds us, a space of infinite

graciousness where we are cherished and loved, there the soul comes to bathe in the stream of mercy! This is at the heart of George Herbert's poem 'Love':

> Love bade me welcome: yet my soul drew back,
> Guilty of dust and sin.
> But quick-ey'd Love, observing me grow slack
> From my first entrance in,
> Drew nearer to me, sweetly questioning,
> If I lack'd any thing.

Gracious love absolves the guest of all feelings of unworthiness and unease. There is so much to be learned of Divine Beauty from the silence of God.

INTO BEAUTIFUL DANGER

WHILE BEAUTY USUALLY QUICKENS OUR SENSES, AWAKENS OUR delight and invites wonder, there are occasions when the force of beauty is disturbing and even frightening. Beauty can arrive in such a clear and absolute sweep that it throws the heart sideways. It takes over completely and we are overwhelmed, unsure what to do or how to be in the presence of this radiance. The authority of such beauty unnerves us for a while. This is of course an exceptional experience of beauty, yet it befalls everyone at some time. It could be the beauty of a person, the beauty of nature, music, painting, poetry or the unseen beauty of kindness, compassion, love or revelation. For a while we are caught up in the majestic otherness of beauty. It is an experience in which the sheer eternal force of the soul strains the mortal frame; the natural gravity of the body no longer grounds one. This causes unease and yet the unease is still somehow delightful. Perhaps this is what Rilke was thinking of in the first Duino Elegy:

> And if I cried, who'd listen to me in those angelic
> Orders? Even if one of them suddenly held me
> To his heart, I'd vanish in his overwhelming
> Presence. 'Because beauty's nothing
> But the start of terror we can hardly bear,
> And we adore it because of the serene scorn
> It could kill us with. Every angel's terrifying.'

In the face of such beauty our bodies feel paper thin; this beauty could undo us. Eventually, time comes to our rescue and its pedestrian sequence calms us again.

Beauty manifests God. However, beyond what becomes manifest is the realm of God which is primal beauty. This is the splendour of divine Otherness which the human mind cannot even begin to imagine. We would dissolve in the light of that beauty. The sublime loveliness of the divine form would unravel every texture, every cell of our being. Out of this unknown, unknowable source flow the forms of everything that is. This primal beauty is suggested by the image of the beatific vision where the soul and God become the one gaze. To enter this pure presence is the dream and desire of the contemplative heart.

The Contemplative Life:
Creating a Space to Receive Divine Beauty

THE CONTEMPLATIVE LIFE IS TOO DANGEROUS AND SEVERE TO remain a gratifying project of the ego. It would be the utmost psychic recklessness to venture where, indeed, angels fear to tread. Only the secret grace of destiny brings one through such a life. It is easy and even delightful to speak about God from a safe distance, and in fact most public and social discourse about God is little more than loose talk. It may be well intentioned, but it is a language

dictated by the grammar of surface or spiritual correctness. The contemplative speaks from a different place. The words taste of fire. They are pilgrim words. Of all journeys this is the ultimate journey. There is nothing else but God and there is no cheap consolation or easy entry to the banquet. The doorway is narrow and often located in the most unattractive setting. The texts of the contemplatives are alive with danger and possibility. They are not theories but a visceral straining to suggest what the touch of God is like. There is intense fire in the contemplative imagination. This is where fresh revelation is forged. In the play *St Joan*, by George Bernard Shaw, Joan tells her inquisitor that she hears voices that come from God. The inquisitor says, 'They come from your imagination.' Joan answers, 'Of course, that is how the messages of God come to us.'

When God's voice whispers tenderness into that inner desert of thirst, the effect is ecstasy. The heart has been cleansed of everything that might distract from preparation for the guest; its longings have been woven into one strand. The truly contemplative heart has a passion and wildness that can celebrate the magic of God. Yet it knows that this is but a passing visitation and it has learned to distinguish emotion and presence. The contemplative heart also learns to love emptiness and absence because it believes that the beauty of God can only be glimpsed through the most severe lens of truth. The aesthetic of the contemplative heart insists on the ultimate conversation between beauty and truth. Only at the extremity of barest truth will the radical beauty of God become audible and visible. The ascetical life dreams of awakening beauty. When you are in the presence of a contemplative person, you can sense this. An atmosphere of stillness and a sense of clarity remind you who you are and recall your heart to the gentle wonder of the divine. There is subtle and refined beauty bequeathed by a life of prayer.

The contemplative is one who is drawn into the subversive gentleness of the divine presence. She knows that gentleness can be

a greater force for transfiguration than any political, economic or media power; indeed, as we have seen, this gentleness can even transfigure death. And yet contemplative knowing is neither naïve nor strategic. In silence and solitude the contemplative has learned the mysteries of the heart's fragility, smallness and darkness. Yet the contemplative is not content to engage her life with the tools and explanations of psychology. She has come to sense that the inner world goes deep, indeed deeper than the wounds and breakages that others inflict. The contemplative has broken through to that sanctuary in the soul where love dwells. Crucial to this contemplative journey is the trust and imagination to realize that regardless of how you have been damaged, there is within you a sanctuary of deep love, trust and belonging. This is the ancient dream, the masterpiece of divine creativity: the creation of the human heart. Before time – back in the winter of Nothingness and then all through the infinite springtime of evolution – the dream was the birth of an intimate well of kindness, care and love in the world, dwelling in the tabernacle of the human heart.

WHERE PERPETUAL LIGHT AWAITS THE GAZE OF THE SOUL

NO-ONE WAS SENT INTO THE WORLD WITHOUT BEING GIVEN THE infinite possibilities of the heart. It is sad that so many of us go through our lives without ever seeming to discover the depth and beauty of the heart. Most of us have only an inkling of who we are. We believe so easily the negativities we have been told and think that our lives are merely endurance tests or holding places for wounds that will weep for ever. Then there are always the wonderful surprises. For instance, we meet someone who has never had a chance in life and hard luck and brutality seem to have been their constant companions, yet in some way they secretly broke through

to that inner sanctuary. Though awful suffering came to them, it never touched their essence. We sense in them a profound tranquillity and gentleness. It is as if the imagination has opened that inner door to the eternal treasures. Once we begin to glimpse who we really are, many lonesome burdens and false images fall away; our feet find new freedom on the pastures of possibility.

The contemplative uses experience as a theatre of divine nearness and companionship. It is ironic sometimes how naïvely we tend to write off the contemplative life as a domain of self-protected cosiness and uncritical belief when in truth the contemplative life is a calling to the most vulnerable and critical openness. There are times of huge aridity, sheer emotional endurance and a sense of the loss of God that is equal to the emptiness experienced in the most thorough atheism. When we look at religious people we often find the image over-predictable and imagine their minds to be tame and domesticated. Yet often behind that façade there dwells critical sensibility of the most refined rigour which endeavours to be completely vigilant and allow neither fear nor illusion to blur the mirror of Being. As Ibn Arabi says, 'His appearance in his light is so intense that it overpowers our perception, so that we call his manifestation a veil.' The contemplative is one who risks the eyes of her mind for the moment when the veil slips aside and the perpetual light shines through.

BEYOND IMAGES: THE UNRIPPLED PRESENCE

THE CONTEMPLATIVE SENSIBILITY WANTS TO REACH BEYOND images and forms to dwell in the pure, unrippled presence of God. The tools of the contemplative are the finesse and rigour of stillness and silence. This is also the language of death: stillness and silence. In the midst of life, the contemplative chooses to dwell with death, to dare this primal companionship. The contemplative is the artist

of the eternal: the one who listens patiently in the abyss of Nothingness for the whisper of beauty.

It would be naïve to restrict the domain of the contemplative exclusively to those who live in cloisters. To a greater or lesser degree every human heart is contemplative. In a small town near us there was a lovely writer and musician who lived a rather bohemian life; he was given sometimes to the drink but he had a beautiful, awakened mind. He was a kind of 'undercover mystic' and many people, especially young people, came to talk to him when they felt their minds troubling them. He was well aware of how lonesome and disturbing this could be. I once asked him how he had managed to live alone on that edge. He said: 'I was a very young man when I first felt the burn of that old mystical flame within me. I realized immediately what an adventure and danger it would be and that there was no going back. On that day I made a bargain with myself, the bargain was: no matter what came I would always remain best friends with myself. I am old now but I never broke that bargain.'

ON THE FRONTIER OF BEAUTY: TO REFINE YOUR CONTEMPLATIVE HEART

For beauty is the cause of harmony, of sympathy, of community.
Beauty unites all things and is the source of all things. It is the
great creating cause which bestirs the world and holds all
things in existence by the longing inside them to have beauty.
And there it is ahead of all as . . . the Beloved . . . toward which
all things move, since it is the longing for beauty which actually
brings them into being.

PSEUDO-DIONYSIUS, *The Divine Names*

PLACED WITHIN THE FRAME OF A UNIQUE AND DIFFERENT DESTINY each one of us is troubled by the ultimate questions. No-one else's answer can satisfy the hunger in your heart. The beauty of the great questions is how they dwell differently in each mind. How they root deeper than all the surface chatter and image, how they continually disturb. Your deep questions grow quickly restless in the artificial clay of received opinion or stagnant thought. If you avoid that disturbance and try to quell these questions, it will cost you peace of mind. Sooner or later each one of us must succumb to our contemplative longing and gain either the courage or recklessness to begin our contemplative journey. The explicit religious contemplatives offer us inestimable shelter and guidance on this path. They have garnered the wisdom from a long tradition committed to nothing else but the pursuit of these questions. From some of their adventures they have brought back reports of those numinous territories and attempted to bring their kinetic geographies to word. The tradition has always cautioned against undertaking that journey alone. As on a climb in the Himalayas a guide or sherpa is recommended, when one is setting out, there is a lot to be learned from those who have gone before us. Those who publicly and committedly undertake the journey provide some signposts for those of us who are implicitly or secretly drawn in these directions.

In general, in a society there is an encouraging and creative tension between the explicit and the implicit. Those who are willing to stand out and take the risk of following their gift place a mirror to our unawakened gifts. To know they are there, day in day out, at the frontiers of their own limitation and vision, probing further into new possibility, enduring at lonely thresholds in the hope of discovery, to know they are willing to risk everything is both disturbing and comforting. The presence of the contemplative and the artist in a culture is ultimately an invitation to awaken and engage one's neglected gifts, to enter more fully into the dream of the eternal that has brought us here to earth.

If we could but turn aside from the glare of the world and enter our native stillness, we would find ourselves quickening to new life in the eternal embrace. This is the subversive consolation of God, that sweet mercy that sees beyond our blunders and falsities. There we need feel no shame or guilt or anxiety. No storm can touch us there. In the presence of the God of Beauty our own beauty shines. God is the atmosphere where our essence clarifies, where all falsity and pretension vanish. Here we are utterly enfolded. No words are needed; no actions required; for everything is here. God is the time-circle where all our possibilities unite. In God the ultimate portraiture of the soul fills out. All our different selves unite: the selves we are and were and could have been and could be, the unchosen selves, all our nights and all our days, our visible and invisible lives. It is impossible for language to express this nearness for in the end every thought is an act of distance. Even words like 'nearness', 'intimacy' or 'love' still indicate separation. Only the strained language of paradox can suggest the breathtaking surprise of such divine closeness. God is breath-near, skin-touch, mind-home, heart-nest, thought-forest, otherness-river, night-well, time-salt, moon-wings, soul-fold.

God is that field beyond more and less, near and far, self and other, past and future, elsewhere and otherwise, before and after. God is that beautiful danger wherein the earth no longer needs to behave, where the levels are no longer separate. As Eckhart says: 'Height is Depth'. Perhaps this was the field that Eckhart glimpsed and that glimpse burns through the Everest of his thought. One of his followers said: 'The master spoke to ye from eternity but ye have understood him according to time.' The subversive beauty of God holds the secret design of everything that happens outside, in time. Yet to enter that beauty is not a dissolution but a trans-figuration where the signature of your essence glows in the mountain of Being. Created in beauty and secretly sustained all the while by beauty, you surrender now to ultimate awakening. Home at last – as Eckhart says: 'Back in the house you never left'.

A BEAUTY BLESSING

As stillness in stone to silence is wed
May your heart be somewhere a God might dwell.

As a river flows in ideal sequence
May your soul discover time is presence.

As the moon absolves the dark of distance
May thought-light console your mind with brightness.

As the breath of light awakens colour
May the dawn anoint your eyes with wonder.

As spring rain softens the earth with surprise
May your winter places be kissed by light.

As the ocean dreams to the joy of dance
May the grace of change bring you elegance.

As clay anchors a tree in light and wind
May your outer life grow from peace within.

As twilight fills night with bright horizons
May Beauty await you at home beyond.

ACKNOWLEDGEMENTS

THE QUESTION OF BEAUTY HAS FASCINATED ME FOR A LONG TIME.
Many friends have helped me in the research for this book. I
became acquainted with the depth of the beauty theme in the philo-
sophical tradition through the mind-shaping lectures on Greek
philosophy of the late Professor Dr Gerard Watson at Maynooth
University. Dr P.J. McGrath's lectures in philosophy opened up the
wonder, light and clarity that the beauty of thought could hold. Dr
Noel Dermot O'Donoghue's work in mystical theology exposed the
threshold where the mountains soared from the foothills. For his
illumination of the world of medieval aesthetics I am indebted to
the wonderful books of Umberto Eco. For insights into Beethoven,
I am indebted to the work of J.W.N. Sullivan. Bryan Magee's book
on Wagner is wonderful. In researching the theme of colour, I
learned a lot from the books by Philip Ball and John Gage; Victoria
Finlay's book on colour is rich in imagination, adventure and
insight. The *Letters* of Keats were a constant inspiration, as were
frequent visits to the Thought-Cathedral of Meister Eckhart. I
learned about music therapy from Rachel Verney, a gifted music

therapist. Tom Kenny of Kenny Art Galleries told me the story about 'Teannalach'. The phrase 'Fáilte roimh thorann do chos, ní amháin thú fhéin' I got from Lelia Doolan; the translation is Bob Quinn's.

My heartfelt thanks to Hugh Van Dusen, my editor at Harper-Collins. His graciousness, courtesy, and wonderful erudition have accompanied the journey of the book towards the light. His friend-ship offers great support and shelter; conversations with Hugh always make the mind sing. My thanks too to my former editor at HarperCollins, Diane Reverand. Her encouragement and support have been lasting gifts. Kim Witherspoon has been wonderful in 'watching over' everything; I am grateful for her care and clarity. Dr Lelia Doolan did a trenchant critique of the manuscript several versions ago; I am grateful for her friendship and the generosity of her beautiful mind. I thank Dr John Devitt of Mater Dei for his critique and the inspiration of his erudition. Professor Laurie Johnson of Hofstra University read the manuscript several times and offered challenging criticism. I am ever grateful for her love and encouragement. I am deeply grateful to the poet David Whyte for our friendship and great conversations, and to the priest-poet Pat O'Brien for his friendship, generosity and inspiration. I was privileged to have great discussions about beauty and architecture with Jennifer Vecchi; I am deeply grateful for her friendship and inspiration, and that she introduced me to the work of Santiago Calatrava. Fr Martin Downey loved the topic from the beginning and gave great encouragement. I wish to thank my friends Anne and Sheila O'Sullivan and Ethel Balfe, who gave me constant sup-port and encouragement; Ethel accompanied this journey of words from its first meanderings and kept the way lit. I thank Barbara Conner for all her wonderful work and for her care, friendship, wisdom and intuition. I thank the poet Nöel Hanlon for her love and the grace of illumination – there all the days. Near the end Kathleen Duffy arrived and helped gather it all over the threshold. I wish to thank my family, especially my mother, Josie. When someone

asked her a few months ago how I was, she said: 'Beauty has him nearly killed.' My father Paddy and my uncle Pete introduced me to the beauty of landscape, the beauty of work and the beauty of spirit; memories of them are icons that keep the heart bright. The first story in the book happened on Loch Corrib with my great old friend, the late Joe Pilkington; we all miss him yet he continues to surprise us with presence. During the writing of this book, my friend Donie Lynch passed away; he was an 'undercover mystic', a beautiful outsider who offered sanctuary when the mind hurt. Tony O'Malley, the great Irish painter, died too; his work testifies to a lifetime dedicated to the passionate and careful evocation of beauty. I give thanks for friends and their secret crochet of prayer that keeps all the spaces between luminous. A final pagan thanks to the mountains of the Burren and Conamara and a salute to the Atlantic Goddess!

BIBLIOGRAPHY

Agha Shahid Ali, *The Country without a Post Office*, New York, 1977.

Angelus Silesius, *The Cherubinic Wanderer*, trans. Maria Schrady, New York, 1986.

Ibn Arabi, *Journey to the Lord of Power*, Vermont, 1989.

Philip Ball, *Bright Earth: The Invention of Colour*, London, 2001.

Hans Urs von Balthasar, *The Glory of the Lord: A Theological Aesthetics: 1: Seeing The Form*, Edinburgh, 1982.

Bill Beckley and David Shapiro (eds), *Uncontrollable Beauty: Toward a New Aesthetics*, New York, 1998.

John Berger, *Harpers*, March 2002.

St Bernard of Clairvaux, quoted in Eco, *The Aesthetics*.

Robert Bly, *The Soul Is Here for Its Own Joy*, Eco Press, 1995.

Dietrich Bonhoeffer, *Letters and Papers from Prison*, SCM Press, 1953.

Claude Bragdon, *The Beautiful Necessity: Seven Essays on Theosophy and Architecture*, Routledge, 1922.

Peg Zeglin Brand (ed.), *Beauty Matters*, Indiana University Press, 2000.

Hermann Broch, *The Death of Virgil*, trans. Jean Starr Untermeyer, Oxford University Press, 1983.

Jean Morrison Brown (ed.), *The Vision of Modern Dance*, London, 1979.

Anne Carson, *Eros – the Bittersweet*, Princeton University Press, 1986.

Henri Cartier-Bresson, Artsworld TV interview, 12 April 2003.

Constantine P. Cavafy, *Before Time Could Change Them: The Complete Poems*, trans. Theoharis C. Theoharis, New York, 2001.

Joan Chittister, *Illuminated Life: Monastic Wisdom for Seekers of Light*, Orbis Books, 2000.

Hélène Cixous and Mireille Calle Gruber, *Rootprints, Memory and Life Writing*, London, 1997.

Samuel Taylor Coleridge, *Biographia Literaria*, London, 1975.

Ned Crosby, *Leaves on the River*, Galway, 2001.

Catherine David, *The Beauty of Gesture: The Invisible Keyboard of Piano and Tai Chi*, Berkeley, 1996.

Dante, *Inferno*, trans. John D. Sinclair, Oxford University Press, 1961.

Dante, *The New Life*, trans. Dante Gabriel Rossetti, New York, 2002.

Arthur C. Danto, 'Beauty for Ashes', in *Regarding Beauty: A View of the Twentieth Century* by Neal Benezra and Olga M. Viso, Washington, 1999.

Peter Davison (ed.), *Reviving the Muse: Essays on Music after Modernism*, Brinkworth, Wilts, 2001.

John Donne, *The Complete English Poems*, New York, 1991.

Denis Donoghue, *The Sovereign Ghost: Studies in Imagination*, New York, 1976.

Maureen McCarthy Draper, *The Nature of Music: Beauty, Sound and Healing*, New York, 2001.

Hajo Düchting, *Paul Klee: Painting Music*, Munich/New York, 1997.

Isadora Duncan, excerpts from her writings, in *The Vision of Modern Dance* by Jean Morrison Brown, London, 1979.

Meister Eckhart, *The Essential Sermons, Commentaries, Treatises and Defense*, trans. Edmund Colledge, O.S.A., and Bernard McGinn, New York, 1981.

Umberto Eco, *The Aesthetics of Thomas Aquinas*, Harvard University Press, 1988.

Umberto Eco, *Art and Beauty in the Middle Ages*, Yale University Press, 1986.

Ralph Waldo Emerson, *Selections*, ed. Stephen E. Whicher, Boston, 1960.

Epictetus, The Art of Living: A New Interpretation by Sharon Lebell, San Francisco, 1994.

Marsilio Ficino, *Meditations on the Soul*, Vermont, 1996.

Victoria Finlay, *Colour: Travels through the Paintbox*, London, 2002.

Philip Fisher, *Wonder: The Rainbow and the Aesthetics of Rare Experiences*, Harvard, 1998.

Hans-Georg Gadamer, *The Relevance of the Beautiful and Other Essays*, Cambridge, 1986.

John Gage, *Color and Meaning: Art, Science and Symbolism*, University of Chicago Press, 1999.

William Gass, *On Being Blue: A Philosophical Inquiry*, Boston, 1976.

William H. Gass, 'Goodness Knows Nothing of Beauty: On the Distance between Morality and Art' in *Harper's Magazine*, April, 1987.

Etienne Gilson, *The Arts of the Beautiful*, New York, 1965.

Louise Gluck, *Proofs and Theories: Essays on Poetry*, New York, 1994.

Goethes Werke, Zwölfter Band: Philosophische und naturwissenschaftliche Schriften, Berlin/Weimar, 1981.

W.S. Graham, *Collected Poems, 1942–1977*. London, 1979.

John Hadfield, *A Book of Beauty*, London, 1963.

Richard Harries, *Art and the Beauty of God*, London, 1993.

Daniel Harris, *Cute, Quaint, Hungry and Romantic: The Aesthetics of Consumerism*, New York, 2000.

Heraclitus, *Fragments: The Collected Wisdom of Heraclitus*, trans. Brooks Haxton, Penguin Press, 2001.

George Herbert, *The Complete English Works*, Alfred A. Knopf, 1995.

Patrick Heron, *Painter as Critic: Selected Writings*, ed. Mel Gooding, London, 1998.

Geoffrey Hill, *Tenebrae*, London, 1978.

James Hillman, 'The Practice of Beauty' in *The Sphinx*, 4, 1992.

William Hogarth, *The Analysis of Beauty*, Yale University Press, 1997.

Richard Holmes, *Coleridge: Darker Reflections*, London, 1998.

Gerard Manley Hopkins, *Poems and Prose*, sel. and ed. W.H. Gardner, Penguin Books, 1976.

Immram Curaig Máile Dúin, in Gerard Murphy (ed.), *Early Irish Lyrics, Eighth to Twelfth Century*, Clarendon Press, Oxford, 1977.

Derek Jarman, *Chroma: A Book of Colour*, London, 1995.

St John of the Cross, *Poems*, trans. Roy Campbell, London, 2000.

Wassily Kandinsky, *Concerning the Spiritual in Art*, Dover Publications, 1995.

John Keats, *Selected Letters*, ed. Robert Gittings, Oxford University Press, 2002.

Thomas Kinsella, *Collected Poems, 1956–1994*, Oxford University Press, 1996.

Susanne K. Langer, *Feeling and Form: A Theory of Art*, New York, 1953.

Walter Liedtke with Michael C. Plomp and Axel Rüger, V*ermeer and the Delft School*, Yale University Press, 2001.

Li-Young Lee, *Book of My Nights*, New York, 2001.

Li-Young Lee, *Rose*, New York, 1986.

Lucretius, *De rerum natura*, trans. William Ellery Leonard, New York, 1957.

James W. McAllister, *Beauty and Revolution in Science*, Cornell University Press, 1996.

Bryan Magee, *The Tristan Chord: Wagner and Philosophy*, New York, 2000.

Osip Mandelstam, *The Collected Critical Prose and Letters*, London, 1991.

James Alfred Martin, Jr, *Beauty and Holiness: The Dialogue between Aesthetics and Religion*, Princeton University Press, 1990.

Carlo-Maria Martini, *Saving Beauty*, London, 2000.

Rollo May, *My Quest for Beauty*, New York, 1985.

John Miller (ed.), *Beauty: An Anthology*, San Francisco, 1997.

Gabriela Mistral, *Selected Prose and Prose Poems*, ed. and trans. Stephen Tapscott, University Press of Texas, 2002.

Robert C. Morgan, 'A Sign of Beauty', in Bill Beckley and David Shapiro (eds), *Uncontrollable Beauty*, New York, 1998.

Francesca Aran Murphy, *Christ: The Form of Beauty*, Edinburgh, 1995.

Anne-Sophie Mutter, 'The Soul of Mother Courage', in *BBC Music Magazine*, January 1996.

Vladimir Nabokov, *Speak, Memory*, London, 1999.

John Nash, *Vermeer*, Amsterdam, 1999.

John Navone, *Enjoying God's Beauty*, Minnesota, 1999.

Pablo Neruda, *Selected Poems*, Penguin, 1977.

Friedrich Nietzsche, *The Birth of Tragedy*, Penguin, 1993.

Isamu Noguchi, *Essays and Conversations*, ed. Diane Apostolos-Cappadona and Bruce Altshuler, New York, 1994.

Isamu Noguchi, *The Isamu Noguchi Garden Museum*, New York, 1987.

John O'Donohue, 'The Absent Threshold: The Paradox of Divine Knowing in Meister Eckhart' in *The Eckhart Review*, Summer 2003.

Rudolph Otto, *On the Idea of the Holy*, Oxford, 1928.

Michel Pastoureau, *Blue: The History of a Colour*, Princeton University Press, 2001.

The Confession of St Patrick, trans. John Skinner, Foreword by John O'Donohue, Doubleday, 1998.

Don Patterson, 'Aphorisms', in *Oxford Poetry*, XI.2, Summer 2001.

Plato, *The Symposium*, trans. Suzy Q. Groden, University of Massachusetts Press, 1970.

Plotinus, *The Enneads*, trans. Stephen Mackenna, Penguin, 1991.

Marguerite Porete, *The Mirror of Simple Souls*, trans. Ellen L. Balinsky, New York, 1993.

Pseudo-Dionysius: The Complete Works, trans. Colm Luibheid, New York, 1987.

Kathleen Raine, 'The Use of the Beautiful', in *Defending Ancient Springs*, Golgonooza Press, 1985.

Howard Rheingold, *They Have a Word for It*, Putnam, 1988.

Rainer Maria Rilke, *Werke*, Insel Verlag, 1965.

Louis Roberts, *The Theological Aesthetics of Hans Urs von Balthasar*, Washington, 1987.

Stephen David Ross, *The Gift of Beauty, The Good as Art*, New York, 1996.

Ralph Rugoff and Susan Stewart, *At the Threshold of the Visible*, New York, 1997.

The Essential Rumi, trans. Coleman Barks with John Moyne, Castle Books, N.J., 1995.

Edward W. Said, *Musical Elaborations*, Columbia University Press, 1991.

George Santayana, *The Sense of Beauty*, New York, 1955.

Elaine Scarry, *On Beauty and Being Just*, Princeton University Press, 1999.

Ethel Schwabacher, *Hungry for Light*, Indiana University Press, 1993.

Shelley, sel. Kathleen Raine, Penguin, 1974.

William Stafford, *Crossing Unmarked Snow*, ed. Paul Merchant and Vincent Wixon, Ann Arbor, 1998.

Wallace Stevens, *Collected Poems*, New York, 1967.

Karlheinz Stockhausen, *Stockhausen on Music*, London, 2000.

J.W.N. Sullivan, *Beethoven: His Spiritual Development*, London, 1979.

Christopher Sweet, *The Essential Johannes Vermeer*, New York, 1999.

John Tavener, *The Music of Silence: A Composer's Testament*, Faber, 1999.

Frederick Turner, *Beauty: The Value of Values*, University of Virginia, 1991.

Alexander Tzonis, *Santiago Calatrava: The Poetics of Movement*, New York, 1999.

Paul Valéry, *Dialogues*, trans. W. McCausland Stewart, Bollingen Series XLV-4, 1956.

Richard Wagner, *Selected Letters*, trans. and ed. Stewart Spencer and Barry Millington, London, 1987.

Simone Weil, *Gravity and Grace*, London, 1963.

Ludwig Wittgenstein, *Remarks on Colour*, University of California Press, 1978.

Naomi Wolf, 'The Beauty Myth', in *Beauty*, ed. John Miller, San Francisco, 1997.

William Wordsworth, *Selected Poems*, London, 1996.

W.B. Yeats, *Poems*, ed. A. Norman Jeffares, Dublin, 1989.